Kelley Library - Salem NH

3 4520 00216087 4

KELLEY LIBRARY
234 MAIN ST.
SALEM, NH 03079
TEL. 898-7004

P9-BZI-093

WITHDRAWN

778.59 BARRETT, C. 2005
Barrett, Colin (Colin R.
Digitalvideo for beginne
a step-by-step guide to
34520002160874

DEMCO

KELLEY LIBRARY
234 MAIN ST.
SALEM, NH 03079
TEL. 898-7064

digitalvideo *for beginners*

A Step-by-Step Guide
to Making Great
Home Movies

Colin Barrett

LARK BOOKS
A Division of Sterling Publishing Co., Inc.
New York

Digital Video for Beginners

10 9 8 7 6 5 4 3 2 1

Published by Lark Books, a division of
Sterling Publishing Co., Inc.
387 Park Avenue South,
New York, N.Y. 10016

This book was conceived, designed and produced by:

I L E X
Cambridge,
England

Distributed in Canada by Sterling Publishing,
c/o Canadian Manda Group,
One Atlantic Ave., Suite 105,
Toronto, Ontario, Canada, M6K 3E7

If you have questions or comments about this book,
please contact:
Lark Books,
67 Broadway,
Asheville,
NC 28801

(828) 253-0467

All rights reserved

ISBN: 1-57990-680-0

CIP data for this title is available from the
Library of Congress

The written instructions, photographs, designs,
patterns, and projects in this volume are intended for
the personal use of the reader and may be reproduced
for that purpose only. Any other use, especially
commercial use, is forbidden under law without
written permission of the copyright holder.

Every effort has been made to ensure that all the
information in this book is accurate. However, due to
differing conditions, tools, and individual skills, the
publisher cannot be responsible for any injuries,
losses, and other damages that may result from the
use of information in this book.

Printed and bound in China

For more information on digital video, see:
www.web-linked.com/virdus

Contents

Introduction 6

What you need to know about your camcorder 12

Anatomy of the camcorder 14

Useful accessories 16

The lens 18

Focusing 20

Getting the right exposure 22

Low light 24

Artificial light and color temperature 26

Timecode 28

Built-in camcorder effects 30

Widescreen 32

Step-by-step shooting techniques 34

Planning the shoot 36

Shooting to edit 38

Establishing shots 40

Backgrounds and surroundings 42

When to zoom and pan 44

Action shots 46

Get in close 48

Shooting cutaways 50

Reverse shots 52

Over-the-shoulder shots 54

Point-of-view shots 56

Composition 58

Color 60

Natural light 62

Difficult lighting situations 64

Sound recording 66

Audio dub and commentary facilities 68

Organizing your footage 70

How to shoot great home movies 72

The natural look 74

Filming children 76

Children's birthday parties 78

School plays and concerts 80

Filming babies and toddlers 82

Video portraits 84

Weddings 86

Christmas and special holidays 88

Halloween 90

Summer vacation 92

Winter vacation 94

Sports events 96

A video tour of your house and yard 98

A video portrait of your neighborhood 100

Step-by-step digital video-editing techniques 102

Video-editing software 104

From camcorder to computer 106

The rough edit 108

Trimming clips 110

Insert edits 112

Transitions 114

Sound editing 116

Adding sound at the editing stage 118

Titling 120

Illustrated titles 122

Video special effects 124

Showing and sharing your movies 126

Making a videotape 128

Making a DVD 130

DVD menus and interfaces 132

Video compression 134

Movies and the Internet 136

Glossary 138

Index 142

Bibliography, online resources, acknowledgments 144

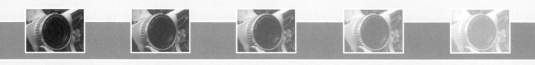

Introduction

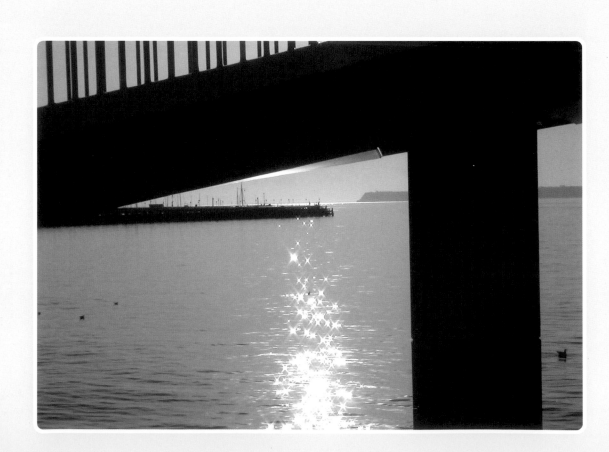

I know what you're thinking: today's digital camcorders are designed to be so easy to use that even a novice can pick one up and start shooting. Why, then, do you need a book like this? There's an easy answer. Once the initial fascination of recording and playing back hours of video wears off, the smart home-movie maker will discover that there's a big difference between shooting video and making something that somebody else will want to watch.

Introduction

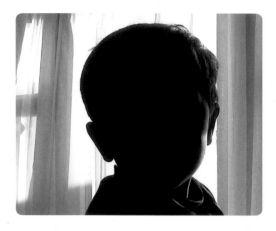

△ Beginners' movies are full of the same old mistakes. Here, the young child has been framed in close-up with no thought for the strong light behind him. It happens in other places where there's a strong, concentrated source of rear light—such as churches, for example. If it's not possible to move your camera position there's a way of overcoming this effect.

Assuming that you've bought, or are about to buy, your first digital camcorder, it's a fair bet that you'd like to show your recordings to members of your family, close friends and perhaps even work colleagues. While there must be the occasional camcorder owner who shoots only for personal amusement or as a means of documenting particular processes or events, the majority of us like the idea of our work gaining a wider audience. Even though a basic camcorder is designed as a "point-and-shoot" device, it won't make the video for you. Anyone can capture family moments with the minimum of fuss, but making great family movies takes a bit more thought.

Beyond the red button

The truth is, although camcorder makers go out of their way to make each new model stand out from the competition, most of them don't differ that much. For example, nearly all digital camcorders are similar in terms of their functionality, the range of features they possess and—within reason—the images and sounds they produce. True, the more expensive prosumer models will produce high-resolution pictures and contain more advanced features and manual controls, but in terms of basic usage it's like the difference between a Dodge Viper and a Honda Civic—an experienced driver could hop into either and get to the same destination. In the same way, most camcorder users will quickly discover how to insert a videocassette into an unfamiliar camcorder or work out how to operate the zoom lens.

In fact, it's even easier than that. At the most basic level, all that you need to do is point the camcorder in roughly the right direction and hit the red Record button. Given that the red button can normally be found without reference to the operating manual, this is something even a complete novice can manage.

Unfortunately, a great number of camcorder users don't move on from there: pointing the camcorder and recording is all very well, but is what you're shooting any good? The acid test is to sit your family members and friends down in front of a TV and play them what you've recorded. How do they react? Do they laugh and ask to see a sequence again? Do they offer only muted praise out of politeness? Do they fall asleep only 20 minutes into a three-hour recording?

◁ We're all getting used to watching TV and DVD movies on large, widescreen TVs, and it's no surprise to find that camcorder manufacturers are now incorporating widescreen recording options into the latest models. The wide 16:9 aspect-ratio pictures certainly lend themselves to more creative opportunities than do the more conventional 4:3 ratio pictures, but think carefully before committing to widescreen; not only does it require a different approach to composition and framing, but it could be that your favorite aunt won't be able to watch your latest video properly on her ageing TV.

◁ Camcorders will do everything in automatic mode if you wish, but it's far better to explore what can be done using manual overrides. Take focus, for instance; what would the camcorder's auto-focus utility make of a situation where you wanted to vary the focus slowly from foreground to distant horizon? Only by taking control of the manual functions will you be able to get the results that achieve the desired effect. The same is true of exposure and color control.

This is where the majority of home users fall down flat. The result is that many home videos are often uninteresting and, frankly, boring. In some cases, they're much, much worse.

It's all a question of discipline. A camcorder is like a car, a computer, or a horse: if you want to use it, you need to take control. If you can't control your car, you won't get anywhere safely. Similarly, a computer novice won't necessarily be able to scan a document and send it to someone via email without knowing how the computer works, at least in an elementary way. As for horses, if you haven't learned to take control of the beast you'll end up in a muddy ditch—if you manage to get into the saddle in the first place. While a camcorder won't throw you in the physical sense, it certainly will make it very tempting for you to record lengthy unsteady sequences, zoom in and out all of the time and even apply unnecessary digital effects throughout. Unless, that is, you learn how to tell the camcorder who's boss.

So, who is the boss?

That means learning what makes your digital camcorder tick. To that end, you'll find that the first section of this book provides you with a detailed overview of the kind of features the average camcorder has on board and an explanation of what they do. Don't worry: I've tried to keep this jargon free, as there's no point in getting bombarded with phrases and complex terminology if it all means absolutely nothing to you. After working with video for over 30 years, I've learned that there's no bigger barrier to learning than jargon; it's a complete turn-off for the beginner, so it's a no-no here too. What I've attempted to do is to break you in gently, starting with a simple guide to the average camcorder and a description of what its main features are likely to be.

You'll notice already that I've made reference to the "average" camcorder. Is there such a thing? Are all makes and models identical? Well, no, they're not. Some load tape from the bottom, others on the side.

Introduction

▷ Serious video-making often demands a more considered and professional approach. Sooner or later you'll decide that hand-held camerawork is fine for the occasional holiday movie, but for key shots and sequences there's no substitute for a rock-steady camera support. While you don't need to spend a fortune at beginner level, it's worth buying the sturdiest tripod you can afford. You won't regret it. Alternatively, there are other means of keeping your camcorder steady that won't break the bank.

Some have the zoom or focus controls on the top, others at the rear or on the side. They even come in a bewildering variety of shapes and sizes. However, they all do pretty much the same basic things in much the same way. If yours differs slightly from the examples used here, you still won't have any trouble working out what to do. When you start to get really ambitious, you'll be able to connect up any digital camcorder to a modern computer and edit your video footage like a real pro. But that comes later. First steps first.

Why digital?

Lots of people own camcorders that aren't digital, and you might be quite happy with your old VHS-C model, so why the emphasis on digital here? Well, the simple reason is that digital camcorders are fast taking over the world, with sales of the older analog formats—VHS-C, Video-8, and Hi-8—diminishing rapidly. And this is happening for some very good reasons. Digital is to video technology what the CD has become for audio; the music on a CD comes as a whole string of ones and zeroes which, when replicated any number of times, don't diminish in audible quality—whereas a vinyl disk or cassette tape loses quality every time it's copied. Every track on an audio CD is nothing more than a digital file which can be moved from here to there without fear of data loss, and in that respect it's no different from any other kind of file that you'd manage on a computer. Digital video has the same

quality: the camcorder turns the incoming light into a very long string of ones and zeroes (called binary code), and it's this code that is written to the tape. Play back the tape in the camcorder, and the reverse happens. The digits on the tape are converted back into something a TV screen and sound speakers can make sense of—TV pictures and their accompanying sound. But that still doesn't explain why this book is about digital video making as opposed to general all-round video camcorder techniques.

Well, the answer is simple. Because it's in what we call the "digital domain," it's much easier to do things with a digital recording— and once it's committed to tape it won't ever degrade in quality. What goes in is what comes out, no matter how much you copy it or move it around.

This has significant advantages for someone planning to edit their home videos, as the whole of a tape's content can be pulled into a suitably equipped computer and modified. You can add titles, music, and sound effects. You can chop out the toe-curling footage of Uncle Fred embarrassing himself in front of everyone at the family celebration, and make the whole thing look like real TV. And when you save it all back to digital tape in the camcorder, the quality will be exactly as it was when you first recorded it. That's where digital scores over analog every time.

Keeping it simple

Bear in mind that this is a simple, no-nonsense guide to getting the best family movies out of a regular digital camcorder. If you want heavy detail, technical explanations or advice on making a feature film for $50, then this isn't the book for you. It has been written in response to repeated requests by users, and would-be camcorder users, for a book aimed at the complete newbie—the novice, the beginner, the person with absolutely no previous knowledge or experience of digital camcorders or home-movie making. It's not just about learning how to use the features on your camcorder, it's about thinking how to use those features to make family movies that people want to watch.

What should become clear to you is that it doesn't actually take much to transform your home video footage into something that your viewers will genuinely enjoy watching, time and time again. Even with your camcorder switched to fully automatic mode, it's possible to shoot really great-looking home movies. Nor do you need to learn a complex set of professional techniques; good video is more the product of what you don't do rather than what you do, and by imposing upon yourself some simple disciplines you'll make your shots and sequences a

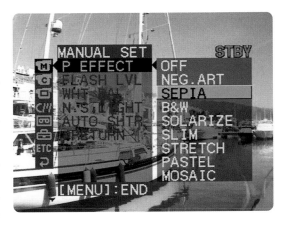

whole lot more watchable. It could be as simple as never zooming when recording, or treating every shot like it's really a still photograph. Looking before you hit the Record button, thinking about what it is that you plan to shoot and then carefully measuring what you're shooting by what you think your viewers will expect to gain from a shot are all habits that are very easy to get into.

The simple act of not zooming is a perfect case in point. Try it for yourself. Shoot some footage of an everyday scene, and resist the temptation to zoom or move the camera while you're recording. After the shot, press pause and set up the next shot—then repeat the exercise. Now you're making movies the proper way. Move over Mr. DeMille!

◁ Many camcorders offer a whole range of digital picture effects that can be created in camera and applied to your recordings right there as you're shooting. They're fun, people love them—but beware, once they're committed to tape you can't remove them; so think carefully before selecting them and pressing the Record button. If you have a computer which can be used to edit your movies later, it's probably best to leave this kind of thing until then. That way, you can experiment without affecting your original recordings.

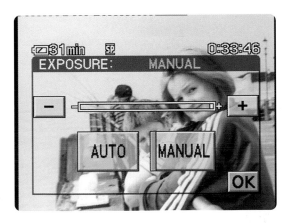

◁ Camcorders differ in their appearance and, to a lesser extent, in what they allow you to do. However, they all have a zoom lens, a built-in microphone, a rechargeable battery, a tape compartment, a viewfinder and the means to output your footage digitally and to a TV or VCR. A large number of camcorders have color LCD screens, battery lights and a whole host of sophisticated features. But if you're looking to make relatively simple movies, there's no need to buy an expensive model—one costing between two and three hundred dollars will be perfect.

What you need to know about your camcorder

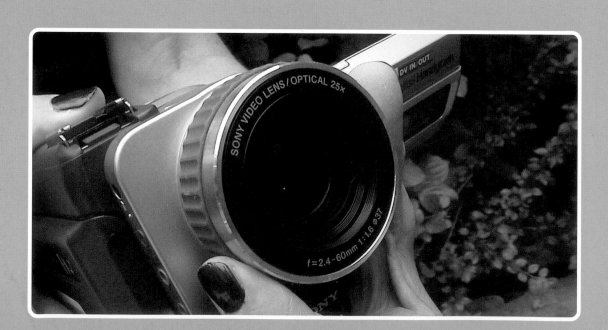

The digital camcorder isn't just a simple video recording tool but a collection of marvelous technologies just waiting to be explored. Look at an experienced video or film-cameraperson at work and you'll see that there's more to it than simply switching it on and hitting the red button. With practice, the camcorder becomes an extension of its user, the two functioning as one. In fact, it's only when the videomaker has an intimate knowledge of the equipment's capabilities—and the limits to which these can be pushed—that it becomes possible to obtain great results. Take time to make friends with your camcorder and you'll be richly rewarded for your efforts.

Anatomy of the camcorder

Pick up any recent digital camcorder and you'll see that, although they can look quite different from each other, they all have a common set of features: a zoom lens, a viewfinder, a built-in stereo microphone, recording and playback controls, and some means to connect the camcorder to a TV, VCR, or computer. An increasing number now have flash memory cards for the storage of digital still pictures, and some even have facilities that enable users to send stills or small compressed video clips to family and friends via their cell phone. To begin with, however, let's take a quick tour around a typical camcorder in order to find out what each bit does and why it's there.

◁ **Power switch**

The Power On/Off switch also provides the main selection between the Record and Playback modes. If your camcorder lets you take digital still images and even has the ability to be used as a webcam, you'll probably see options for these on the power switch, too. Of course, the one important button that's usually placed right in the middle of the cluster is the red Record button.

◁ **Tape compartment**

This is where the tape is loaded into the camcorder ready for recording or playing back your video footage. Like the mechanism inside the camcorder, Mini-DV, Digital-8, and MICROMV tapes are very delicate and should be treated with care. Always protect the open compartment from dust and sand as they can cause irreparable damage.

◁ **Tripod bush**

Today's camcorders are designed primarily for hand-held operation, but for stability and control, a tripod or a monopod is extremely useful. It's rare for a camcorder not to have a screw-thread socket on its base—we call this the tripod bush.

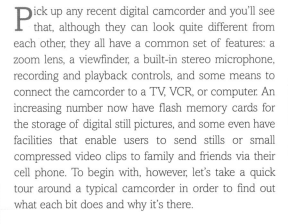

△ **AV connecting sockets**

All self-respecting digital camcorders make it possible for you to export your tape recordings to a computer for editing and for transferring still pictures, too. You'll want to view your creations on a TV set or even re-record them to a VHS tape. These output connections will be standard, with other models also enabling you to feed outside signals into the camcorder for re-recording onto the digital tape inside.

Zoom lens

Not only does the lens have a key role in passing light onto the internal imaging device, but it also provides the means to vary that amount of light (exposure) and adjust the picture sharpness (focus). Some lenses will have knurled focus rings on the lens barrel itself, whereas others will allow focus adjustment either automatically or by the use of a thumbwheel elsewhere on the camera body. On most consumer camcorders, the exposure is adjusted this way, too. Camcorder lenses also offer the ability to zoom into or out of objects in the frame in order to increase or decrease magnification. Lenses will have a minimum focal length—measured in millimeters (mm). This will be considered to be its widest setting. Fully zoomed in, the lens also has a maximum telephoto setting (*See Zoom ratios, page 45*).

Microphone ▷

The vast majority of camcorders have a built-in stereo microphone that will automatically capture the sound as you record. It will often be positioned either underneath the lens or, in the case of the model pictured, on the top of the main body. These mics produce reasonably good stereo sound indoors, but they can be affected by wind noise when recording outdoors.

◁ **Accessory shoe**

Many camcorders have a standard accessory shoe on which a battery light or additional microphone can sit. In some cases these are "hot shoes"—carrying power or enabling increased functionality for the accessory. Zoom microphones, for instance, allow you to zoom in to the sound source in the same way as the lens zooms. These are called "intelligent accessories."

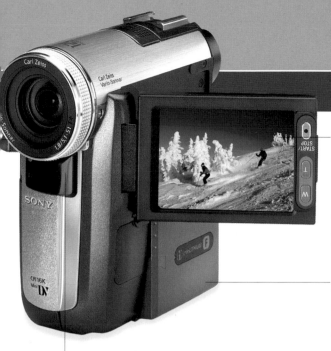

LCD screen

The Liquid Crystal Display (LCD) screen provides a larger image than the viewfinder, and can be a more convenient way to monitor your recordings. LCD screens fold away into the camcorder's body when not in use, and can often be viewed in a variety of positions. Like the viewfinder, the LCD screen will also facilitate the display of other data—date/time, tape usage, and battery status, for example—as you're recording or playing back. An increasing number of LCD screens now have touch-screen technology, reducing the need for lots of buttons on the camcorder.

Rechargeable battery

The Info Lithium or Lithium Ion battery is much smaller than on older camcorders, and can be recharged either on the camcorder itself or on a separate charger unit. Some batteries fit snugly into a slot into the camcorder's body, while others attach to the outside.

Infrared sensor

This enables communication between the Remote Control (if supplied) and the camcorder. In some cases, it will also assist the autofocus function of the camcorder by shooting an infrared beam to the center part of the frame which is then used by the imaging system to determine accurate focus when taking stills in conditions of darkness.

△ **Flash light**

Many camcorders also have digital still photography facilities, so the addition of a built-in flash is becoming more commonplace. This can be set to pop up when the Photo button is pressed. A flash-memory card—such as Memory Stick or an SD Card—will be used to store the images as well as small compressed movie clips.

△ **Viewfinder**

On smaller, hand-held camcorders, the viewfinder will usually be situated at the rear of the camcorder and will provide either color or black-and-white pictures. It's worth using the viewfinder when you wish to conserve battery power (color LCD screens consume more power) or when you need to frame and focus shots carefully. It's common for viewfinders to be equipped with a rubber ring to make their use more comfortable and to reduce the light falling onto their tiny screens.

About the formats

Mini-DV

Launched by Sony in 1995, DV (or Mini-DV) is the most popular consumer digital video format. DV camcorders provide what is arguably the best quality of all of the home video formats, with all models capable of transferring video signals out to another device (such as a Windows or Apple Mac computer) via FireWire—also known as i.Link. An increasing number of DV camcorders also make it possible to copy edited recordings back to the DV tape in the camcorder using what is known as DV-in.

Digital-8

This format was introduced by Sony in the late 1990s and uses 8mm videocassettes (as used by Video-8 or Hi-8) to record and replay a video signal identical to DV. Signals use FireWire (i.Link) to transfer a DV-specification signal out and—where appropriate—back into the camcorder. Some Digital-8 models will enable users to insert standard analog Video-8 and Hi-8 tape recordings and play them back, in addition to converting the signals as they are passed via FireWire to a computer for editing.

MICROMV

MICROMV is a format that uses cassettes that are 70% of the size of DV cassettes, and which records in a format called MPEG-2—the same basic format used in DVD discs. Although the limited number of MICROMV camcorders available contain i.Link connectors, it isn't possible to transfer video to a computer without the use of special computer software (usually supplied by Sony with its models).

DVD

Hitachi first launched camcorders that record to 8cm DVD discs back in 2001, and several other major manufacturers soon followed suit. Like MICROMV, DVD camcorders use MPEG-2 compression prior to writing the signals to disc. One of the major problems of DVD camcorders has been that the discs written to by the camcorder can't always be played back on every model of home DVD player. Luckily, these issues are being resolved steadily.

Although all digital camcorders have the ability to shoot in a broad range of lighting conditions and have built-in stereo microphones, there are times when your camcorder will need a helping hand with light and sound. You may be planning to shoot in dark surroundings or in situations where the camcorder is too far away from the source of a sound to capture the audio clearly. This is where specialized accessories come in handy. A battery-operated light or directional microphone will sit on the camcorder's accessory shoe (which the majority of models have) and will throw more light onto a subject or make it possible for your viewers to hear what a person is saying a reasonable distance away from the camcorder. It also helps to be able to hear what your camcorder is actually recording, too. Even a pair of low-cost headphones will enable you to hear more precisely what the recorded sound will be like—and they'll also help you to position the microphone in relation to the source, such as a wedding speech or a birdsong in an open landscape.

△ A battery light is an inexpensive and effective accessory for adding illumination to your subject. Check the accessory sheet that came with your camcorder and the chances are that there will be at least one on offer. It's a good idea to use rechargeable batteries, as the lamp will probably give you less than 15 minutes' operating time from a single set.

△ A good directional microphone produces a clearer representation of sound that is directly in front of the camcorder and will help reduce the pick-up of unwanted sounds. They won't, however, cut out all extraneous sound (it would take a very expensive microphone to achieve this) though it will make a difference to the general quality of the audio. Many microphones of this kind are battery operated and often come with a foam windshield, designed to reduce the effect of moderate wind blowing across them.

Steadying influence

Another immensely useful accessory is the tripod. It's amazing what a difference steady shots can make to even the most ordinary home video. A modest investment in a tripod will not only help overcome the camera wobble that is a common feature of many home movies, but a tripod will also make you stop and think about what it is that you're trying to convey when you actually hit the Record button.

That said, there will be situations where it isn't practical to carry a tripod around, so a monopod or mini-tripod might come in handy instead. A monopod is a single telescopic pole with a standard tripod bush on the top, making it a useful and portable support for your camcorder. You may have seen them being used by sport photographers, especially those using huge telephoto lenses. A mini-tripod will fit into a jacket pocket and provide a convenient means of support to a lightweight camcorder just when you need it. Place it on a wall or tabletop for instant support. Some of them even have a small suction pad on the base of the central column, making it possible to grip a shiny surface for extra stability.

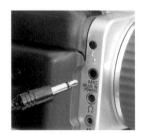

▽ In order to use an external microphone, check that your camcorder has an external microphone jack input. This will be found adjacent to the headphone jack.

◁ In order to check the quality of sound coming into the camcorder, it's advisable to acquire the best-quality headphones you can afford. A pair of closed-cup headphones is a useful means of eliminating other sounds around you, but the kind of headphones that are used with personal stereo devices will be acceptable in a lot of cases.

Getting connected

In order to transfer video signals and stills digitally from the camcorder to a computer or another camcorder, you'll need to use either USB or FireWire connections. What are they and what's the difference between them?

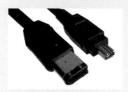

△ **FireWire**
Originally patented to Apple Computer in the late 1980s, your camcorder manufacturer might refer to this as i.Link or even its proper name, IEEE1394. Commonly known to everyone in the digital imaging fraternity as FireWire, it's the standard method of moving bits of data recorded on your DV tapes to your computer— or even another camcorder or digital recorder. The FireWire (i.Link) socket on your camcorder will almost certainly be a smaller 4-pin type, whereas your Apple Mac or Windows PC video capture ports will probably be of the larger 6-pin type. FireWire carries your digital video pictures, stereo sound, and other associated information in one cable, enabling it to be copied again and again without it degrading.

△ **USB**
The standard USB connection isn't capable of shifting data at the same speeds as FireWire, and is more commonly used for the transfer of images to and from a memory card in addition to smaller, compressed video clips for emailing to friends or uploading to a website. There are two types of USB—USB 1.0 and USB 2.0, the latter being much faster (with speeds above FireWire), but all connected devices have to be able to process USB 2.0 before the speed advantages take effect.

For the moment, it's a case of using FireWire for digital video and USB for stills and compressed video.

▷ It might come as no surprise to learn that a tripod will have three legs. In almost all cases these will be telescopic in either two or three stages, and will probably have a central column that can be wound up and down in order to set the camcorder's height. Although lightweight camera and camcorder tripods can be obtained at a very low cost, it's a good idea to spend as much as you can afford. You will need a tripod that gives not only a sturdy means of support when rehearsing and recording your shots, but which also has a pan and tilt head that can enable you to perform panning shots (moving the camera horizontally from left to right and vice versa) and tilting shots (up and down).

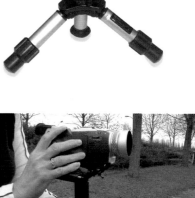

▷ If you can't think of any obvious uses for a mini tripod, think again. In fact, it's an almost indispensable asset for any camcorder enthusiast due to its compact size and wide range of applications. Even when using a camcorder in hand-held mode, it can often be a good idea to attach it to the tripod— you'll be surprised how it aids stability, especially when taking "walking shots."

▷ Like a tripod, a monopod will be telescopic. It's slightly more manageable than a proper tripod, and provides a quick and unobtrusive way of getting a stable shot without having to set out three legs and set the pan and tilt head level before recording. When used in combination with a tilting LCD screen, it's a very handy way of getting a shot over the heads of a crowd, too.

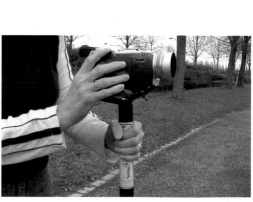

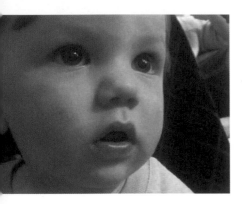

△ For good, strong, close-up images, move in close to the subject and zoom out wide. This will have the added benefit of keeping much of what is also in the frame reasonably sharp—but only if there's sufficient light. The downside (or maybe even the upside) is that chubby cheeks might just appear even chubbier!

The more light you can give the camcorder's CCD, the better the resulting images will be. There are two main reasons for this. To start with, a lot of camcorders in the middle and lower end of the home video market have smaller imaging devices (1/4-inch and even 1/6-inch single CCDs aren't uncommon) and they have to work much harder to resolve a good image than their 1/2-inch professional counterparts. The other reason for pulling in as much light as you can is that, as every photographer knows, the more light you have at your disposal the greater the freedom you have to experiment with exposure, contrast, and focus. Moreover, it's hard to increase the level of natural light by using artificial means without harming the resulting picture quality. The lens itself plays an important role in getting decent pictures, whether you're shooting video or stills with your camcorder.

Flatten and flatter

When you're trying to record a room full of people, you need to zoom out wide and move back as far as possible in order to get it all in. If you want to see a close-up shot of a child as he or she eats some chocolate cake you might zoom in. However, there are times when it's preferable not to zoom in but to physically move the camcorder into a closer position while still keeping the zoom at its widest setting. The pictures might just look better—but at a cost. A wider lens setting (a minimal focal length, in other words) will have the effect of slightly distorting the image, and this is particularly true where consumer-quality lenses are concerned.

Higher focal lengths—such as lenses that are fully zoomed into the subject—have the effect of producing a more even image, and for this reason we say that a telephoto lens can "flatten and flatter" a subject, whereas a wide lens can often make a subject look wider and fatter than he or she may be in real life.

▷ This scene was shot from a distant pier on the end of a 20x optical zoom with the effect that both the closer objects and those much further away up the hill all appear to be in focus. This is an example of the "flattening" effect of the telephoto lens when used at a distance.

◁ Here's a shot taken from a distance of many yards, with the camcorder zoomed in to a ratio of about 10:1. This gives the image a generally even quality; objects in the background are clearly visible and only slightly out of focus. The telephoto facility is flattening the scene.

Tip

When considering what camcorder to buy, consider the minimum and maximum zoom lens focal lengths in addition to the zoom ratio, and ignore digital zoom ratios. Sales staff like to quote them but high-ratio digital zooms over 120x magnification offer very little practical benefit.

Optical and digital zoom

Even if you don't yet own a camcorder, the chances are that you'll be familiar with what a zoom lens actually does. It's common to see a close-up of a landscape feature only for a camera to be zoomed back in order to reveal the wider landscape in which it exists. In all probability, the lens was zoomed through its full range—from maximum telephoto to its widest setting. A lens's focal length is measured in millimeters (mm), and if you have a still camera, you might take pictures with a 50mm lens (the standard focal length, roughly equivalent to the view as perceived by the human eye), and this we call a "fixed focus" lens simply because it can't be changed. A zoom lens can, and therefore we refer to both its minimum and maximum focal lengths respectively. So, a camcorder whose lens offers a zoom ratio of 10:1 with a lens whose minimum focal length is 4.5mm (the distance between the rearmost element and the surface of the CCD) will have a maximum focal length of 45mm. With a 12:1 (or 12x) zoom, this would be 54mm, and so on.

The majority of digital camcorders have an additional zoom facility that enables the magnification of images beyond the optical zoom capability of the lens. This is known as digital zooming, and results not from moving the glass elements within the lens itself, but from an electronic process designed to electronically enlarge the picture cells (known as pixels). This can prove useful where the magnification is no greater than, say, 40:1, but is ineffective on ratios as high as 700:1. There just isn't enough visual information captured to make the enlargement possible.

With the digital zoom utility switched on, it's possible to zoom beyond the camcorder's optical zoom capability—but at a cost to quality. In these three images, you can see that, at 20x magnification, the image of the distant tree is relatively clear. Push the zoom further to 40x magnification and the pixels—the little rectangular picture cells that make up the image—become apparent. Zoom into the full 120x magnification and the image is decidedly blocky. You can still make out the top of the tree, but it's not an image that you'd wish to incorporate in your videos. An increasing number of camcorders feature digital zooms of 200x, 400x, and even 700x magnification. It sounds good on paper, but don't be fooled: there isn't any genuine advantage.

Focusing

△ Depth of field is a photographic term for how much of the area before and behind the object in focus will be sharp. It can be controlled in a couple of ways. It might be that you really want the background to be out of focus while the subject is pin-sharp, but it could also be that you want the background to be in focus as well. To achieve a wide depth of field you should acquire a wide-angle lens attachment. This will further increase the camcorder's field of view and, in doing so, increase the overall depth of field.

Have you ever had to endure somebody else's home video in which the pictures are fuzzy more often than they're sharp? Have you noticed that every time the camera is moved or zoomed the focus goes all over the place? The majority of camcorders now have an auto-focus to take the strain out of keeping the image in focus, but there's a price to be paid if you don't follow some basic rules. For a start, auto-focus doesn't make instant adjustments to the incoming pictures—it takes a few seconds to analyze the central area of the image coming through the lens, work out what can be made sharper, and make the appropriate changes. To function properly, the auto-focus feature would prefer it if you either held the camcorder steady or—better—mounted it on a tripod. Why? Because without this stability, auto-focus could actually prove to be more hassle than it's worth.

The trick with auto-focus is to be gentle. Instead of hitting Record and expecting the focus to adjust as you record, why not hold the camcorder steady and let the image stabilize before recording? Similarly, if you want to change the shot slightly during recording, make your camcorder movements slow and gentle in order to give the auto-focus a chance to do its work properly and inconspicuously.

Situations that can fool auto-focus

The problem with auto-focus is that it's constantly looking around for something else to focus on, so you have to be careful not to allow it to get away with anything that might impair the quality of your shot. Having settled down to a nice, sharp image, the focus circuit will instantly respond to changes in the optical characteristics of the image just when you least want it to. Your carefully framed shot might take into account the bushes that you've placed at one side of the shot; their framing isn't significant enough to attract the attention of the auto-focus, and focus therefore remains constant, but a sudden gust of wind or careless movement of the camcorder could result in a rude awakening for the auto-focus and a dramatic change to the sharpness of the overall image.

The alternative is to look for a way to override the auto-focus, and at times the only answer is to control your focus manually—assuming that your camcorder will allow it. Manual focus means that you can choose which part of the image should remain in focus and which shouldn't and, because it won't change unless you make an adjustment, your recorded images won't lose their focus if the wind picks up or some traffic moves in the background.

Using focus lock

Have a look for a button (or menu item) called "manual focus" or "focus lock" on your camcorder. Before recording, set the focus according to your preference—either manually or automatically—and then lock it in place simply by switching to manual focus. Now, your focus won't go wandering even if you do. The downside? It's now down to you to make any necessary changes manually using either the menu thumbwheel, lens focus ring, or—as is possible on some digital camcorders—by using the LCD touch-screen's spot focus feature.

Manually adjusting focus

By switching off the auto-focus and experimenting
with manual settings, you'll soon be adding a
professional touch to your movies in a way that
impresses family and friends. You'll need a tripod on
which to set up the camcorder on an interesting scene
or landscape feature. Look for a nearby tree or bush
with an overhanging branch that can be featured in
shot, very close to the lens. Zoom the lens out to its
widest setting and let the lens automatically focus on
the branch. Switch the focus to manual. Now, with
your shot appropriately framed, adjust the focus
manually so that the focus shifts from the branch to
the distant scene. Now try it in reverse ensuring that
you don't knock the camcorder or move the tripod.
This technique is called "pulling focus" and is much
more effective than simply letting the camcorder get
on with recording the scene as it sees fit.

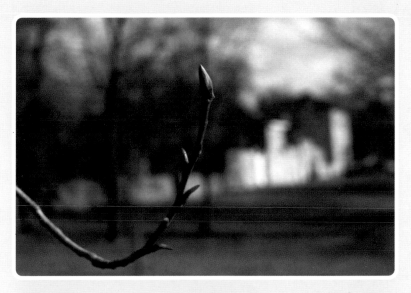

Spot focus

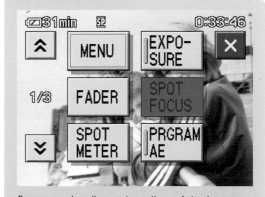

Some camcorders allow you to use the cam's touch-screen
controls to select the main area of focus within the scene. You
just touch the area that you want to concentrate your focus
on. This is known as "spot focus."

Getting the right exposure

Don't underestimate the importance of exposure when setting up your video shots. Exposure is better described as the process of letting light into your camcorder via the lens—and the part of the lens that controls this is the aperture. If you've ever used a still photographic camera, you'll probably be aware that the aperture has a number of f-stops, each of which has a seemingly odd nominal value. The larger the number, the smaller the opening through which light can pass. An average still photo camera might have an aperture ranging from f22 at the bottom end to f2 or even f1.6 at the top end. In this case, an aperture of f1.6 would be its widest aperture—this would enable the most light to pass through the camera's lens.

Light is of course vitally important for all cameras, and this includes your camcorder.

∇ With strong sunlight creating an even spread of light, the auto-exposure circuit has no trouble working out the optimum exposure for the shot.

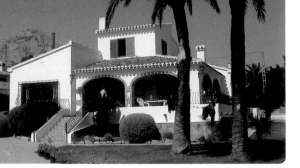

However, unlike film or very high-quality video, both of which will happily work with much lower levels of light, the lower-cost consumer video camcorder will quickly show its limitations if you record in dark corners or outdoors at sunset. The likelihood is that the images will start to look grainy and underexposed. Depending upon the make and model of camcorder being used, the resulting images might even take on a reddish hue or—even worse—get washed-out altogether. Always try to work with as much light as you can, as it's only when you have a ready supply of it that you can be selective about how you use it.

The benefits of auto-exposure

Like auto-focus, your camcorder will regulate the exposure of each shot automatically if you wish it to. There are many advantages to this—especially if you're new to video. It might be that you're filming a children's birthday party indoors and with only house-lamps for illumination. You don't want to have to make manual adjustments to the exposure before hitting the Record button, and you certainly don't want to make minor adjustments to the exposure every time you move the camera. By letting the camcorder work out what's best for the recording, you can be sure that you'll end up with a good—if not perfect—compromise in the circumstances. However, there are pitfalls to such an approach, just as there are disadvantages to shooting with auto-focus active all of the time.

Like the focus circuits, the auto-exposure prefers not to have to do too much work. With everything constant and stable, you can be sure that the end result will be good. As soon as somebody walks through your shot wearing a bright white dress or holding highly reflective wrapping paper, however, things start to go wrong. The camcorder's auto-exposure circuit will go into rapid-response mode and reduce the aperture accordingly. This unsightly bouncing up and down of the exposure can impair the

Touch-screen exposure control

An increasing number of digital camcorders, such as Sony's DCR-PC330 DV, offer an intriguing method of determining exposure. Its touch-sensitive color LCD viewing screen enables the user to select the area to be measured by the camcorder's exposure control by simply touching it.

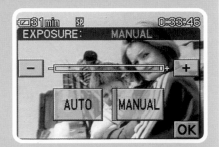

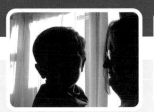

Compensating for strong backlight

Sometimes you'll find yourself pointing the camcorder at someone positioned immediately in front of a bright source of light or window. We call it the "church window syndrome"—and it's a situation that many camcorders find difficult to cope with in auto mode. Some camcorders have what's called a "Back Light" feature, which, when activated, forces the exposure in favor of the foreground subject rather than the overwhelming light source behind. Although all background detail might be lost due to over-exposure, at least the subject will be properly exposed. The better option, of course, is to either reposition the subject or tighten up the shot (by zooming in or moving physically closer) to make the foreground subject dominant in the frame.

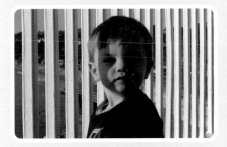

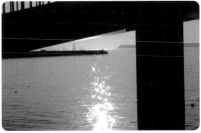

△ As the resolution of the average camcorder's CCD improves, so it becomes possible for the imaging devices to cope with contrasting subjects. Here, the very bright railings contrast with the shadows on the boy's face, producing a highly satisfactory shot. Always look for interesting lighting conditions—and be prepared to wait for the exact moment when it will be just right.

△ Shooting against the light is something we instinctively avoid, but take a serious look at the way the light hits your subject and consider pointing the camera toward the source of light. You'll get some dramatic shots. These are produced by the camcorder's auto-exposure circuits as they significantly reduce the aperture in order to control the upper light levels within the shot. Don't be afraid to experiment and you'll find that at least some of your shots will be wonderfully moody.

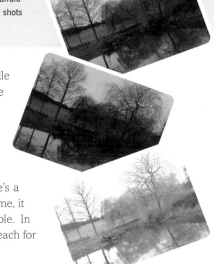

look and feel of your video. In this situation, it's a good idea to allow the camcorder to find the optimum exposure before you start shooting, and then lock it manually before recording. Now it won't vary—but watch out for unexpected changes when you move to a new location or if the clouds move in!

Measuring exposure

Most modern digital camcorders use a simpler method of calculating the optimum exposure than their stills photography counterparts. The most common is the center-weighted meter, which considers the light level in the middle of the frame and determines the overall exposure according to this reading. Providing that the illumination across the whole frame is reasonably constant, this won't create problems with the resulting exposure, but if there's a stark contrast elsewhere in the frame, it could render your images unusable. In such situations, you may have to reach for the manual exposure controls.

Although today's camcorders are designed to cope reasonably well in low light, they're much happier when they have lots of light available. Having said that, the improvements in CCD technology are notable in that most camcorders can go where you wouldn't have dreamed of taking them only a few years before. In the same way that a camcorder's automatic-exposure system will reduce the aperture of the lens when there's more light than it needs to render a good image, so the opposite happens when there's insufficient illumination. The part of the camcorder's circuitry that tackles this problem is the AGC (or Automatic Gain Control) circuit. This does what it suggests—seeking to lift the sensitivity (the "gain") to a level that will result in viewable picture. Unfortunately, a viewable picture isn't necessarily one that will be pleasing to the eye, so you need to think carefully when aiming to record in situations of low light. Low-light images are often flat, unsharp, and uninteresting. Because the aperture is likely to be wide open, you'll probably have problems with depth of field as well.

The incorporation of smaller CCDs in many low and mid-range camcorders doesn't help either. With chips now as small as 1/6 inch in some models, it's not reasonable to expect a high performance from such a camcorder at low-light levels. The makers like to boast that their models will work at light levels as low as 4 or even 3 lux (the standard measure of illumination, or available light level), but if the resulting pictures are grainy and possess a red bias, then that's not much to write home about.

Shooting in low light

If you're faced with recording a scene indoors under conditions of low lighting (*1, right*), take every step to increase the amount of available light by switching on

Supporting the camcorder without a tripod

Many a good night shot has been ruined simply because the camcorder wasn't properly supported during recording. You don't need to lug a tripod around with you all of the time, but keep an eye out for suitable means of support. A nearby wall, a gatepost and even the roof of a car might help you to get that all-important shot of a sunset or zoomed-in shot of a shy animal.

Hand-holding the camcorder

The incorporation of LCD screens on camcorders might make it easier to see what you're recording, but their use won't necessarily aid stability when recording hand-held. You'll stand a better chance of getting stable shots if you grip the camcorder properly, and avoid waving it around as you record the scene in front of you. Rather than placing your right hand through the strap and resting on the zoom control, try holding it around the body with your left hand providing additional balance. Not only can you easily make manual adjustments while recording, but the temptation to zoom at every opportunity is avoided, too!

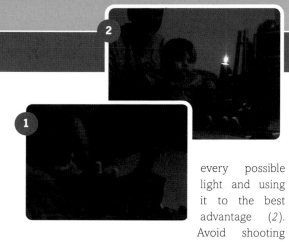

every possible light and using it to the best advantage (2). Avoid shooting directly into lamps—such as table lamps or small wall lamps—as they'll not only influence the automatic exposure, but you could end up with vertical smearing, which is often produced by the camcorder's CCD chips. Where possible, use artificial illumination to its best advantage by keeping your subjects close to it in order to benefit from the source, then switch the camcorder to manual exposure in order to balance the incoming light to a level that looks right in the viewfinder or LCD screen.

Shooting at night outdoors

Modern digital camcorders are quite capable of producing good images outdoors at night—providing that there's sufficient light. Usually, a halogen lamp is sufficient to light up a barbecue or garden party. Alternatively, you might prefer to mount a battery light onto the camcorder itself in order to get shots of revelers enjoying themselves. If, however, you'd prefer to be slightly less conspicuous when recording, you'll have to look at the illumination of your subjects very carefully in order to ensure that they'll be seen when the final video footage is played back on a TV screen. An additional problem caused by TV monitors is that they are inclined to clamp the black level, so that black actually is black—even if your intention

was that it should be a charcoal gray. This can play havoc with under-lit night shots, and is another incentive to get as much light in the scene as possible.

Reflected light on the surface of water makes for impressive night shots. The glistening moonlight on the surface of the ocean or a river makes for very effective images, and the lights that surround a harbor can add to the atmosphere. In this sequence of shots (*right*), the exposure was set to automatic. However, reflections on the water are countered by the areas of darkness which could then have encouraged the exposure circuit to over-expose the shot—and bleach out the light areas. In the end, we opted for an average, center-weighted, exposure (3, 4). Any lighter, and picture grain would have been noticeable. Any darker, and the image would be underexposed.

The final image in the sequence (5) was lit using a video-light mounted on the camcorder (6). Such lights can and do provide a very welcome boost in emergencies— but don't rely on them to illuminate a scene effectively for more than a few minutes as their batteries will drain very quickly.

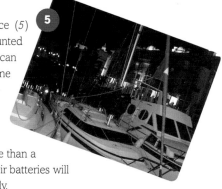

There are times when natural light just isn't enough. Try filming the kids singing karaoke in a dark room or a family gathering on the patio after sunset and you might conclude that you really need more light. You have a choice—put up with the resulting graininess and lack of definition in your sequences, or buy some lighting equipment. It doesn't need to cost a fortune, either; most people opt for a battery-operated light that sits on the camcorder's accessory shoe. There are lots to choose from and they're all designed to provide ample illumination at the flick of a switch (*see page 16*).

Color temperature

This isn't a reference to the heat given off by a lamp but to the color that various light sources give off. Although the human eye and brain aren't aware of it, natural daylight has different properties to the light that emanates from household lights, street lights, and video lights. If a camcorder is set to film in daylight, but is pointed at an artificial light, the images will have a strange color cast. A camera set to shoot indoors will also create poor images when taken outside. To avoid these problems, you need to understand the basics of color temperature, and the vital differences between daylight and artificial light.

The normal color "temperature" of light at noon on a sunny day is measured at 5,600 Kelvin (the standard measurement of color temperature), although on very hot, sunny days when the sky is blue and the light is intense, it can be much higher. With your camcorder set to daylight mode—normally the default mode when you switch on, though it can be manually overridden—you'll be able to record a scene which, when played back, looks perfectly normal. However, if you were to switch off the auto function and then record indoors under artificial lighting, you'd notice that the picture would have a distinctly blue cast to it. Similarly, set the camera's white balance to indoor light and shoot outside and the images will take on a reddish hue.

A typical halogen lamp will operate at a color temperature of approximately 3,200 Kelvin, with some producing 4,000 Kelvin. With most camcorders offering the simple choice of "indoor" and "outdoor" color temperature, you'll be working in the range of between 3,200 and 6,000 Kelvin.

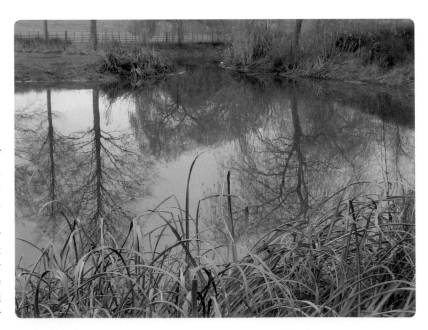

Setting the White Balance manually

In order to set the optimum color temperature for the chosen lighting situation, you might find that you have to press a button labeled WB (White Balance). Professionals focus the camera on a piece of white paper or cardboard and press the White Balance button. Whatever the color temperature of the light, the camera adjusts so that the white card looks white, rather than red or blue. This means that whether you're shooting indoors or out, the light looks realistic, rather than artificially colored. It's not a bad idea for you to "white balance" your camera, either; zoom the camcorder onto a piece of white paper onto which the light is being reflected (an indoor light, the light of the evening sun, and so on) and then manually set the WB control until it is confirmed in the viewfinder or LCD that the correct setting has been achieved. Obviously, it's preferable that you should be operating with WB set to manual for the duration of the scene, otherwise there isn't much point to the exercise. The camcorder would override this setting in a matter of seconds under automatic control.

▷ Camcorders often offer a choice of preset Program AE (auto exposure) settings, ranging from Auto to Indoor, Outdoor, and some more specialized settings designed to help you to cope with snow or beach scenes. Most of the time, you'll leave it on Auto, although as you get to know your camcorder better, you might find these presets useful. In these two images, you see the direct effect on the sky outside the room of the Indoor (right) and Outdoor (far right) selections.

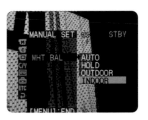 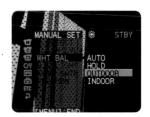

◁ Here you can see where the correct exposure of a simple outdoor scene can be affected by the choice of White Balance (WB) settings in the camcorder. The image on the opposite page shows the result of a correctly balanced image. In order to achieve it, the Outdoor setting has been chosen, resulting in a correctly exposed image. The color temperature of the available daylight will be in the region of 4,500 Kelvin (the scene is very wintry, after all), but having chosen the correct setting in the camcorder's WB menu, the image will at least be faithful to the actual scene.

▷ In the second image, you can clearly see that something isn't quite right. In fact, the WB setting in the camcorder has been manually set to Indoor light, with the result that it expects incoming light to be consistent with tungsten, or artificial, light. It isn't, but because the camcorder is doing what it's told, it produces a picture that is biased in favor of blue. There are situations where you'll be faced with light sources that are both artificial and natural in the same setting (such as where you're shooting in your home in which the interior lights are switched on but where sunlight also streams in through a window). In this case, you'll need to make a decision in favor of either one or the other. The majority of today's digital camcorders can cope with this reasonably well, so sometimes it's worth leaving the job to the camcorder switched to Auto White Balance mode.

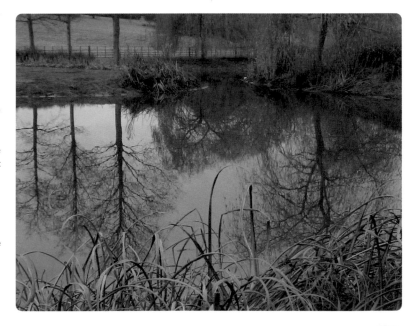

Timecode

We're so used to the tape timers on camcorders and VHS recorders resetting themselves after a tape is removed that it's easy to overlook the usefulness of timecode in a digital camcorder. However, timecode plays an immensely important role in your day-to-day videomaking acitivities—it's just that you're probably not aware of it. Unlike the volatile VCR tape-timing system, which resets itself when you remove the tape from the player and therefore has minimal practical value, the timecode generator built into your camcorder has the potential to make life very easy for you. It's useful when you need to find that elusive previously recorded sequence, and even more so when you get to the serious business of editing.

The timecode that you see displayed at the upper right hand cover of your camcorder's LCD screen or viewfinder is a numerical reference to hours, minutes, seconds, and frames as they have been recorded onto a DV, Digital-8, or MICROMV tape. From the instant you record onto a tape, the recording system starts to embed a digital signal into the data stream being recorded, and this timecode signal makes it possible for you to pick out an exact frame or sequence each time you put the tape back into the camcorder or tape player. Ideally, a timecode sequence should be continuous from the beginning of the recording to the end. Unfortunately, the design of today's camcorders makes it all too easy to corrupt that sequence unknowingly and allow the recording of two or more sequences with identical timecodes.

Duplicate timecode

So, why is that important? Well, if you only ever intend to hook up your camcorder to a TV set or video recorder for unedited playback, it isn't such a big issue. However, there are still circumstances where you could be confused. Imagine Granny asks to see the bit where Uncle Fred accidentally falls into the swimming pool while fully clothed. It's at around the 16 minutes' mark—but with two sequences on the tape, which one? At some stage, the tape timecode generator reset to zero and started to record a new sequence, so what you now have to do is rewind the tape fully and check it out manually.

▷ The LCD screen might contain a mass of information, but the timecode can be usually be found in the top right, with the digits referring to the hours, minutes, seconds, and frames.

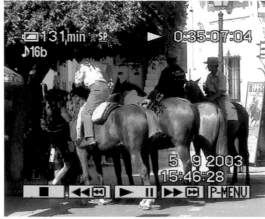

Tip

When you buy a new digital tape, put it into your camcorder and, with the lens cap firmly in place and preferably with a dummy jack inserted into the microphone socket to cancel it, record a black signal for the duration of the tape. When you next record onto the tape, the images and sounds will be recorded over the black, but the timecode will remain constant even if there are gaps in recording. We call this process "pre-stripping" or "pre-coding" the tape, and it's a bit like formatting a computer disk prior to use.

The way to avoid timecode problems is to ensure that the camcorder always starts recording onto a part of the tape that already has timecode recorded onto it. In doing so, the camcorder will pick up the previous timecode and continue the numbering sequence from that point onward. If, however, there's a slight gap between the last bit of footage and the sequence you're now recording, the timecode will automatically return to zero. Once it's recorded, you can't change it.

Another way around the broken timecode issue is to ensure that you overrun the recording after each sequence. Before switching the camcorder off (and, possibly, removing the tape), put the lens cap on and record an additional 5–10 seconds of essentially black footage. The next time you want to record, play back the end of the recording and park the camcorder in this area of black. When you start recording, the system will automatically pick up the previously recorded timecode, and carry it on.

Although all tapes will have a timecode that starts at 0.00.00.00, it's very handy to know that you can find the Uncle Fred shot at 0.16.30.14. Timecode becomes more important, however, if you plan to edit your footage on a computer at a later stage.

Counting time

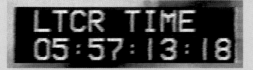

Timecode is a measurement of hours, minutes, seconds, and frames. If you live in a part of the world where your television system is NTSC (USA, Canada, Japan, and several other locations around the world), then your video signal will consist of 30 frames per second. (Actually 29.97 frames per second. *See Glossary under NTSC for explanation*.) PAL users (in most of Europe, Australia, New Zealand, many parts of Africa, and South America, for instance), see a TV picture made up of 25 frames per second. In Britain, the timecode sequence will run 0.00.00.24 and then to 0.00.01.00 as the frame counter counts another second. In both NTSC and PAL, each frame is actually made up of two half-scans called "fields," with there being two in each frame, 60 (NTSC) or 50 (PAL) fields per second.

Some camcorders do not display a complete timecode sequence. If you look in your camcorder's viewfinder or LCD screen and see a timecode displayed in only hours, minutes, and seconds, don't worry. They might not be visible, but frames are being counted as well.

Editing with timecode

If, at a later stage, you decide that you wish to use a computer to edit and polish up your home-video production, you'll be grateful you got your tapes and timecodes organized. This is an example of an editing list in Adobe Premiere Pro. It's a more professional-level editing program than the ones we'll use in this book, but it shows the timecode references of an edited sequence. That doesn't mean that only professionals need timecode. It's important that there are no duplicate codes in any edit list, for reasons you'll learn in Chapter 5— *Digital Video Editing*.

Media Start	Media End	Media Duration	Video In Point	Video Out Point	Video Duration
			00.00.00.00	00.00.05.24	00.00.06.00
			00.00.00.00	00.01.14.12	00.01.14.13
00.07.20.05	00.07.24.21	00.00.04.17	00.07.20.05	00.07.24.21	00.00.04.17
00.06.51.23	00.07.35.08	00.00.43.11	00.06.51.23	00.07.35.08	00.00.43.11
00.00.04.13	00.00.08.04	00.00.04.17	00.00.04.13	00.00.08.04	00.00.04.17
00.07.35.09	00.07.54.24	00.00.19.16	00.07.35.09	00.07.54.24	00.00.19.16
00.00.09.05	00.00.29.19	00.00.20.15	00.00.09.05	00.00.29.19	00.00.20.15
00.07.55.00	00.08.35.04	00.00.40.05	00.07.55.00	00.08.35.04	00.00.40.05
00.00.29.20	00.00.37.19	00.00.08.00	00.00.29.20	00.00.37.19	00.00.08.00
00.08.35.05	00.08.44.03	00.00.08.24	00.08.35.05	00.08.44.03	00.00.08.24
00.00.37.20	00.00.57.05	00.00.19.11	00.00.37.20	00.00.57.05	00.00.19.11
00.08.44.04	00.09.15.07	00.00.31.04	00.08.44.04	00.09.15.07	00.00.31.04
00.00.57.06	00.01.03.04	00.00.05.24	00.00.57.06	00.01.03.04	00.00.05.24
00.09.15.08	00.09.51.24	00.00.36.17	00.09.15.08	00.09.51.24	00.00.36.17

Built-in camcorder effects

All mainstream digital video camcorders come with a number of extras that seem all too appealing when they're demonstrated to you in the camera shop. The manufacturers know that digital effects never cease to amaze newcomers to video, so they go to a lot of effort to incorporate an ever-increasing range of them into their camcorders. Whether or not they have any real practical use is for you to decide, but there's no doubt that there's a lot of fun to be had in the short-term.

But let's not confuse fun with making good family movies. Although digital video effects (DVE) are easy to activate and provide amusement for those watching, their impact is very short-lived. The effects that prove to be most popular with camcorder users are often those that remind users of the many pop videos and TV intro sequences that have exploited such effects over the years. The big problem with DVEs is that although they make it fun to apply posterization, pixelation, or a scratchy old movie effect to a boring school concert recording, once it's recorded, you're stuck with it. There's no undo button and, after approximately two minutes, it all gets a bit monotonous.

The more astute camcorder user will avoid applying these effects at the recording stage, opting instead to experiment with them at the playback stage as they copy the recording to VHS or view them with the family. And if you have a computer that is set up for video editing, you'll be able to apply all these effects and more in the majority of popular video-editing applications.

Accessing the effects

The selection of onboard digital effects will vary from one camcorder to the next, but they're usually accessed through a thumbwheel or touchscreen menu system. It's very easy to activate the menu and then flip through the list of effects.

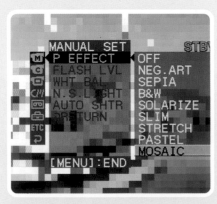

△ Many of the digital effects on offer are fairly standard. They're usually activated by navigating a set of menus, with the results instantly visible in the screen. Featured above is a standard Sony touch-screen LCD menu showing the Picture Effect options.

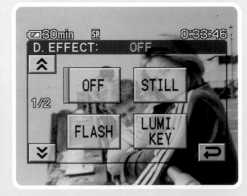

△ Camcorders with touch-screen controls will enable you to select not only the effect but also vary its properties, including the brightness, intensity, or speed.

△ **Black and white**

Some people still lament the day when TV went to color, so here's your chance to turn the clock back by shooting your own black-and-white video movie.

△ **Mosaic**

The mosaic effect is one that was used on TV pop music shows in the 70s and 80s, and works best on sequences containing a lot of movement. Use it sparingly!

△ **Negative**

Great for weird and wonderful sequences, such as the latest family sci-fi movie. The negative effect does what it says—it turns all colors and shades into their negative.

△ **Pastel**

The pastel effect filter gives your footage a weird, artistic quality. It's difficult to know when and where to use this—possibly in your retro 80s music video.

△ **Posterization**

This effect, used in film and TV for many years, looks best on sequences containing a lot of movement—such as people dancing, a busy street scene, or people engaged in some form of sporting activity.

△ **Shake**

The camcorder creates a motion blur and applies it to movement in camera with the effect that moving objects are followed by a ghostly trail.

△ **Sepia**

A nice "old photo" effect, which looks great if you want to create an old-style movie sequence. Some manufacturers offer an "old movie" effect. This adds a sepia tone plus some fake film scratches and jumpy framing, for that 1920s silent classic feel.

△ **Slim**

This has the opposite effect of Stretch in that it compresses the image horizontally, making objects look tall and thin.

△ **Stretch**

This effect does exactly what it says—it stretches the objects in the screen—making thin people look fat just like the hall of mirrors in an amusement arcade.

△ The TV picture we're all used to seeing is the standard rectangular 4:3 aspect ratio. Despite a multiplicity of formats in evidence in film over the same period, we've become accustomed to seeing TV pictures in this screen format since the late 1940s.

Many home video-makers now have DVD players and widescreen TVs in their homes, so it's natural that they might want to shoot their digital movies in that format, too. In response to the booming market for widescreen TV displays, camcorder manufacturers have been incorporating the option to record in either the traditional 4:3 aspect ratio or in what is known as 16:9 widescreen. But what does it all mean in practice?

Historically, television production on both sides of the Atlantic has taken place in a screen ratio of 4:3—measuring 4 horizontal units by 3 vertical units, this is the standard TV "box" that sits in most living rooms. This shape was arrived at, in part, due to the technical limitations of cathode-ray tube production and the resulting distortion that wider scanning would induce. It was also felt that it was a screen ratio that viewers would feel more comfortable with when watching early TV broadcasts in their homes. Ironically, while the first films used the same ratio (called the

Academy ratio), film had been using a different format for a couple of decades before TV came along. Here, the screen ratio was a wider 1.85:1. As film production saw movies being shot in ever-wider ratios, TV stuck fast to the standard aspect ratio—and this caused all sorts of problems with the way widescreen movies were displayed on an ordinary TV screen. How was a 16:9 ratio film to be displayed—were the broadcasters to pick out areas of the film using a transfer process called "pan-and-scan," or were they to show the movies in full width? On the one hand, you lost part of the image from view, while on the other, the film was shown with large unused black bands at the top and bottom of the TV picture. As neither is really satifactory, widescreen TV became commonplace—and that's the reason you can now shoot widescreen digital video, too.

△ The first, and most common, technique is to put a lens on the camera or camcorder that produces a 16:9 widescreen format image but which actually squeezes it horizontally into the limited 4:3 space allowed by the CCD. This is called "anamorphic" widescreen, and relies upon the use of a widescreen TV at the display end to unsqueeze the image in playback. If it's displayed on a standard 4:3 TV set, the image will appear in its compressed format and produce tall, thin characters! Anamorphic isn't new—it's been used in the movie industry for decades. Some makes of camcorder do include imaging circuits that facilitate anamorphic mode recording, though you'll normally have to pay extra for this.

Counting the pixels

In North America, an NTSC digital TV picture is made up of 720 pixels horizontally and 480 pixels vertically, while in Europe and other parts of the world where the PAL TV system is used, the image is constructed using 720 x 576 pixels. In each case, this is the maximum number of pixels that your DV or Digital-8 tape can record—so we have to use a few tricks to get a widescreen picture onto tape in order to make best use of the digital space available.

Alternatives

If you want to play safe and not commit your footage to either of the above, you could simply shoot your home movies in the normal 4:3 mode but be mindful of how you're actually filling the frame. If you shoot it safe by thinking wide and concentrating your subjects

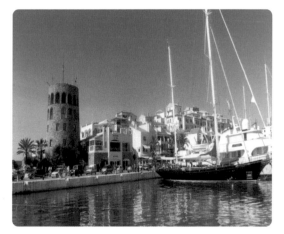

◁ The effect of watching an anamorphically produced image on a standard 4:3 TV set. Because the recorded image has been horizontally squeezed into the CCD's image space, it needs to be "unsqueezed" back at the display end.

Thinking in widescreen

Regardless of the technical considerations, shooting in widescreen does allow you the luxury of experimentation. You'll soon discover that landscapes look much more impressive, and you can create some stunning compositions by placing your subjects further to the right or left of the frame in order to emphasize the depth of field within the frame. One important thing to consider, however, is camcorder stability: while the wide image looks wonderful in many situations, it's also quick to display any shortcomings in your camerawork. Use a tripod or other means of stabilization for the best effect. Given the fundamental difference between a standard 4:3 aspect ratio image and 16:9 widescreen, you need to give much more thought to what you're shooting and why. It's advisable to learn the basic rules of composition before embarking on your first widescreen movie, too.

within an imaginary center portion of the screen, you'll be able to switch the display on a widescreen TV to show it as widescreen or watch it as the 4:3 footage that it is. Alternatively, if you're using a computer video-editing program, it's possible to create a cheat widescreen effect by placing a letterbox over the footage before or after you cut your masterpiece together. That way you'll safeguard your options, preserve the image quality, and you won't lose any precious resolution, either.

△ Another common technique that was first seen on digital camcorders in the late 1990s is the letterbox, or vertical cropping, method. The camera considers only the center portion of the image on the CCD and, in doing so, chops off the top and bottom of a 4:3 image to resemble widescreen. It will display quite happily on a standard 4:3 TV screen (it's basically 4:3, after all) but will look good on a widescreen TV when the display itself is appropriately switched. The drawback is that this cropping means you'll be using only 75% of the scan lines for the image.

Step-by-step shooting techniques

The need to think before you press the Record button can't be overstated. A lot of what you see on most people's home videos is messy, unstructured and uninteresting largely because the person using the camcorder has given little thought to the needs of those who'll end up watching the resulting footage. After all, if you're not recording a scene on video to show other people, there are probably very few reasons to be recording at all. Surprisingly, there's a very fine line between video that's just a complete mess and video that people actually enjoy watching time and again. In most cases, the good video results from taking a little bit of time to work out what you're aiming to convey and how you might achieve it. In this chapter, we're going to look at some of the basic techniques that will help you to turn otherwise ordinary video into great video that your family members, friends, and colleagues will want to see again and again.

Even the simplest home movie can benefit from good planning. Don't be put off, however. It doesn't involve you having to sit through lengthy meetings that produce lots of paperwork, all it means is that you should give a bit of thought to what it is that you intend to achieve when you start shooting—and the effect you wish to have on your viewers. Okay, it's highly probable that your viewers are members of your family, aunts and uncles, co-workers from the office, or neighbors, but that doesn't mean they want to be bored.

Think of preparation this way—how would you feel if you were on a cruise ship for three weeks and had just discovered that you left the battery charger at home?

Hopefully, disasters won't happen that often, and a bit of forethought is all that's needed to avoid them. Of course, there's more to good planning than simply thinking about equipment—even though that's important enough. If you're planning to shoot a sports event, for instance, you might need to research the best shooting position in order to get impressive shots. It might also be worth checking out whether the location has an available AC supply into which you can tap (organizers permitting). The same principle applies to recording music concerts, school plays, public ceremonies, and religious services.

◁ It's quite surprising how many people will take their camcorder with them with the intention of recording quite a lot of material without even checking to see whether they have all the necessary accessories or, indeed, whether the camcorder's batteries have been charged up. Once the newly purchased camcorder has been removed from its packaging, it's common for the camcorder and all of the associated bits and pieces to be left lying around. There are lots of bags and kit boxes available at a very reasonable cost that will help you to keep your gear organized. A simple soft camera bag will protect your camcorder and provide storage for the battery charger, AC cable, a spare battery, and a couple of videocassettes at the very least. For added protection, consider acquiring a rigid carrying case into which the camcorder and all accessories can be neatly placed. This type of storage is good because it gives you an instant view of what's in the case and what isn't.

◁ You may be surprised to learn that many camcorder users don't bother to write even the most basic information on their recorded tapes. This results not only in their having to rummage through piles of tapes every time they wish to view their recent vacation video, but it can also result in the accidental erasure of the whole tape when hurriedly preparing to record. At the very least, mark the labels on the tape with a brief description to prevent problems later on, and don't forget to mark the cassette box card inserts, too. If you're really organized, you'll devise a numerical index system!

Tip

If you're traveling overseas, check the AC mains voltage standards in those countries you're planning to visit. Even if they are compatible, you might welcome the inclusion of a socket-adapter in your kit. If you're traveling to a country on the other side of the Atlantic, for example, are you aware that the AC supply in Europe is 220-240volts AC or that the North American NTSC TV standard is completely different to the PAL system used in most of Europe? If you hope to recharge batteries or view your footage on TV while on a foreign visit, you might consider such issues important.

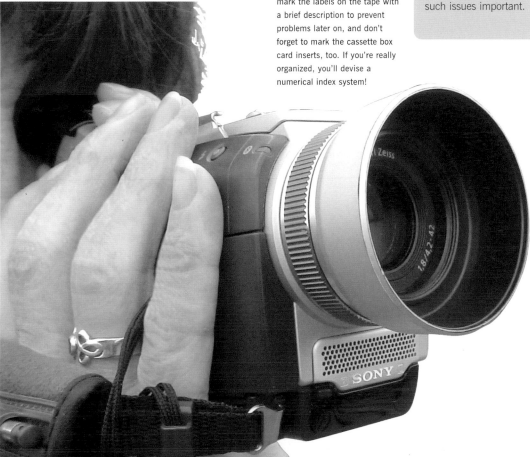

◁ Once you're at your shooting location, the next part of the process involves thinking about what to shoot and how to go about it. It's very easy to switch the camcorder on and start recording from wherever you find yourself standing or sitting, but what will the viewers actually see when it's played back to them— and what will they think of the results? Put a little effort into considering your position—stand farther back, position yourself higher, or get down among the children and get a really good child's eye view of what's going on.

shooting techniques
Shooting to edit

▽ Here's a pony-and-trap taxi rank. It's early afternoon, the air is humid and the waiting pony looks anything but happy. The shot is framed with the mountain scenery beyond the arches to give a sense of perspective.

We think of editing as being the process of cutting out the unwanted bits—and to a certain extent that's true, but in reality it's much more than that. Think of a video production, however basic, as being composed of individual shots and scenes in which you're telling a particular story. It doesn't have to be a complex TV documentary or low-budget feature movie that you're making, it could be a simple recording of something that matters to you. Every time you frame a shot and hit the Record button, you're adding another building block to your construction. Every piece will contribute to the video movie that you hope will impress others, giving them an informative and entertaining impression of the subject in focus.

Even if you don't plan to use a tape-to-tape or computer-based editing system to compile your final video movie, it's worth shooting with editing in mind.

Why? Well, for a start it forces you to think about what you're doing and—more importantly—how the viewer will perceive what you've recorded. In shooting to edit, you're not only composing your shots properly but you're also making sure that each shot starts and stops properly. Moreover, if you think, frame, and record in the manner described on the previous pages, you'll find that you start to build sequences without realizing you're doing so.

If you have the facility to edit your camcorder footage later, then you can afford to be a bit more liberal in your use of videotape. However, whether you're editing as you go in the camera or with a computer later it makes good sense to think about how you can make your shots flow from one to another. If, for instance, you're shooting a scene on a vacation, look for varied shots that complement each other rather than shooting footage that all looks the same. A wide shot of a beach scene which is then followed by a close-up of a bather paddling at the waterline will produce what the moviemakers call a nice juxtaposition. Cutting from a wide shot to a close-up not only produces a pleasing change for the viewer, but it enables you to build up your scene bit by bit, and at a pace that you can determine yourself,

△ We've taken the camcorder closer to the pony in order to empathize with its mood. Its eyes blink occasionally as it regards us with indifference. The shot is held for approximately three seconds.

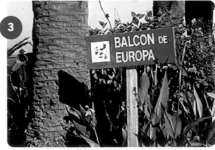

△ In order to give clues as to where we are, we grab a shot of a signpost, from which we can either pan right or cut to the following shot. The shot is framed before rolling the tape. We then record for approximately five seconds—just enough to give us flexibility in editing, if that's our aim.

Tip

Practice a zoom or panning shot before pressing the Record button. Work out where the movement will start and end. This gives the shot a self-contained feel and makes editing a lot easier.

PRO-TIP *If you're filming somebody walking along, let the camera come to a gradual halt, and let your subject walk out of the shot. Or you can start with an empty frame, and follow the subject when they move into frame.*

rather than your having to rely upon a general panning-around shot that has no impact.

If you're planning to edit digitally at a later stage, it could be that you will want to construct a sequence of images to accompany your favorite piece of music, in which case it really does become necessary for you to plan ahead and shoot a set of shots that will look good in the music montage when completed.

Don't video a scene, shoot a sequence

We're at a coastal beauty spot. There are lots of interesting focal points for a camcorder user, but for many the temptation to hose-pipe the scene and produce nothing with any visual impact will be too great. Always take a moment to think how you can break a scene down into a set of individual shots that, when combined into a sequence, actually direct the viewer from one point of focus to another in ways that suit you. Before you do this, you need to survey the location and work out what's

happening and when. It doesn't really matter in what order you shoot (although if you're not planning to edit later it's a good idea to shoot in a sequence that makes sense). If you are to edit later, simply look for good shots and take plenty of them.

▽ A high-angle shot looking down at the shore; we follow a few bathers having a good time in the sea. Again, don't try to zoom in to individuals as you'll probably not be able to keep them framed due to your distance away from them and the dependence on the zoom lens.

▽ We've pulled back from the previous close-up shot and continued with the high-angle viewpoint. Not only does this shot give additional contextual material, but the unusual viewpoint adds to the viewers' appreciation of where we are when shooting.

◁ From the best viewing point we can now see the coastal landscape around us, including the sea, the cliffs, and the mountains beyond. Avoid the temptation to pan or zoom the camera around the scene. Set this shot up (by placing the camcorder on a wall, if necessary) and let the shot tell its own story.

△ Shooting on the end of the camcorder's zoom, we need to hold it very carefully in order to avoid undue camera shake for this close-up shot of the waves hitting the rocks below us. While a tripod is preferable, it isn't always practical to carry one around when visiting such locations, so it's worth developing your own handheld shooting techniques and practicing often.

◁ Here's a wide shot of a tree-lined terrace that leads to an observation point, which is usually very popular with tourists. Luckily, because of the time of day, it's not very busy. At the end of the shot, don't stop recording immediately, especially if people are walking in through the shot. Always allow time for interesting pieces of action to occur.

Establishing shots

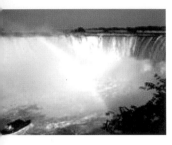

△ It could be said that the most striking impact of Niagara Falls is not the visual but the thunderous roar of the waterfall. Either way, it only takes a second for your viewer to identify your location once this establishing shot appears in your video.

If you're making a video record of a touring vacation or a sea cruise, give some thought to ways in which you can convey a sense of time and place through the sequence of shots you record. Remember that a picture can replace a thousand words, so if you're in San Francisco, London, or Sydney, why not take a shot that establishes your location at the beginning of that sequence. A nice wide shot of the Golden Gate Bridge, the Houses of Parliament, or Sydney Harbour Bridge is enough to convey this meaning in an instant. It says, "This is where we are." Alternatively, you might be recording a family gathering at home—the wide shot that you have managed to take of all the family and guests chatting will serve to establish the scene prior to the more specific shots that are to follow. Having established your location, you can then continue to tell the story of your visit by shooting other interesting material in and around the place.

There aren't many people who wouldn't be able to identify the locations depicted in these images, and you can therefore imagine how appropriate it would be for your sequence of shots taken in New York to begin with an establishing shot of the Statue of Liberty or London shots to begin with a shot of Tower Bridge.

◁ The Statue of Liberty is a sufficiently well-known and iconic feature of the New York skyline that it doesn't even require a caption. You'll probably be shooting this from a boat, so make sure that the camcorder is adequately supported for a stable, wide shot. This is where a mini-tripod comes in very handy!

▷ As with the Statue of Liberty, the Opera House and Tower Bridge communicate to your audiences in an instant that we're in Sydney or London respectively. Set up and hold a shot for a few seconds and that's all your viewers need to be able to relate to the location.

PRO-TIP When TV shows and movies use establishers, you usually hear the first line of dialog while still looking at the outside of the building. This helps to draw the viewer into the scene. When you come to edit, you can also use the indoor sounds during the last moments of your establishment shot.

◁ There are innumerable examples of how even a short, static shot of a famous landmark can help to establish the location of the ensuing sequence. If you're really clever, you won't need to include an explanatory caption, and you can have fun with your viewers. For instance, can you tell where this shot was taken?

Setting the scene

The establishing shot isn't reserved for depicting exotic locations, of course. You can use it every single time you make a recording. Let's say the family is visiting a small coastal hamlet in the middle of winter. The few people that are in the scene are spending a relaxing time beachcoming and taking it easy. At first, you might think there isn't much to shoot, but think again. The first image sets up the scene—an empty beach surrounded by old buildings. Waves gently break on the shore. This shot doesn't necessarily tell us where we are, but it gives us sufficient information to know that we're at a small, coastal location at an off-peak time of the year. By shooting carefully, you can use the establishing shot to build up a sequence of other shots to tell a little story about the place and the time.

△ An establishing shot is simply one that provides a quick overview of the setting in which we find ourselves. This shot does exactly that—and begs for the camera to go in for more descriptive closer shots. Having set this shot up, hold it for 10 seconds, and then move in to get shots of the activities.

▷ Having walked up the hillside with your companions, make the extra effort to run ahead of them in order to get a shot of them walking up the steep hillside toward the camcorder. The shot is ideal because the visually striking panorama sets the scene for a selection of supplementary shots that can include close-ups of your companions looking exhausted!

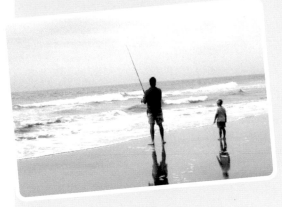

◁ Here's a more modest establishing shot, and one that doesn't contain a breathtaking vista or recognizable landscape feature. However, the way it's used at the beginning of a sequence determines how effective it is as an establishing shot. Cut in to close-ups of the boy watching his dad reeling in a line, followed by other interesting shots that will tell a self-contained story.

The establishing shot is a visual device whose application can make a huge difference to the quality of your work. You might think that it's all a bit over the top—given that your main audience is family and friends—but you'd be wrong. The establisher is a vital tool to the creation of a sequence that is self-contained and that tells its own little story from within. Its primary use (possibly when used under a caption that labels the location, date, and time) is to convey everything necessary about what's to come. Follow it with a selection of shots that tell the story from different angles and perspectives and you'll quickly find that your viewers will soon be congratulating you on the professional look and feel that your sequences possess. The establisher has done its job, so don't be afraid to get right into the action for those impressive close-ups, either.

shooting techniques
Backgrounds and surroundings

It's one thing to simply point the camcorder at your subjects and record them doing whatever they're doing, but it's another thing to take into consideration the environment in which they're positioned in order to create a shot with pleasing composition. Even when a shot is reasonably well composed, it's common to see video footage where no attention has been paid to the background. We've all seen TV interviews in public places in which the person answering the questions is unaware of silly goings-on behind them, and they're the most obvious examples of situations where the cameraperson should have taken more care in choosing the setting. Sometimes, the outcome is so funny that the clip makes it onto the "hilarious home movies" TV shows, but what it tells us is that it's just as important to think about what's beyond the subject as the subject itself.

Of course, giving thought to the background isn't new to video—it's just as important when you're taking still photographs as well. Yet how many times have you seen a lovingly taken picture of somebody's favorite aunt only for your eyes to be drawn to the over-flowing garbage can that's just visible over her right shoulder?

Perhaps it's not surprising that these familiar everyday objects go unnoticed, given that we tend to take their presence for granted in normal daily routines. So, if you're really eager to enhance the quality of your imagery then take a more critical look at the visual environment that you'd prefer to see for your subject. Switch the camcorder on, look through the viewfinder (or into the LCD screen), and consider everything that's in the frame. Position the camera so that the relationship between the subject and the background looks good—and if it doesn't, make the appropriate adjustments before recording. This simple pause can prevent many embarassing mistakes—making sure that your friend, who's grabbing a drink at a roadside bar, doesn't have a drainpipe going through his head, or that your mother-in-law doesn't have a tree growing out of the top of hers!

▷ Here's a shot of a young girl being pushed on a swing by her mother, in front of the camcorder. Notice the angle at which it has been shot—very low down. Not only does it provide an interesting—and unusual viewpoint, but it masks the unattractive garbage cans that lay just beyond them!

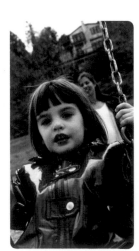

▽ The beach is the perfect setting in which to capture images of the kids at play. Unfortunately, many camcorder users don't get the right shots—preferring instead to stand up and shoot only from adult height. In this shot, by kneeling we've come down to the children's level and have moved in close in order to throw the background out of focus. It makes for a much more pleasing composition.

◁ This is a stunning shot featuring an experienced hiker treading a mountain trail that takes us through a vista overlooking a mountain range. The mountains that rise in the distance combined with the various visual points of interest are sufficient to grab the attention of those viewing. However, in situations like this, it's really important to give the shot time to do its job. As always, avoid the temptation to zoom or pan unnecessarily. Hold a well-composed shot and let the scene tell its own story. The viewer's attention will first be drawn to the hiker, after which it will take in the splendor of the scenery.

Tip

Images like these demand a good, stable platform for your camcorder. A monopod, positioned in the floor-well of your vehicle, will help to keep the camcorder stable in order for you to zoom in to the subject. Camera shake will ruin these shots.

◁▷ These shots of central African giraffes are striking for the lack of background detail that only adds to the sense of remoteness and isolation. The lone female (left) has been shot on the end of a zoom lens in order to reduce the depth of focus. This has the effect of making the distant mountains insignificant. The blue sky and grass has the effect of isolating the giraffe in the landscape. In the second shot, the mother attends to her young offspring. Again, the complete lack of background detail only adds to the effect of the shot. Notice how the sun's light (coming from the right) adds a three-dimensionality to the image, too.

Tip

If you do wish to use a zoom, set the camcorder on a tripod or other steady surface. Practice the zoom, and record only when you're sure it works. Apply gentle pressure to the zoom rocker as it picks up speed, then gently ease off as it nears the end of the zoom.

All camcorders come with zoom lenses. This could be considered to be a good thing or a bad thing, depending on your viewpoint. It's probably fair to say that the many really bad home videos that exist out there are what they are because the person using the camcorder decided that, having paid for a camcorder with a zoom facility, it should be used at every opportunity. This is a shame, because it's more likely that the same video footage would have been greatly improved if the zoom wasn't used at all.

Look at almost every mainstream TV program or—particularly—feature film, and you'll see very few uses of the zoom lens. Where you are more likely to see zooms is in live music shows and sports coverage; it's quite common to see a very wide shot of the whole stage which is then followed by a zoom all the way in to the lead singer's face. Similarly, the close-up of the person with the ball in a game of soccer might suddenly become a wide shot as the ball is kicked forward—thanks to the zoom lens. Look at virtually any mainstream feature film, however, and it's very unlikely that you'll see a zoom in a sequence.

One or two carefully planned zooms in an average-length home video is just about acceptable, but more often a home video will be full of them, and the viewing enjoyment will suffer. So if misuse of the zoom is possibly the most common cause for unappealing home videos, the best solution is to use them only if you're sure it will achieve something spectacular in your movie.

Where a zoom works well

Below is a shot of a derelict castle in Corfe, in the southwest of England. How would you treat this subject? Would you settle for a static shot as seen here? Would you start with a wide shot and zoom in—and if so, into what part of the image? If you chose instead to start the shot with a close-up of an object within the shot, which would it be?

Depending upon your choice, the emphasis and impact of the shot would be markedly different. If you are going to zoom in this kind of situation, it's essential that the camcorder is tripod-mounted and that the shot is rehearsed before recording.

▷ In this shot of a ruined castle in the UK, our eyes are instantly drawn to the castle in the upper part of the picture, so how would a camera operator treat it? Would he or she zoom in, and then zoom out—or leave the shot locked off and allow the viewer to make the choice?

Optical and digital zooms

As already discussed on page 19, it's the physical shift in the relationship between the precision optical elements in a lens that enables us to achieve a zoom. However, some camcorders feature zoom ratios of as much as 700:1—with 120:1 and 200:1 now being quite common. However, in the case of these, the magnification is achieved not by the glass elements moving backward and forward, but by an electronic process that involves digitally enhancing the pixels (picture cells) that make up the digital image.

▷ In these images, we start with a frame from a video shot with the zoom lens set to its widest setting. Naturally, there's little to be seen in the sky even though we know there's a plane in the sky. The temptation to zoom in is too great, and the second frame is taken at a digital zoom ratio of 40:1. In a quest for an even closer shot, we zoom in using the full range of digital zoom at 120:1. You can see that there's little point—the aircraft is but a blurry mess in the sky, and the shot is very unstable, too. What use does it have in a video? Think carefully before zooming—especially when you're not sure how it will benefit the resulting video sequence.

Good reasons for not zooming

- Most zooms are undertaken without the camcorder being supported properly, so they can often look wobbly and unprofessional.
- A lengthy zoom in or out takes up valuable time, and once it's recorded, you're committed to it. A very slow zoom can appear painfully slow when other people are watching.
- The presence of a zoomed shot makes it impossible for you to determine the duration of the shot during editing without cutting into and out of the zoom. This is generally regarded as being messy and unprofessional.
- Good zooming takes practice, a stable camera platform, and forethought.
- A cut from a carefully composed wide shot to a close-up is often better than an unsure zoom.

△ You can see here that the image suffers the same problem of heavy pixelation due to the use of the digital zoom utility.

Zoom ratios

Look in your camcorder's user guide and you'll see a reference to the lens's focal length. If the widest measurement (that is, when the lens is zoomed-out to its widest picture setting) is 45mm and the fully zoomed-in measurement is 450mm, the zoom lens is said to have a zoom ratio of 10:1, or 10 times. The zoom ratio will vary from lens to lens and camcorder to camcorder, with some being 12:1 and even 20:1. The greater the ratio, the greater the magnification relative to the minimum focal length.

PRO-TIP *If you want to get closer to the subject during a shot, don't zoom, but move closer. On movie sets, this is achieved by attaching the camera to a dolly—a wheeled mounting that usually runs along a miniature railtrack. However, with practice, you can get the same result over short distances with a handheld camera.*

shooting techniques
Action shots

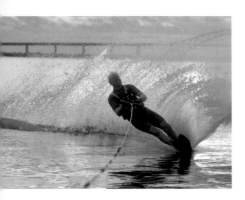

△ Getting the right shot in situations like this requires you to be in the right position at the right time. Don't try zooming—you'll create problems—and record as much footage as you can before switching off.

Tip

You might be restricted, or prevented altogether, from using cameras and camcorders at certain sporting events. Check with the organizers first if you think this might be the case, otherwise they might assume the power to confiscate your footage or charge you a special fee.

Video was made for action shots. Getting really good action on video is dependent upon being in the right place at the right time—and the more action you shoot, the quicker you'll develop a feel for it. The most obvious source of exciting and dynamic motion is sports, and it doesn't take long before camcorder users feel the urge to point their lenses at sporting action—and that's everything from the kids skateboarding or members of the family skiing. There's a lot of potential for shooting some really good material that can subsequently be cut to a suitable piece of music, but there's also the potential to get it wrong.

Shooting solo

We're all influenced by what we see on television, and it's easy to believe that we can replicate the effect of fast-moving action on viewers by taking a camcorder to a sporting event or activity and recording our own sequences. However, there's a significant difference; televised sporting events are invariably covered by production units that use several cameras. This gives the television director a comprehensive choice of shots with which to keep the audience entertained. The single camcorder user, on the other hand, must try and depict the sporting action with only one camcorder, and this can often limit the recording to lengthy wide shots or aimless zooming in and panning around in order to capture both the action and the tension of the moment. The big problem with shooting sports is that, if you're doing it on your own with a single camera, you're restricted to a single angle, and this will undoubtedly have an impact on what you can, and cannot, achieve.

Obviously, the action itself is important, but it's the way it's represented in pictures and sound that will determine its ultimate impact upon your

△ Shooting high-speed motor racing is one sport where you need to be in exactly the right place in order to get the required shots. If you're seated in a stand on a piece of straight track, all you'll see is one car after another whizzing past you at 160mph; so for the most dramatic shot, it's far better to position yourself within sight of a tight corner; that way you'll catch the cars as they come out of the bend. You might also be lucky enough to capture a really dramatic incident, too!

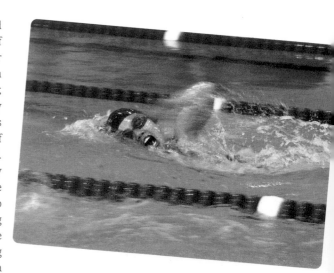

△ Here's a really striking shot that's not that difficult to obtain—from a practical viewpoint, at least. With the camcorder sitting on the side of the pool and zoomed-in to frame the water tightly, the swimmer is allowed to swim through the shot. Like many good action sequences, this lends itself to slow motion (easy in most editing software). What makes this shot striking is the light, which hits the subject from camera right, and lends the swimmer a real sense of depth.

audience. The important thing to consider with any kind of action—even if it's the annual field days at the children's school or a group of skateboarders competing in the local park—is to shoot lots of individual shots from many viewpoints. Don't try to cover action from a visually safe position in order to get it all in the frame. It won't work. You need really dynamic shots, and lots of them. Always get as physically close to the action as you can (without compromising the safety of yourself and others, of course) and try to avoid too much camera movement. Think of how you might want to edit the shots together later—perhaps even have the music track in your mind as you select and record each of the shots you'll use.

When shooting action, don't be afraid to break a few rules. Within reason, you can throw continuity and composition out of the window— and you can shoot from as many weird and wonderful camera angles as you like, too. For best effect, of course, you'll need to have the means to edit your material later. Cut to a suitably pacy music track, you'll be able to put together sequences that look every bit as good as those made by the professionals!

▷ Skateboarding is the kind of backyard activity that often attracts camcorders, usually for one of two reasons. First, it can produce great shots and, second, the boarders themselves like the idea of their prowess being recorded and shown to one and all. As with many other sports, the best angles can often be the low ones. Put the camcorder on its widest lens setting and zoom out fully. You might even wish to invest in a wide-angle lens adapter to create extra visual impact.

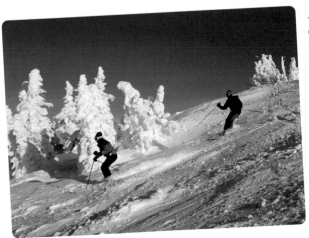

◁ Recording skiers in action can either be extremely difficult or very straightforward. This is a good example of the principle that good position is everything; if you have a vantage point that gives you a good wide shot of the slope but also enables you to get relatively close shots of the skiers as they perform their twists and turns on the snow, then use it. Unless you have a good tripod and head, you might find the use of a monopod welcome here.

Stable handheld shooting

When taking hand-held shots of fast-moving action, hold the camcorder rigidly and keep your elbows tucked into your sides. When panning, swivel your whole body at the waist. Be at one with the camcorder for stability, and use the zoom only to reframe a shot.

Get in close

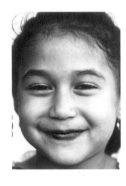

△ All mums, aunts, and grannies love big close-ups of their children, nieces, nephews, and grandchildren, so don't be afraid to get in close and get them!

If you're ever in a position to watch other people using their camcorders, you might notice that they're generally averse to getting in really close to their subject. It doesn't matter whether the camcorder is being framed at a human being or an inanimate object—the majority of users seem very reluctant to get in close for those juicy close-ups. More often than not, a camcorder user will stand at a distance of maybe 8 or 10 feet and zoom in while viewing the open LCD screen and hand-holding the camcorder. What a wasted opportunity!

Today's consumer digital camcorders have lenses of a much higher quality than ever before, but they also provide excellent value for money. Having said that, they're not perfect—and it's when you try to pick out someone's face in a widely framed shot that you realize the visual quality could sometimes be better than it is. As every good photographer will tell you, there's nothing quite like a nice, big, juicy close-up. The best close-ups are obtained by zooming the camcorder out to its widest setting and moving in as close as you can get to the subject without actually bumping into them.

Close-ups work particularly well with children and people whose faces display real character. Close-up shots also provide for really good video in the instance where you're featuring—say—a brightly colored flower in the foreground of the shot and a beautiful landscape beyond. Don't be afraid of what your camcorder can do, and don't feel self-conscious (as, surprisingly, many people do) when taking the time to set up a really great-looking shot in a public place. You might feel embarassed at the time, but you'll reap the rewards when you view your footage later!

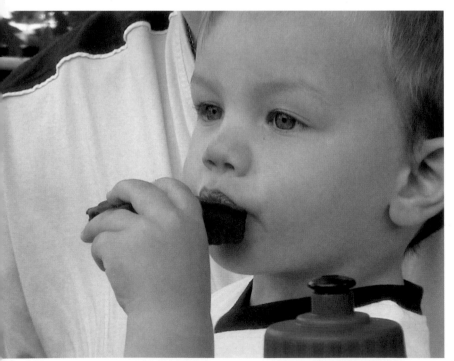

◁ Young children make great subjects for video and photography simply because they're not yet self-conscious about being in the frame. For that reason, you can get right up close as they observe what's going on around them. Here, young Ewan eats cake as he watches the world go by.

▽ You're shooting video, not still images, so don't go for the shots in which your subjects smile embarrassingly at the lens. If you want them to talk on a particular subject in a sort of video-diary style, then prime them with a question, and get them to talk to the lens as if it's a close friend.

Macro

An increasing number of modern video camcorders have a macro facility. Although it doesn't look like it, this very big close-up of a tulip was taken with the front element of the camcorder's lens almost touching the petals.

The trick with getting some really good near-macro shots is to zoom wide and get in as close as you reasonably can. To begin with, allow the camcorder's auto-exposure and auto-focus circuits to calculate their optimum values respectively, and then switch to manual operation once you're happy with the outcome. If you subsequently use manual focus, take care not to move the camcorder backward and forward because even the slightest variation in focal distance will throw the object in and out of focus as you move.

▷ Getting very big close-ups of wildlife is very, very difficult to achieve. However, if you're extremely patient and understand something about the behavior of your subjects, you'll be able to get the one shot that will impress your viewers. You'll need very good light and you'll need a tripod, too. Bear in mind, also, that the closer you are to the subject, the more problems you'll have with focus, especially if there's even the slightest breeze.

Tip

When shooting close-ups, zoom out fully and get in really close. Use your body to move the camcorder backward and forward in order to maintain framing and manual focus. The shot may need a bit of steadying, using a tripod, a table-top, or some other support.

The cutaway shot is in evidence in virtually everything you see on TV and in the movies, and neither its importance nor its usefulness should be underestimated. The cutaway is so-called because it does exactly that—it provides us with the means to cut away from a piece of action to another associated shot for a brief duration. Most commonly, the cutaway will consist of a shot of a person, or persons, looking on and possibly reacting to what they're seeing in our main shot. The sequence will therefore consist of a main shot that provides the central focus of the video sequence, from which we then cut away to someone observing the action for a few seconds. Afterward, we might cut back to the action.

The cutaway is particularly useful because it gives us license to chop out any unwanted footage in the main sequence (sometimes called the "master" shot in moviemaking terminology) as well—which is often the reason why editors will insert it. The insertion of the cutaway allows you not only to add an additional point of interest to the sequence (such as people looking on or another piece of related action) but it also enables you to cut the master shot down to an acceptable length. In addition to this, the cutaway can be used to emphasize a particular point that you wish to make. Say, for example, that in a sequence featuring a boring music recital, we cut to a couple of old ladies asleep in the audience. What does this tell us about the quality of the performance?

Everyday cutaways

Even taking into account the cinematic reasons for using cutaways, they're also good when you just want to add visual variety to your movie projects. Those who view your home videos also watch broadcast TV, and have come to expect a sense of pace in the programs they see. The cutaway is something that you should consider using whenever you're recording an event at which there are spectators, and it's useful when taking shots almost anywhere.

Shooting a sequence with cutaways

In the following sequence, we could have simply focused on the child for a few seconds and then panned around to show the ducks in the water at a distance. The resulting zooming in and out would have been messy, and the whole recording would look like any home-video recording. In our sequence, we've established that the child's attention has been grabbed by something out of the camera's field of vision. What it is we don't know, until we cut away to the object of his attention—the ducks.

This isn't something that requires a complex post-production editing system to achieve—just use the camcorder's pause button and time your shots with care.

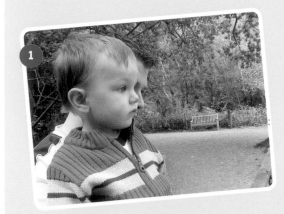

△ We start with a shot of a young child being lifted up so that he can see the lake and the ducks. The little boy asks about the ducks and whether they'll come to see him.

Tip

If you're shooting a scene for which you know you'll need a very quick cutaway, try to monitor the recording with one eye and survey cutaway possibilities with the other. When you see a contender for a shot, quickly zip to it, grab it over 3–4 seconds, and then get back to the main action.

PRO-TIP *You may find that cutaways shot on one project can be used in another. When you come to edit, if you can't find the perfect image, check your old tapes, and you may find something that fits perfectly. It doesn't matter that it was filmed at a different time and place, as long as the viewer can't tell.*

◁ The camera cuts to a shot of ducks on the water, feeding on breadcrumbs and tidbits that have been thrown by other people.

▷ We cut back to a close-up of the child as he points to the ducks and notes that they're now paddling toward him.

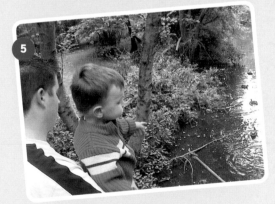

◁ The group of ducks senses that lunch is on its way and approach the pair by the side of the lake.

▷ The boy is given some bread which he proceeds to throw at the ducks. The ducks are alerted to the arrival of their lunch and start to quack enthusiastically.

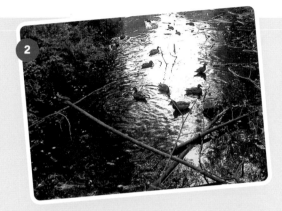

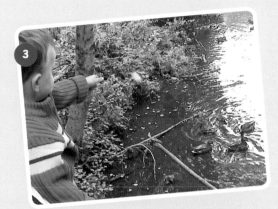

◁ The ducks are now competing with each other for the available food supply.

▷ The boy then throws some more bread, although his limited throwing ability means that some tasty morsels hit the ground rather than the water.

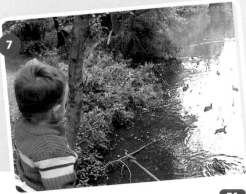

shooting techniques
Reverse shots

Often, when shooting in domestic situations where people are talking to one another, it's very easy to take some shots of a person talking or performing without thought for including a shot of a person looking or reacting to what he or she is saying or doing. This is different from a cutaway or general interest shot; the reverse shot will often provide a balancing shot or action that is very much a part of the sequence. The most obvious example of this is a conversation or interview featuring two people chatting or interacting in a drama scene. In order that a viewer can make sense of what's happening in a scene, it's important that you adhere to some of the most rudimentary rules of shot continuity.

Questions and answers

The most common application of good continuity is in the use of the so-called "reverse shot"; you see them all the time in television interviews and TV/movie dramas in which a shot of the actor or interviewer is inserted after a shot of the other actor or interviewee answering a question. You'll have seen it yourself many times, even if you're not aware of it. The reverse shot is exactly that—a shot taken from the reverse angle to the main, or master, shot. So, a person composed in medium close-up (MCU) might be balanced by the equivalent shot taken in the other

direction and featuring the person asking the questions or reacting to what is being said. In the case of the TV interview, a "silent" reverse shot will usually feature the interviewer simply listening to, or nodding in agreement with, a point that is being made by the person seated or standing across from him. It's for this reason that the shot is commonly called a "noddy" shot. In editing, only the visual is used, and is inserted over the sound of the interviewee's speech.

Reverse shots are also a feature of dramatized production; two actors in dialog will be shot so that each character's lines are recorded separately and in full. After taking one character's performance, the director and/or cameraman can then set up a reverse shot in order to record the second character's dialog.

Shooting for edit

You can do this very easily, especially if you're planning to edit the material later. Maybe you're recording a conversation with an elderly relative as a means of documenting the history of your family or of members of the community. Having allowed a subject to sit comfortably in their favorite armchair, you might then mount the camcorder on a tripod and frame a medium close-up (a head-and-shoulders shot), you can then record the subject's responses to questions posed by an interviewer either to your left

▷ These two frames show the relative framing of each of two people who are chatting. Note that the shot of the person on the left is balanced by what we call a reverse shot of the person on the right. The composition of the second image is virtually a mirror image of the first. Notice also that the subject will be placed slightly off-center in the frame in order to give some visual "space" into which the eyes will look. Hence, the person on the right is looking left (toward the person on the left) and is therefore positioned slightly right in the frame. The corresponding composition is given in the reverse shot. Look at any TV or movie and you'll see this to be the case.

or right. Afterward, you might then choose to move the camcorder to the equivalent position across from your subject and record the questions, plus noddies, being asked again. When editing, these can then be intercut to produce a video sequence that looks every bit as professional as those you see on TV.

△ The same principle applies to shots featuring two participants in the frame at the same time. In the top frame, person A and person B are conversing together. Using the principle of not crossing the line (see diagram, right), the camera can assume the same "mirroring" position in order to get what is known as a 2-shot, favoring first person A and then person B. The bottom set-up is a reverse of the first—and adheres to all accepted rules of continuity.

The Line of Continuity

Even recording a simple reverse shot requires an understanding (albeit subconscious) of the Line of Continuity rule. Place two people facing each other and in discussion. Draw an imaginary line through them, and consider recording shots in which person A is given a head-and-shoulders framing. Now cut to the other person—person B—reacting to what is being said. It's customary to provide a balanced, complementary, framing. For the viewer to believe that A and B are interacting, A should be looking from the left to the right of the screen, and B should be looking from right to left. You can make sure this happens by keeping your feet on one side of that imaginary line, no matter what direction you point the camera.

In the diagram, notice the relative positions of the camcorder in recording each of these shots, and note that the camera has remained on the same side of the line that goes through the performers. This produces correct visual continuity. If we were to cross the line for any shot, the continuity would be destroyed—and viewers might wonder what is going on. Staying on one side of "The Line" is a fundamental rule of moviemaking, and evolved in the earliest days of cinema. Try it with members of the family and see for yourself!

Tip

In order to overcome people's natural self-consciousness, try to grab reverse reaction shots of them when they're least aware of it. They'll be much more natural.

shooting techniques
Over-the-shoulder shots

When you're faced with shooting groups of people sitting or standing in close proximity, it's very tempting to stand well back and get all of them in the frame. While it's probably a good idea to grab such a shot as an establisher in the first instance, it's an even better idea to quickly get in close and get some nice over-the-shoulder (O/S) shots.

Creating intimacy

What's really appealing about shots of this kind is that they convey a sense of intimacy with the people in the shot, and draw the viewer into the scene and so help him or her avoid feeling like a bystander. The viewer gets the sense of seeing exactly what the people in the shot are seeing and experiencing.

An over-the-shoulder shot is exactly what the term suggests—putting the camera into a position where it's taking a shot over the shoulder of one person in order to gain a more acute angle onto the other subject. It might be more than one person, of course, in which case you have even more exciting visual opportunities. In all cases, don't be afraid to literally rub shoulders with those in the frame—the closer you get, the better the composition often is.

▽ This shot works well as an establisher, featuring a woman seated on a rock overlooking a canyon. We can't see what she's looking at, but what might work well is if the handheld camera walks toward her and looks over her shoulder to reveal what it is she's looking at.

▷ Here's a similar example of an over-the-shoulder shot that hints at what's beyond but that keeps the main subject (the woman with the bike) in focus. To get this initial shot, you'll need to be a distance away and zoomed in. That way, you'll have better control over the depth of focus.

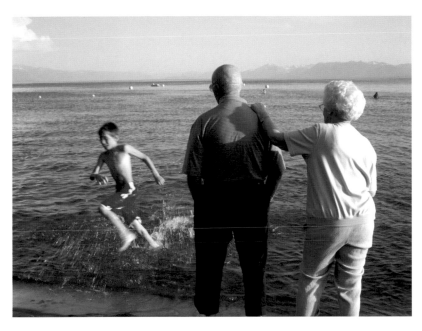

◁ Here, we're looking over the shoulders of the elderly couple as they watch their grandson splashing in the ocean. Our position enables us to see them in addition to the boy. Our next shot might be taken from their left in order to see the expressions on their faces, followed by close-ups of the boy himself. There's a lot of visual potential in this one simple scene.

Tip

When shooting over the shoulder of people, it's vital that you don't attempt to zoom around while recording. Have the courage to hold the shot static and allow the scene to develop naturally.

◁ An over-the-shoulder shot is ripe for a classic pull-focus, of course. Like the shot of the woman with the bike, you'll need to have zoomed in slightly in order to take manual control of focus. In the first shot, the man is out of focus, but as you pull focus, he becomes clearer, with the foreground having now become blurred.

shooting techniques
Point-of-view shots

The point-of-view (POV) shot is one in which the camera assumes the viewpoint of the person who is being featured in the video production. As you can imagine, it's used to let the viewer see what the person featured in the shot is looking at—and can be used in all sorts of ways. It's common for a POV shot to be used in handheld mode to mimic the movement of a person walking, but it could easily be used on the front of a moving object—such as a car or a roller-coaster. Why would you wish to use a POV shot? Well, it's a great way to add that extra bit of drama and such embellishments will always make your video production stand out from the rest.

Shooting a POV does require a couple of basic skills. You'll need to support your camcorder properly when simultaneously walking and recording, since a lot of undue camera shake is guaranteed to ruin the effect. However, the mere fact that the shot might be designed to depict the person's eyes as he or she is walking means that a degree of camera shake is necessary in order to give that natural feel to the sequence.

◁ Here's an example of the use of POV that's so easy to do there's no excuse for not trying it. The subject here is spending time combing the rocks on a secluded out-of-season coastal village. In the first shot, we see a young man making his way over the rocks at low tide in the hope of finding life in a rock-pool. What does he see?

▽ The camera assumes the young man's standing position and looks into the rock pool as if it were he. We could cut to a closer shot of his face as he detects a crab or fish moving in the water and then cut back to a close shot of the object in the water. In doing so, you've used the POV to tell a little self-contained story, too.

▽ What makes moviemaking so much fun is that you can be a master of deception. Who's to know that the people in this image aren't the ones looking into the rockpool? By putting this shot in place of the one with the young man looking into the pool, you'd convince your viewers that the pool is what they're seeing instead!

Tip

When taking a POV, it's not absolutely necessary for you to be in exactly the same position as the people doing the observing—but if you are, it helps with the illusion.

Getting a POV shot is something that you can do very easily with your camcorder, especially if you're shooting people who might be observing a landscape or other point of interest. In addition to shooting people looking at interesting things, take a bit of time to take a shot of them looking—and then take a shot of what it is they're looking at. This is possibly the simplest demonstration of the POV, and as you develop a more experienced eye, you'll find yourself grabbing POVs without thinking.

△ Here's a sequence that is established by a wide shot, taken from the ground, of a paraglider being towed by a powerboat at a seaside resort. Aside from our being able to determine that there's someone up there strapped to the sail, we can't see much more detail.

▷ Here's a much more dramatic shot that perfectly complements the ground-based establishing shot. This perfect example of a point-of-view shot puts the viewer into the position of the paraglider. You can achieve the same effect with a range of activities, provided that you can support a camcorder at the same time!

Composition

▽ Here we see an image with a criss-cross grid superimposed to divide the frame into sectors—three horizontal and three vertical. If you position a scene on either the first or second vertical, the eye has more than one point upon which to focus. This gives the frame greater visual impact. In this image, our attention is first drawn to the boy in the foreground, but because he is positioned off-center, our attention is drawn beyond them to the out-of-focus boy in the background. Notice the relationship between the subjects and the points on the grid. The rule is equally applicable to landscape shots.

I f you're serious about improving your video-making skills, you'll need to take some time to grasp the basics of composition. To begin with, you might think that the way you feature a person or an object in the frame isn't really that important, but it is. The basic rules of composition have evolved since the very early days of photography and cinema in the late 1800s. In fact, if you look at the majority of portrait paintings that precede the photographic age, you'll see that the rudimentary rules were actually laid down a hundred years or more before that. So why is composition important?

It's important to remember that your audience will only see what you let them see. If you take a close-up shot of the kids building sandcastles on a beach without including a shot that reveals that your family is all alone on the most beautiful tropical island, your audience will think it's just an ordinary beach at a regular vacation spot. They won't get the whole story. Good composition can be designed to tell a complete story in a single shot, or hide elements that you don't want your audience to see. Most home moviemakers don't achieve well-composed shots of this nature simply because they're always in a hurry to get it done. Take a few more seconds to consider what's in the frame and the shot will improve dramatically.

The Rule of Thirds

The use of the word "rule" seems a bit harsh, but it's so fundamental to good composition that's it almost written in stone, and influences the way we should try to compose images, whether we're dealing with landscapes or people. Take almost any scene, and in preparing to record it, people will attempt always to place the focal point of a scene in the center of the frame regardless of what other points of interest there are. Apply the Rule of Thirds to the composition and your scene is transformed.

▽ The best shots—especially establishing shots—benefit from drawing the viewer into the scene and directing his or her eyes to a particular point within the frame. This is known to photographers and moviemakers as the "vanishing point." It's a good idea not to make the center of the frame the vanishing point, but to shift it either to the left or right (applying the rule of thirds, too).

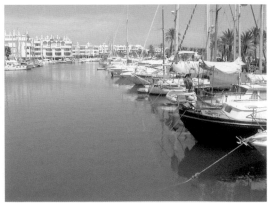

Tip

When composing shots of people, avoid cutting off at the elbow. There's no scientific reason why this should be—except that it looks better if you frame just above or below.

Framing shots of people

The terms Close-up, Long Shot, Medium Shot, and so on might be familiar to you as shot descriptions. There's a collection of such expressions that are universally understood by people working in the film and TV industries, and it's always worth getting to know them—and not just because it will make you look good when in the company of film professionals! This chart sets out the four most basic, and commonly used, shot types. The Long Shot (LS) and Medium Long Shot (MLS) often get mixed-up. People do often refer to the widest shot you see here as being LS, though it's MLS in some quarters. The Medium Shot (MS) features the top half of the subject, usually cutting off at the waist. The Medium Close Up (MCU) cuts off just above the elbow when they're at the person's side, and usually halfway between the elbow and the shoulder. The Close Up (CU) concentrates on the face, and cuts off just slightly below the shoulder.

LS MS MCU CU

△ There's a vanishing point here, although it's not so obvious thanks to the clutter of boats, boat masts, and rigging. In this case, however, the shot served as an establishing shot and after a few seconds, the camera panned off right to a scene containing people unloading provisions from a truck.

▽ Here are three variations on the simple close-up shot. Following the convention as set out in the diagram, we can see how the CU is a head-and-shoulders shot of the subject—possibly in conversation with a friend or family member.

▽ The BCU (Big Close Up) is even more intimate—so much so that you'll need to negotiate its composition before shooting!

▽ The VCU (Very Close Up) is, as the description suggests, very intimate, and serves to convey a sense of what the subject is actually thinking.

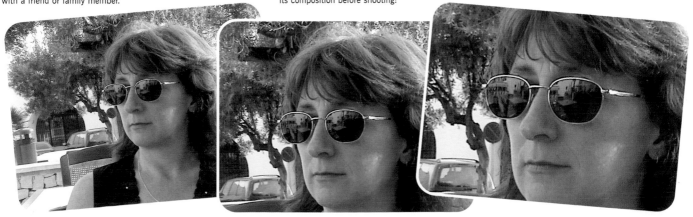

Color

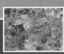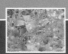

As with still photography or the painting of landscapes in oils or watercolors, the importance of color in your video recordings can't be understated. Even though the majority of today's camcorders contain only a single CCD, they're capable of rendering images of higher resolution and visual quality than we've ever seen before with non-professional equipment. Given the right light conditions, a modern consumer camcorder will produce images whose reproduction is comparable to those seen on TV. What's particularly noticeable about today's models is the way they're able to reproduce colors with such vibrancy. It wasn't that long ago that we had to avoid the very high-frequency colors like saturated reds and blues for fear of their breaking up and bleeding into other objects on the screen. Thanks to better CCDs and improved image processing, we don't have to worry about this anymore.

Take time to look for colorful objects and consider how you can use them in your shots. Even if you're shooting in a garden or natural landscape, look for brightly colored flowers or the lovely rich color that comes from a wide seascape and make the most of it. In looking at the colors available to you, also consider the other vital aspects of camcorder operation—such as exposure and focus. Using a combination of manual functions, you'll quickly learn that a striking image rarely occurs by accident; you have to create it.

Light and shade

Remember that colors are always at their most vibrant when they're brightly lit, and—wherever you are in the world—that will usually be under the midday sun on a beautiful summer's day. That's why objects can often appear to lack color when featured during the depths of winter—something that's particularly true of landscapes in the northern hemisphere. The same landscapes that appear full of rich, vibrant color in April through to September can look cold and gray in the period between late November and mid-February. That doesn't mean you shouldn't shoot then—every season has its visual strengths.

The color of light

Record a natural landscape in conditions of bright sunlight in the middle of the day and your colors will be reproduced as you'd expect them to be. However, if you record the same scene later in the day as the sun is setting, you'll notice a marked difference in the general "look and feel" of the image—particularly if you have made your recordings with the camcorder's white balance controls set to manual. As daytime turns to dusk, the colour of the sky turns from blue to a reddish, purple hue. With the changing light comes a change in color temperature. Color temperatures are measured in degrees Kelvin, with the colour of sunlight at 12:00 noon being in the region of 5,600 Kelvin. However, as the sun moves across the sky, the color temperature drops down to between 4,000 Kelvin and 3,000 Kelvin, and because the camcorder's WB (White Balance) might be given a daylight setting, the overall picture will have a distinctly red bias. If, on the other hand, you have set your camcorder's WB (which effectively means the same thing as "color temperature" in video terms) to Auto, you'll probably notice the effect less, since the electronics are compensating for the shift automatically.

△ With the camcorder's lens on full wide and the morning dew still clinging to the petals, these blue flowers are visually striking. While a shot such as this probably lends itself more to still photography, it can have its uses in a video edited to music—a sequence of flowers mixed to your favorite piece of pastoral music as they blow in the wind, perhaps? The impact of the image is due not just to the color, but also to the fact that they were shot in very big close up (BCU).

Using color with caution

It's important to note that while very rich colors containing fully saturated reds and blues will look perfectly good when played back direct to your TV from the camcorder, they'll suffer as soon as the sequences are copied to an analog tape format like VHS. The reason for this is that VHS tape doesn't have the ability to reproduce fully saturated colors properly due to the inefficiencies of analog tape recording and playback. VHS tape's half-inch width and slow running speed means that it simply doesn't possess the recording bandwidth to faithfully reproduce very rich colors—especially those higher up the color frequency spectrum like bright red. As an experiment, take some video footage of a person wearing a bright red garment; play it back to your TV direct from the camcorder, and then compare this with a copy made to VHS. See how the red behaves when played back from VHS? If you're likely to view most of your video creations on VHS, it's a point worth noting. Where possible, think about this carefully when preparing to make a recording.

Colors that flatter—and those that don't

It is often said that the television image has a tendency to increase people's apparent size by 20% when viewed on a normal TV set due to the limitations of the medium and the inherent "flatness" of the TV screen's image. For this reason, professional TV performers choose their clothing selectively in the hope of looking slimmer in front of the camera, and it's here where the general rules of fashion come into play—but not for that reason alone.

▷ Here's another shot that speaks for itself, and another example of how you can get some great shots simply by taking the time to set up a shot manually. This particular example would make a great introductory shot under a title.

◁ It's the bright colors that make this image, so it's lucky that your camcorder is capable of reproducing them. The colors of the sailboards contrast with those of the sand and the ocean and sky beyond.

◁ Big, white, fluffy clouds against a blue sky might at first present you with exposure problems, but by setting the WB (white balance) and controlling the exposure manually, you'll find that your camcorder will produce excellent images.

◁ Natural foliage, especially leaves that are turning brown as summer turns into fall, can provide you with some spectacular shots. Take time to look for the best visual opportunities when shooting establishing shots.

Tip

You don't always have to carry a white balance card around with you. Just point the camera at the nearest white object, whether it's a sheet, wall, or car, and press the white balance button to get the most realistic colors.

shooting techniques
Natural light

Today's digital camcorders are capable of shooting in very low light, and this makes it much easier for you to shoot video indoors to an acceptable quality. It does, of course, depend upon a given camcorder's ability to resolve a lowly lit scene well, and this is entirely dependent upon the size and quality of the CCD (Charge Coupled Device) being employed within the imaging system. The larger and higher-resolution CCD used, the better the quality of the resulting images will be. The majority of modern digital camcorders are capable of producing good-quality images in natural light, and in the majority of circumstances, it's preferable to shoot this way than to go to the effort and expense of having to acquire, carry, and set up artificial lights.

There are all sorts of benefits to trying to shoot in natural light where possible, but it does require you to pay a little bit more attention to light than you might have in the past. Natural light is constantly changing, so you need to look at any scene with a more critical eye. Where is the main light source? How can you take advantage of it when recording the next scene? What happens if the light level drops during the recording session?

The light after the storm
With a heavy thunderstorm now having passed over, the light shines once again on this seaside town. As the strong sunlight breaks through the intensely gray clouds, it reflects on the wet streets and sidewalks and bounces off the white architecture common to the region. It's contrasting light of this kind that video camcorders have the most problems with—especially those camcorders that have only a single CCD. To begin with, let the camcorder's auto iris (exposure) circuit take the strain. In time, however, you'll learn how to take control of the manual features yourself, and that's where the quality of your work will improve significantly.

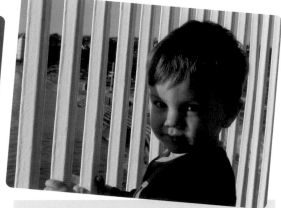

Light and shade
Having noticed how the light passed through the railings onto the little boy's face, we carefully positioned the camcorder to allow half his face to remain in the strong shadow that was produced by the sun coming in from the left. Left in automatic exposure mode, the camcorder insisted on shutting down the iris to a point where the face was barely visible, so it was necessary to ride the exposure manually in order to achieve the right balance between light and shade. Professional film makers call this "contrast ratio."

Shooting into the light

Sunlight can work in your favor as well as against you, so consider what you're trying to do very carefully. Earlier, we discussed how very bright sunlight can impose upon your shots if it is behind your subject, so it's a question of how to take advantage of the bright light instead of considering it to be a nuisance. In this shot, the setting sun—which hits the scene—is a potential hazard to the camera operator as the sailboat passes through the shot, and right between the camera and the intensely bright reflection upon the surface of the water. With too high an exposure, the glistening water would bleach out and ruin the shot, but by allowing the auto-exposure circuit to shut down to an acceptable level, we're actually presented with a much more pleasing image as the boat proceeds toward the harbor in near silhouette. Seize the opportunity to experiment and you'll discover that good natural light is what makes video such a pleasure. Don't be afraid of it—grab hold of it at every opportunity.

△ This shot of boats moored in a harbor was taken with the sun directly behind the camcorder, and has resulted in a general flatness of the image. Although the scene includes several white-hulled boats, their brightness is not of such intensity that they will have an adverse effect upon the exposure, and consequently, the exposure is agreeable throughout the image. With the shooting position being on a jetty some distance away, the shot was taken with the zoom lens set to approximately 20x magnification, and this accounts for the increased depth of focus throughout the range. The shot was used at the end of a short left pan across the harbor to establish our location.

Maintaining a balance

These images were grabbed from analog video that was shot in difficult lighting conditions in a small English pub. As with the shot of the seaside town (far left) the strong sunlight, which enters the scene in each case, bears on the subject to the point where the camcorder has to decide whether to stop down in favor of the light source or maintain a reasonable exposure of the subjects before the lens. By careful movement of the camcorder's position so as to minimize the imposition of the light, we have managed to maintain a happy compromise, and the resulting contrast ratio does some justice to the images recorded.

shooting techniques
Difficult lighting situations

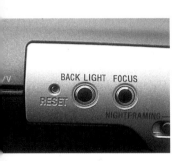

△ Some camcorders have a physical switch designed to provide quick and easy access to the Back Light function. With it, you don't need to fumble through menu systems when you need to make an on-the-spot change.

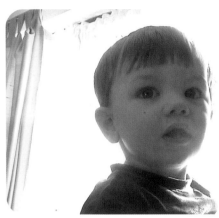

△ Here's a situation most camcorder users have encountered at one time or another. In this instance, the child is pictured directly in front of very strong sunlight coming in through a window. If the camcorder is in Auto mode, the result will be that the iris will be shut down to a point where the backlight ceases to be an imposition. Unfortunately, the person we wish to see in the foreground will be reduced to nothing but a silhouette. What can we do to compensate for this? This image demonstrates the effect of a camcorder's "Back Light" function, which forces the image in favor of the subject while bleaching out the background, without causing electronic problems to the camcorder's image circuits.

◁ Here's a very common situation in which we've attempted to frame a shot of a fellow airline passenger who sits in front of a window through which bright sunlight enters. The camcorder's auto-exposure circuit will clamp down the bright light—and with it all foreground detail too! A solution is to either use a Back Light function or, preferably, reframe the shot to give precedence to the subject.

There are times when you'll find that the lighting conditions are less than perfect when you're about to start recording, but the occasion dictates that you have to get something usable on tape anyhow. In general, a difficult lighting situation is one in which you try to work with either too little light or too much. When there isn't enough light, the camcorder's image circuitry will be forced to squeeze every inch of definition out of the CCD in order to record images of acceptable quality. Conversely, we can sometimes find ourselves working in a situation where the amount of lighting hitting the subject is simply overwhelming— even when the camcorder's electronics are happy with what's entering the lens. A classic example is the church scenario where, for whatever reason, the only position you're allowed to shoot from is the one that looks straight into a large, bright window. This inevitably causes all the characters or foreground objects to appear in silhouette.

Coping with too much light

It might be possible to overcome the worst of these effects by zooming in to the happy couple as they iterate their vows, in order to eliminate the large sheet of light in favor of our being able to make out the faces of those who should be the object of the video. But zooming in like this is hardly the best solution— especially if you were hoping to grab some wider shots of the congregation. Another partial solution is to use any Back Light filter your camcorder might have; this effectively forces its exposure in favor of the foreground objects at the expense of the background light, which will now bleach out entirely. The use of the Back Light function harms the overall visual quality of the image, however, and so can only be recommended as a last resort.

Another option is to move the camcorder in order to reduce the dominance of the window in the shot, but—again—it might be that you're not able to change your position to the extent you'd prefer. In general, it's

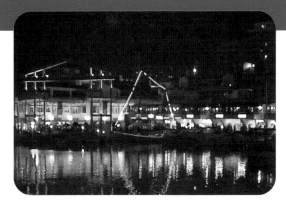

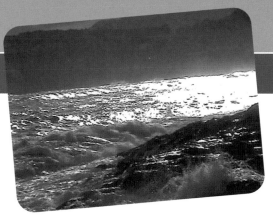

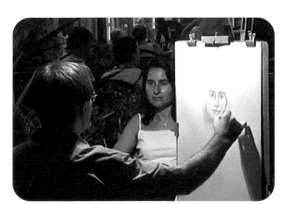

◁ Here's a situation that many consumer-quality camcorders don't like. The restaurant and walkway lights are the only source of illumination around this harbor, but the tiny, bright lights pierce the image to the point where they can create vertical smearing unless you're careful. Here, we controlled the image by switching the exposure to manual and adjusting the image to produce the best effect. It's always a compromise in these situations, which highlight the shortcomings of the smaller CCDs and lower resolution of many digital camcorders.

△ Here's a frame from a video in which we're shooting directly into the sun's excessively strong reflection upon the ocean. Again, many video camcorders cannot cope with such extremes of contrast, with the white level being close to the admissible peak in this case. The auto iris has reduced the exposure to its minimal setting and yet the reflection is still bleaching out. This is barely acceptable on a digital format, but if the footage is copied to analog (VHS, Video-8), the bright part of the frame might break up.

always best to try to physically adjust your position rather than attempting to zoom or pan your way out of trouble. The reason the light is causing you problems is often because of the position in which you're standing or sitting, so move if you can.

◁ Only the artificial lighting provided at this tourist spot saves the scene in which a portrait artist plies his trade in a public square. The inclusion of the areas of white paper in the scene prevents the exposure from increasing further. In situations like this, it's important not to shoot into any floodlights as they'll produce horrible vertical streaking.

Compensating for under or over exposure

Often, the silhouette effect will occur if you're recording a building (or similarly large object) with the sun in the background. In this case, the bright sunrise again causes the iris to shut down in favor of the sky. Beautiful though the quality of the light is, it makes it difficult for us to see any foreground detail. However, by tilting the camcorder slightly, we force the auto-exposure to lift in favor of the detail. It's a shame that the sky has now bleached out as the aperture (exposure) is lifted.

◁ Shooting outdoors in low light doesn't produce impressive results—even when using professional-quality camcorders. One problem with the camcorder attempting to squeeze every bit of detail from a scene is that excessive picture noise (grain) is produced, and this gives a generally gray, flat image that has little appeal. Always look around for available illumination to help you.

Sound recording

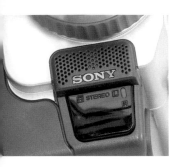

Sound is generally treated as the poor relation when it comes to shooting and editing home videos. Many people give a lot of thought to image resolution, zoom ratios, and digital effects without realizing that poor sound quality can often be more conspicuous than an imperfect image. Play back a recording made on a windswept hill, and the first thing you'll notice is the sound of the wind hitting the unprotected microphone. Of course, that's a pretty extreme example (even professionals will have to work hard to eliminate gale-force wind effects from their recordings) but there's much you can do to improve the general quality of sound on your recordings, and to do so will add considerably to your viewers' enjoyment of your work.

There are several things you can do to improve your recorded sound quality, ranging from improving your technique to buying a few low-cost accessories.

△ On the majority of modern digital and analog camcorders, the Electret Condenser microphone will be found on the front of the body either just below or above the lens. As you can imagine, they're susceptible both to physical handling and wind noise. However, in ideal audio conditions—such as when shooting indoors— the sound will be of good quality and in digital stereo.

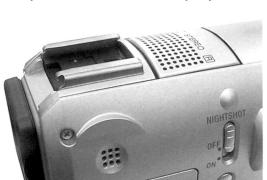

◁ Many newer camcorders, including several from Sony and JVC, possess microphones that are positioned on the top of the body and, therefore, appear to point upward. It doesn't mean that they'll only capture audio above the camcorder; they're cleverly designed to gather stereo sounds from all around in the same way that a front-mounted microphone would. Care must be taken, of course, when handling the camcorder, otherwise you might unwittingly place your hand over the mic when recording.

◁ Needless to say, it's always a good idea to use stereo headphones. While you might not feel it appropriate to use them all the time you're recording, it's certainly important to check the quality of the sound being picked up by the microphone immediately before commencing with the recording. Even a light, whispering wind can have an impact on the microphone and impair the recording quite badly, so to avoid disappointment, check the audio with headphones. You don't need to spend a lot of money on headphones, either; a pair from a low-cost personal stereo will be better than none at all.

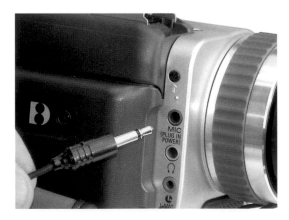

△ Many camcorders not only have headphone sockets but also sockets for the connection of external microphones. This makes it possible for you to place a microphone close to your subject without directly affecting the position of the camcorder. While there are microphones available for all kinds of uses, the two that you might find most useful are the tie-clip microphone and the directional microphone.

The reason why the sound produced by many camcorders is, at best, average, is that many models possess stereo Electret Condenser microphones. Admittedly they produce a reasonable sound at a very low cost, but they're only really useful for capturing what the serious moviemakers would call "general atmos" (atmosphere) and aren't best suited to the more demanding situations you'll often find yourself in.

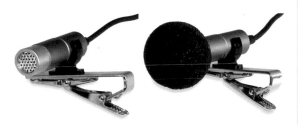

△ The tie-clip microphone is exactly as described. You'll often see it clipped onto an anchor's clothing in a TV studio, but it has other uses, too. Not only can it be attached to a person's clothing in order to enable you to record clearer sound, but it can also be "planted" into or behind objects close to the person speaking so that it remains inconspicuous. Some tie-clip mics have relatively short cable runs, so you might consider buying a length of extension cable.

Tip

When recording speech with only your camcorder's built-in microphone, get as close as you can to your subject. Sound quality deteriorates rapidly after moving away only a few feet.

▷ A directional microphone is one that has a narrower field of sensitivity, usually in favor of sounds in front of the microphone pickup. This microphone is an example of a directional microphone that produces a good, clean sound within a fairly narrow field and yet is inexpensive when compared with similar microphones aimed at the same market. The manufacturer, Sennheiser, has produced microphones for the professional film, video, and TV industries for many years, and its MKE300 model is perfect for low-budget users. The battery-powered unit comes with a removable foam shield, and will sit on a camcorder's accessory shoe as pictured. This particular model produces a single mono, rather than stereo, signal.

Making the best use of the camcorder's microphone

Even without the added expense of acquiring accessories, there's much you can do to improve the way sound is recorded using the camcorder's built-in stereo microphone—although lightweight headphones are so cheap there's hardly an excuse not to use them. For a start, you can always try to get as close to the sound source as possible—the closer the better. The more prominent your source is (whether spoken word or a musical performance), the clearer and more pronounced it will be in the resulting soundtrack. Perhaps you're aiming to record a child describing what he or she did at school that day? Get in really close (and zoom out wide to maintain focus) in order to catch every detail of the child's story. What you're seeking is to record more of the sounds you want and less of those around you that you don't. The technical term for this is a Signal-to-Noise (S/N) ratio—with the word "noise" being used to describe unwanted sounds in general (although it does have a specific relevance to recording techniques and the ability of recording media to preserve a faithful playback recording).

The trick, therefore, is to get in close for optimum sound. Remember that your camcorder's microphone will be stereo, so think carefully about what's on the left and what's on the right. If you're recording music, crowd scenes, or even the sounds of waves crashing on the shore you'll find stereo to be a major plus—especially if you plan to play the final tape through a high-quality home audio system. It's important to remember that you'll need to protect the microphone from even a gentle wind, so you could improvise, for example, by taping foam over the microphone to help baffle the noise.

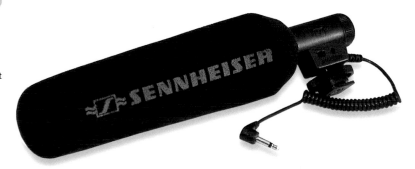

Audio dub and commentary facilities

There will undoubtedly be occasions when you wish to add a commentary to your footage, and there are essentially three ways to do this. You can either speak as you're recording and allow your voice to be mixed with the recorded sound, you can use a camcorder's "audio dub" facility (if it has one) to add a voice to a previously recorded tape or, finally, you can leave the whole job until it is captured into a computer editing system, assuming you have one. Many people will choose to use the latter option, for a number of good reasons.

By recording your commentary at the time of recording, you're committed to that mix of sound forever. There's no way of extracting the sound of your voice from the natural sound effects around you. A small number of camcorders have what is described as a narration microphone, which flips out from the left side of the camcorder's body and is ideally positioned for speech, and it's possible that the spoken word can be recorded to separate dedicated audio

Tip

When writing a commentary, don't feel obliged to describe absolutely everything that the viewer can see on tape. Avoid stating the obvious—people will be able to recognize a mountain range when they see one!

Stating the obvious

A line of commentary that starts with: "No image or movie can quite prepare you for what you see, hear, and smell as you stand on the banks of the holy River Ganges in India" has much more impact than "Well, here we are by the Ganges." What's more, the first piece of commentary is all you need to say, allowing the recorded sights and sounds to tell their own story. If, however, the latter approach is chosen, you're almost obliged to add more words to explain what you're doing by the river and how you came to be there in the first place.

Digital sampling rates

The stereo sound passing through the camcorder's microphone will be converted to PCM (Pulse Code Modulation), which means that the incoming sound waves are converted to a digital datastream—basically a very long string of ones and zeroes similar to the sound that comes on an audio CD. Scroll through your camcorder's menu system and you'll probably see that you have choice of audio recording settings—either 12-bit or 16-bit audio recording. If you have recorded your DV or Digital-8 video footage using 16-bit 48kHz stereo sampling, it might not be possible to add a subsequent 12-bit 32kHz audio commentary track afterward—it depends on the make and model of the camcorder. Some camcorders, such as later Sony models, will permit you to add a 12-bit commentary track provided that you have recorded your original audio as 12-bit as well. It's something you must check and experiment with in advance of your making the recording.

tracks on the tape (although the vocal sound will, of course, still be picked up on the camcorder's other mic as well). More acceptable is the practice of recording directly to the previously recorded tape. There are many camcorders that will offer this "audio dub" facility, by allocating an additional track (or tracks) onto the recording space on the tape and laying the additional recording in at a reduced digital sampling frequency than the main audio. It's very easy to do, and involves cueing the tape at the point at which you wish to add your spoken commentary, pressing the Audio Dub button and releasing the Pause key. When played back, all the soundtracks will be heard in mixed mode, enabling you to hear the original sounds in addition to your own professional-sounding commentary.

Preparing a narration

There are two ways to record a spoken narration (or commentary) as an accompaniment to your video recording. The first, and simplest, is to record it directly to the original camcorder tape on additional tracks provided by the camcorder. The second is to leave it until later and add the commentary to your edited sequence in a computer, if you plan to use one.

A good commentary isn't just a case of putting the cam into its Dub mode and speaking over the footage that plays back—unless you're exceptionally good at making up the words on the spot and enunciating them flawlessly! It's a very good idea to write down your words in such a way that you know they'll fit the sequences perfectly, and then record them only when you know it will work. Don't try to record the whole thing in one pass either; use the professional trick of recording them sequence by sequence and getting each one right before moving onto the next.

Using Timecode

You can use a pen and paper to scribble yourself a script, but a word processor or spreadsheet would enable you to organize your thoughts more efficiently. Write your words, double-spaced, on the right side of the page, and leave the left side for notes about the visual content. Use the tape's timecode to identify each section, and also to provide a clear indication of where your words will start and stop. It might even be worth timing each section with a stopwatch to ensure that your commentary will fit the gap, and take the opportunity to rehearse it a few times before committing your voice to tape.

Mexico Vacation Video Commentary Page 3 of 8

T/C 0.20.24
Shot of cruise ship docking taken from upper deck

(Wait for ship's horn to blow)

By the time the ship came to dock, we couldn't wait to get off and sample the delights of Mexico. Our friends Dan and June had told us about how cheap the clothes were in the main town and we thought it would a great idea to accompany them around. They'd been here several times so it made sense, as the tour company's guides were quite expensive!

T/C 0.21.03
Dan calling a taxi cab

(Street traffic noise)

Despite his local knowledge, we didn't rate Dan's skill at flagging down a cab. We nearly lost him altogether in his efforts to find a cab that hadn't already been booked.

(Dan nearly getting knocked over by the cab as it swerves in to stop by us)

(Wait for everyone to laugh)

Still, that was more his stupid fault! Eventually, we made it through the hustle and bustle of Mexican street life to our destination. Immediately, it seemed like the whole of Mexico had something that we really must buy at …

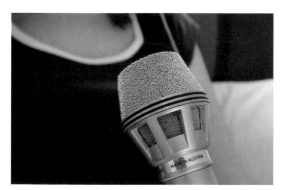

△ Though the camcorder's built-in Electret Condenser microphone will be adequate for general, non-critical, commentary recording, you'll always achieve a higher quality of recording if you use an external plug-in microphone. A good, hand-held or stand-mounted microphone like this AKG mic will provide clear voice reproduction and is reasonably directional. However, it is essential to use headphones when recording in order to monitor any handling noise. Better still, use a microphone stand.

△ Some camcorders have a complex on-screen menu system that is used to select the Audio Dub function. Others have a manual switch somewhere on the main body of the camcorder itself. In this example, the Audio Dub feature is located by use of the touch-screen LCD. Even the tape playback functions themselves are controlled using the screen, and the voice recording can be activated and de-activated using the on-screen record and pause control.

It's relatively easy to find a clip if you have only a couple of 60-minute DV or Digital-8 tapes, but you'll have a problem if you have 20 or 30 tapes and no means of knowing what is recorded on which. Clearly, you'll make life a lot easier for yourself (and for those who might also require access to your recordings) if you adopt a tape logging system. This doesn't need to be as complex or as time-consuming as you might fear—even a simple hand-written sheet detailing the contents of a given tape and indexed according to the the timecode numbers is sufficient to facilitate a simple search, and the small amount of time you spend on it now will save you hours later. If this log is cross-referenced with a summary of a tape's contents listed on the liner-sleeve in the box itself, you'll at least have a chance of locating that clip of Aunt Bessie sitting on the cat when you need it.

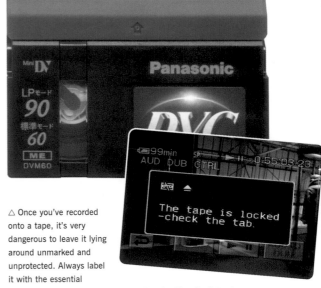

△ Once you've recorded onto a tape, it's very dangerous to leave it lying around unmarked and unprotected. Always label it with the essential information at the very least—and slide the "Save" tab to stop yourself or others from accidentally re-recording over it. In this case, you should then get a warning message.

Keep one eye on the code

Keeping an accurate log of a tape's contents is made much easier if the timecode is continuous throughout the tape's 60-minute (or 90 minutes in LP mode) length. As explained on pages 28-29, timecode is, as the term suggests, a measure of the time in hours, minutes, seconds, and frames. Provided that the position of the recording heads haven't lapsed into a blank portion of the tape (such as when the camcorder is switched off at the recording session, with the tape then being wrongly cued up prior to the next recording), the timecode generator will automatically set up the sequence from the current point. If there's no timecode on that part of the tape, it will default back to zero. For general playback purposes, that might not be considered to be much of a problem—but if there's more than one instance of timecode 0:00:00:00 on the tape, you'll find it rather confusing if you need to find a shot at position 0:01:12:15, for example. To aid logging and shot location later, always ensure that the timecode contains no zero resets.

Keeping your material organized might be considered to be common sense, but in practice, it's the one thing we tend to put off until later. Perhaps, for that reason, it's worth making the process as simple and as pain-free as possible. If you have a computer, of course, then the process couldn't be easier—any word-processor, spreadsheet, or database application is all you need to keep track of your valuable source material. If you intend to import your digital footage into either a Windows or Apple Mac computer, you'll be glad that you did some basic preparation as the job of sorting and assembling will be made much easier. It's a good way to get familiar with your recorded footage, too.

Logging your tapes

It's obvious that a spreadsheet or database program would come in very handy here—especially if the latter is a relational database that enables you to search using keywords. Assigning a unique index number to the tape makes life even easier, since a shot can easily be located once you know the tape index number and the timecode position on the tape itself.

▷ Producing and maintaining a detailed shot-by-shot log of everything that's on your newly recorded tapes is a real chore. Nobody would bother about doing this unless they really did want to regularly access their shots and sequences long after the day they were first recorded. Well, that's all very well, but what happens if somebody asks you to see the shot of Aunt Clarissa accidentally knocking over the Christmas tree back in 2001? You probably know roughly which tape it will be recorded on, but could you go to it right away? What's more important is that if you really do aim to take your video-making seriously, you might actually wish to build up a concise index of your video footage for future reference—and possibly even to include in future editing projects. Making out a detailed shot log is an exercise whose usefulness and importance can't be understated. It doesn't have to be a complex spreadsheet, it can be a handwritten sheet. The point is that you'll know where to find those shots when you need them in a hurry.

Panasonic — TAPE 1 (Mini DV Digital Video Cassette)

■TITLE **Mexico Vacation** DATE 03·04·05

0.00.20 Hotel at Tampa
0.05.00 Boarding cruise ship
0.11.30 Setting sail and sunset
0.17.20 Tour around ship - night
0.38.00 First morning on deck
0.46.30 Kids swimming - to end.

□標準 □LP

DV TAPE LOGGING SHEET — TAPE NO: 01

Timecode	Shot Description	Comments
0.00.00	Black for 20 seconds	
0.00.20	Inside the hotel at Tampa	OK
0.02.24	Dad unloading car	Focus soft?
0.04.00	Shots of hotel room	Bit dark
0.05.00	Boarding the ship at the jetty	
0.07.20	Misc shots on the ship - including the mall, the casino, etc	OK - mostly - good shot of chandeliers
0.10.20	Man casting off ropes onto jetty below	Not very good - bit wobbly!
0.11.30	Ship's horn blows - people waving on jetty and ship - ship starts to push away	Great sound of horn!
0.17.20	More tour of ship at night - also shots of the Tampa + Florida coastline as we sail away	Various good, some not so hot!
0.19.30	Bob and Nancy getting ready for dinner. Molly jumping on the beds.	
0.21.20	Shots out of the cabin window.	Good stuff
0.23.10	People on deck looking out to sea	
0.25.25	Some shots of people at dinner, followed by misc shots on board in the evening	Variable - some filmed by Andrew! Sophie filmed this ☺
0.31.30	Kids disco - general dancing etc	(Sophie's fault entirely)
0.34.20	Trash! Camcorder running when it shouldn't have been!	Havoc - low light. NG?
0.36.00	Sophie and Andrew go to bed.	

PRO-TIP

Keep your tapes in one place. Whether you choose a dresser drawer, bookshelf, or a box in the garage, always put tapes in one place, so that you can find them easily. There's no point in using labels, if you can't find the tape in the first place!

Tip

Assign a unique index number to every tape cassette, tape box, and index log in order to make searches easier. If you're really smart, you'll record this on the front of the tape in-vision, just like a clapperboard.

How to shoot great home movies

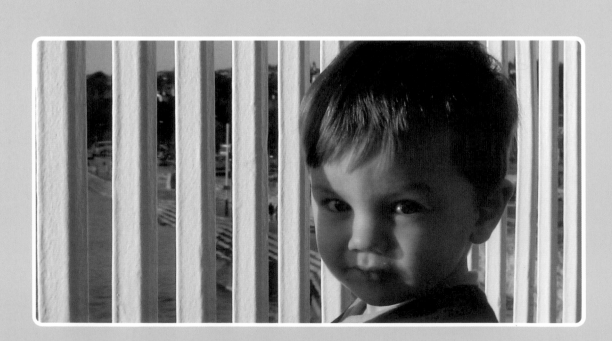

As soon as you pick up a camcorder with the intention of recording aspects of life as it unfolds in front of you, you're engaging in a process of storytelling. You might not have thought about it in quite those terms, preferring instead to think of your efforts as being no more than shooting some video of family activities and memorable events, but the mere action of framing shots, recording them and then—at a later stage—playing them back to your chosen audience, means that you're making an attempt to communicate something in your own personal way. There's no point in committing all this material to tape unless you're aiming to have an effect upon your audience—even if it's simply to make them laugh. Having gained an understanding of your camcorder and what you can do with it, it's time for you to start thinking of ways you can make your own memorable home movies.

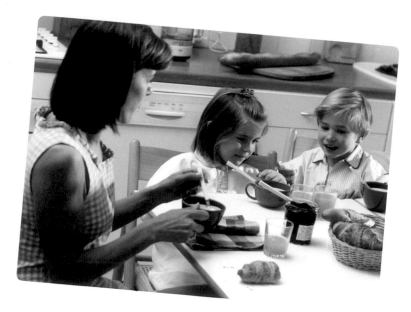

△ Instead of standing farther back with the camcorder in order to get it all in the frame (as many people often do), try to get close and assume the viewpoint of someone who is part of the group. It will help create a more involving sequence.

Trying to get good footage of members of your family or friends is difficult when they're self-conscious. It's one thing to enjoy the company of people you're close to, but quite another to pull a camcorder out and start recording everything they say and do. At best, the people in front of the lens might feel slightly uneasy, so it's part of your job to help them to relax.

People can find it difficult to get used to the camera being too close to them; it's a bit of an infringement on their personal space, after all, and none of us likes to be center stage unless we have designs on making it on Broadway or the big screen. A lens in close-up isn't exactly an encouragement to forget that the camcorder's there, so when you're shooting social groupings of any kind, it's important to let the mood settle down before going in for the good stuff. If you're recording a group of people at a party, hold back and rely on wider shots to begin with. It's here that the over-the-shoulder shot comes in handy as you eavesdrop on conversation or social antics. It's also a good idea not to use the viewfinder too much when in a group, as this detaches you from the action, and the camcorder can serve to place a psychological barrier between you and the people you're with. In these situations, it's best to use the LCD screen if your camcorder has one; position it so that you can't just monitor the shot, but are also able to engage in conversation or banter (trying to avoid the camcorder recording your off-camera remarks, of course).

▷ Here's another example of the camcorder being positioned at the subjects' eye level. The man on the right is demonstrating something to the others and we've kept back to a three-shot. It conveys a different mood than if we stood over them with the camcorder.

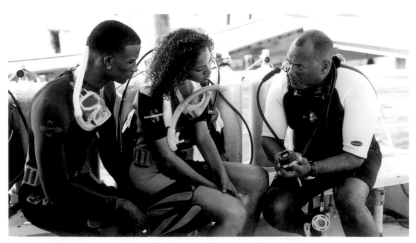

Sampling the party atmosphere

Getting a natural response or reaction from people in front of the camera will depend on how you relate to them while filming or preparing to film. If you point a camcorder at a self-conscious person, you'll get a less-than-positive reaction. Try holding the camcorder in ways that are more subtle—settled on your knee or positioned on a table beside you—in such a manner that the subject doesn't necessarily realize what you're up to. Sometimes, setting the camcorder running and not looking into the viewfinder or LCD at all will produce more natural reactions from those in front of the lens—especially if you're able to maintain participation with the action or conversation.

Tip

Use the LCD screen to check your shots, but maintain eye contact with those in front of the lens while holding the camcorder firmly with both hands. It's much less off-putting for your subjects and helps to maintain a rapport with them.

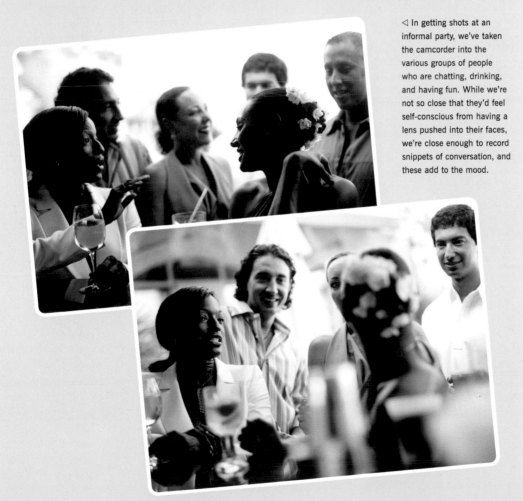

◁ In getting shots at an informal party, we've taken the camcorder into the various groups of people who are chatting, drinking, and having fun. While we're not so close that they'd feel self-conscious from having a lens pushed into their faces, we're close enough to record snippets of conversation, and these add to the mood.

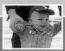

The average child is a natural performer and will make the job of capturing entertaining home video easy. Certainly, children in their early years can help to produce footage that parents and relatives will come to cherish in later years, especially if it shows the natural side of the child, or finds them in a relaxed, contemplative mood, prepared to give the camera their particular take on life.

Although many families now possess camcorders, very few capture footage that reflects the true nature of their children. This is a pity. Very often, the camcorder will be put to use at parties, vacations, and at school events, but if you ask users whether they set up their camcorders in a fixed position in order to record a relaxed chat with their child, they'll look at you blankly. Yet it's exactly this kind of everyday footage that will be of the greatest value to the family when they've grown up.

Candid footage can often provide lots of fun as well, not just in replay immediately afterward, but also in future years, and by encouraging children to engage in some activity that reflects their skills and abilities at that stage of their lives— reading, acting, completing puzzles. You'll find that by setting up recordings at regular time intervals, you'll realize the extent of their development. It's quite surprising to see how much children grow up and become more aware of their world— even in just a few months. Tape is cheap, and the camcorder is yours, so it's well worth trying.

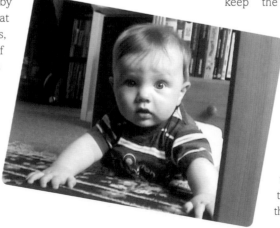

▷ When baby learns to crawl, get right down there at floor level for the best shots. If necessary, place the camcorder on the floor, too!

Capturing spontaneity

There's no doubt that children will act up in front of a camcorder, especially if they see an opportunity to impress their friends. However, children who have had a camcorder lens pointed at them since the day they were born will be less conscious of being recorded on tape than those who haven't, and are less likely to show signs of self-consciousness. Having said that, it's still worth attempting to keep a relatively low profile when recording. Avoid, if possible, the usual stance of standing up and pointing the camcorder downward in order to get all the action in the frame. Body position and body language are very important when it comes to getting meaningful and enjoyable footage in these situations.

The child's-eye view

If young children are seated on the floor and playing, it's essential that the camcorder gets down there with them. As usual, the old adage, "If in doubt, zoom out" comes into play. Don't try to get nice, close shots of children playing while using the zoom control; keep it wide (use a wide-angle lens adapter if you can) and keep the camcorder steady. If necessary, hold it around the body and watch not only what's happening within the group, but what's likely to happen. When used in this way, it's very likely that the camcorder will be positioned virtually on the floor for part of the time, but if that produces the right images and sounds, that's what you need to do.

Looking for the right images

Young children are an especially good source of amusing and entertaining video sequences, especially when there's food involved and they insist on feeding themselves. The child whose face is covered in ice cream or chocolate cake (*1*) is guaranteed to raise a smile, not just at the time that it was recorded but many years later. At parties or in playgrounds, the conversations that take place between children can also be a good source of amusement—but you have to resist the temptation to move onto other subjects and shots, remaining patient with the current subject until you get what you know will be the good shot. It's really important to get in close and hang in there until the right dialog, action, or expression is captured on tape (*2, 3, 4*). Be patient.

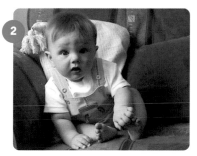
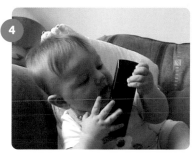

Act naturally

Children will always, almost without fail, forget that the camcorder is watching them if they're fully engaged in a challenging creative activity. For young children, drawing, painting, helping with cooking, or creating things with modeling clay can be a good way to keep them occupied. Water is another attraction for kids—they love messing around with it (although you'll have to be mindful of the consequences of inevitable spillage). Once the excitement of a particular activity dies down, you're then likely to get some effective, enjoyable, and long-lasting footage that you'll love to rediscover in years to come.

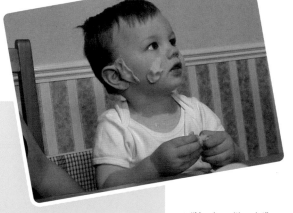

△ "Messing with paint" can produce some memorable shots, but be sure to keep it clear of the camcorder.

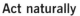

Tip

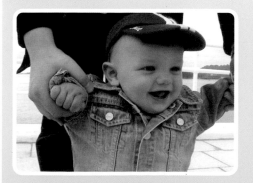

 When recording children, don't look through the viewfinder while towering over them. Use the LCD screen when getting the camcorder in close, and keep eye contact with them whenever possible.

great home movies
Children's birthday parties

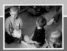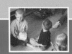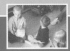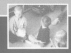

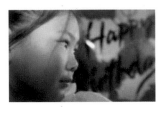

△ Children aren't self-conscious like their parents, which makes it easy for you to grab amusing and candid shots at parties. In fact, they'll all be desperate to have a share of the action!

Children's parties are either really well-organized affairs or they're completely anarchic, and as such can result in either a great movie record of a happy occasion or one containing lots of meaningless and disorganized raw footage. Whatever the age group of those attending the party, there's no escaping the fact that the occasion is taking place for the enjoyment of those present, and you therefore shouldn't expect to stage-manage the event for the sake of good video coverage. However, if the party itself has been organized so that things are happening according to a plan, there's nothing to stop you from liaising with the organizer to make sure that key aspects of the event won't start without your being ready to record them properly.

Given that you're making home movies, it's most likely that the organizer is going to be your wife, husband, partner, family member, or friend. That being the case, a simple request to "wait until the camcorder's running" is all that will be needed. It's at this point that you can quickly evaluate your best

shooting position in order to capture a range of shots that will tell the story in the most effective and entertaining manner.

Making memories

Most children's birthday parties are recorded on video for two reasons. First, we want to capture the moment for the purpose of reminiscence in later years and, second, we'd like a record of the event in order to send copies to close friends and loved ones who couldn't be there on the day. Naturally, the record of the party contributes to what will inevitably form part of the treasure-trove of family memories, and as such there's every reason to take your time and record such occasions properly.

Even the most low-key party can be made to seem special when recorded and edited with care. There are lots of visual and aural symbols to suggest that a party is taking place: balloons tied to a tree or gatepost, birthday cards on window sills, party lights and other festive paraphernalia around the house suggest that things are happening. And, of course, if the party is in full swing, there will (hopefully) be a collection of fun sounds like singing or music emanating from within. Shoot these individual pointers in order to build up a picture of the event from start to finish—begin with the mailman delivering birthday cards, a ringed date on a calendar with a birthday reminder note scribbled alongside it, a pile of wrapped birthday presents, or the traditional birthday cake in preparation.

Sometimes, parties are organized in secret and held as a great surprise to the lucky birthday boy or girl, in which case it's essential to record the preparations. The "sting"—the moment when it is revealed to the person whose birthday it is—always makes for good TV viewing later. Balloons, other decorations around the room, and cards make good visual subjects for an edited montage sequence in the finished video—assuming you will be editing at all. The appearance of the birthday

Tip

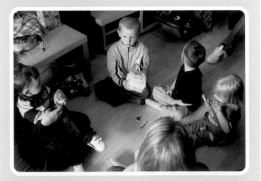

Avoid shooting from high angles unless there's a specific reason. The best shots of kids are those that result from the camera lens being right there at their height.

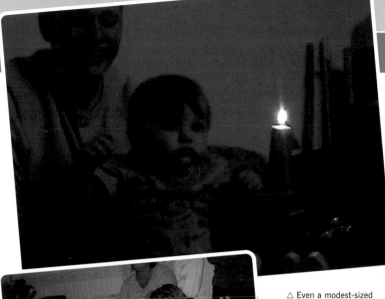

cake, complete with candles, is a high-point of the occasion. It's a must to capture this properly, but doing so needs coordination. Make sure you not only get good shots of the candles being blown out, but that you also allow the singing of "Happy Birthday" in its entirety. There are many examples of recordings in which the taping has stopped before singing has finished—it's essential to listen as well as to observe what's actually occurring.

When recording, always keep one eye on the action on either side of the lens and be ready to grab shots as they happen. Look for nice reaction shots from guests as they laugh, sing, or do unexpectedly amusing things in true party style. If, of course, there's music—whether disco-style or the now-common karaoke—make sure you record complete performances as you won't really know what you can do with the material until you watch it later. There's nothing worse than expecting your viewers to watch their favorite nephew or niece singing a song that cuts out after one minute. Give them a chance—even if you don't intend to include it in your final movie.

△ Even a modest-sized children's party will present you with great possibilities to get some good footage. Blowing out the candles on the birthday cake is just one of the many things that will provide happy memories in years to come. Don't stand back—get in there and grab it while you have the chance.

What was it like for you?

It's a great idea to have a few quiet moments with the person whose birthday it is before or after the party and invite him or her to chat about what it means to be the age they are now. If your interview is being recorded after the party, encourage your subject to provide you with his or her reflections on the event itself: Who came? What presents did you get? What aspect of the party was the most enjoyable? Ask "open" questions that encourage complete descriptive answers rather than single "yes" or "no" responses (see page 85). If the answers are good, you'll be able to use them as commentary over visual sequences if you intend to edit later.

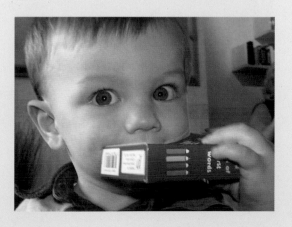

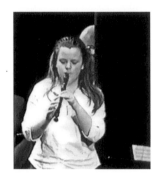

△ Even if you're shooting from a fixed position, record a variety of shots, but use a monopod or a tripod in order to record stable shot sequences. It will reduce arm-ache, too!

Tip

The use of a tripod is more than a luxury in these situations—it's essential! Not only is it virtually impossible to handhold a camcorder while recording concerts and plays, but the quality of the resulting material will be hampered by shaky camerawork. It's hardly worth spoiling your recording of this once-only occasion for the sake of a modest expenditure.

Almost from the time children start at their first schools, their families will want to capture their performances on video for posterity. It's now common to see almost as many camcorders as there are performers at these events, as parents and relatives commit the occasion to video. It's another example of how invaluable the camcorder becomes as a means of documenting a child's development. Again, these recordings are guaranteed to bring you all hours of pleasure once the kids have flown the roost.

Position the camera

The important consideration when taping school plays and concerts is to think of the camcorder's position relative to the performers and the audience. Not only will you have to select a position that gives you good all-round coverage of the stage area, but you must think very carefully about how well the camcorder's built-in microphone will pick up the sound. And, of course, the smaller the children, the quieter they'll speak—so your position will have to be such that the camcorder has a good chance of capturing audio of reasonable quality. One alternative, of course, is either to attach a more specialized directional microphone to the camcorder or arrange for the camcorder to be positioned close to a PA sound system (if such a system is being used). Another solution is to place a microphone close to the performance area and then use an audio extension cable to return the signal to the camcorder.

Another important consideration is the position of the camcorder relative to where your son, daughter or little relative will be positioned for much of his or her time on stage. If junior's on-stage screen direction is left to right, you really should try to position yourself more to the right of the stage in order to connect with his or her general eye-line. That way, you'll be getting a fair number of facial shots. It will help with sound capture as well.

△ Even when shooting a school play or concert performance from a single, fixed viewpoint, there's still potential to gather a variety of shots, whether of the stage performers or of the audience. They'll come in very handy when you're editing it later.

Share your footage

Given the fact that several people will undoubtedly be recording the performance as well, it's a good idea to negotiate footage-pooling with other parents. Where camcorders are a similar format and specification (that is, if they're single-CCD DV camcorders of a similar type) it's possible to interchange footage in order to satisfy the needs of several families in one hit. In this case, it's a good idea to pre-plan how you will collectively cover the performance; three camcorders all recording simultaneously is a good idea provided that each of them is gathering footage that is sufficiently different from the others'. Ideally, position one camcorder at the rear of the hall or auditorium in order to record a wide, master shot. Then position the other two camcorders with a stage left and stage right bias in each case, and agree between you what kind of shots you'll take. If all the collaborating camcorder operators are using tripods, then so much the better. For good sound, it only requires a good sound feed (such as from an external microphone) to be fed to one camcorder; if you're editing, you'll be able to use this as the master track and use the other two only for the purposes of synchronizing the three camcorders' recordings together. They won't necessarily be used. Naturally, you should always monitor the incoming sound with a good pair of headphones.

Gaining permission to record

It isn't as easy to take a camcorder to a school play or concert and simply record what you see and hear for your own use as it used to be. Unfortunately, the increases in the misuse to which a very small proportion of such footage has been put has led to many schools and colleges imposing restrictions—if not a ban—on parents and guardians recording such events with their camcorders. In the event that this might occur, it is strongly suggested that you check with the school ahead of the occasion. In addition to the obvious problems of people using the resulting footage in a wrongful manner, there are other considerations such as musical and lyrical copyright, as well as the rights of the performers themselves, although the rights of the latter will normally be covered by a "blanket" school agreement.

◁ When the world's next great rock phenomenon is giving a performance to parents at the school concert, keep the camcorder running while picking off a range of shots that can be edited later. If you're editing on a computer, you can separate the audio and video, which means that, as long as you have a constant sound track, you can cheat with close-ups later on. Alternatively, you can use footage from another proud parent's camcorder to cover any rough spots in your video.

Tip

Try placing a MiniDisc Walkman recorder close to the front center of the stage, connecting a directional microphone to it for good independent sound. Use this later to synchronize with your master camcorder recording in the computer edit suite. It should maintain synchronization— and give you a clear sound recording.

81

great home movies
Filming babies and toddlers

All children are perfect subjects for entertaining footage, but very small children give us something else—scope to gather footage that documents the tremendous speed at which pre-school children develop and grow up. Many people acquire a camcorder for the first time not only to capture that precious moment when their baby is born, but also to record first steps, first words, and—of course—the first birthday party. Still pictures are a great way to record these moments, too, but there's something special about having a collection of video recordings that have been shot with a degree of care and attention.

Of course, newborn babies are easier to record than toddlers. By definition, toddlers are constantly on the move and into absolutely everything they get their hands on, whereas newborn babies are perfect models—they stay still, yawn occasionally, sleep most of the time, and don't complain about a camera lens being close to their faces. Yet, surprisingly, many new camcorder owners still manage to miss an opportunity to grab those once-and-for-all moments on tape. Though it might seem like an idea not worth bothering with at the time, you'll be grateful for having taken the time to set the camcorder up on a tripod (or on a similar sturdy mounting) in order to record a few minutes of the baby sleeping in its crib or in its mother's arms. Don't do anything, and don't say anything—just let the camcorder run—and if you're smart, you'll even try to capture the gentle sound of baby's breathing. You still don't understand why? Try it for yourself and report back when the child is 18 years old!

Getting down to their level

As we've established in recent sections, it's important to get down to a child's own level—literally. There's nothing more imposing on a small child than an adult holding a camcorder and standing overhead as recording is in progress. Not only does it produce uninteresting high-angle shots that achieve little, but they often fail to convey the true character of the child, or children, in focus. If the child is seated on the floor or on the lawn, a far better approach than this is to get down there with him. That way, you're bringing your viewers down there with you in order to share the experiences (in a virtual sense) with the child involved. After all, you wouldn't play with the child while towering overhead, would you? The resulting video picture and sounds serve to convey a sense of your own experience as it happens, so let your viewers get involved through your shooting position as well.

Something new every day

From the day they're born, children will never cease to surprise and delight you. They learn something new every single day, so if you hope to look back on your early footage with fondness, you really need to shoot new video once a week at the very least. It's much easier when a baby isn't walking or even crawling—you simply set up a camcorder and let it record what the child does. It's a very good idea to record for large chunks of time—preferably with the camcorder on a tripod—as candid footage of this kind will provide you with the best indicator as to how quickly your child has developed. Let the camcorder run for several minutes as the child explores new objects and learns how to interact with them. One day you'll be amazed.

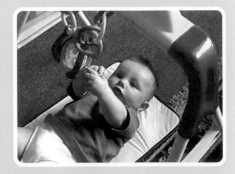

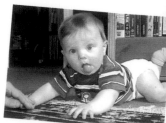

◁ As children grow, their quest for adventure sees no bounds. Even the most basic children's playground is a wonderful place for a young child, so take the opportunity to record their experiences as they happen. As has been mentioned already, resist the temptation to record everything from a single standpoint while relying on the zoom lens to frame the action. Zoom out and get in close—and stay with your subject. If, as many toddlers do, all actions are accompanied by chatter, you'll have a better chance of recording this, too. Close-ups work so much better than distant, zoomed-in shots and sequences.

Recording a video diary

As parents of older children will be able to tell you, it's a really useful exercise to record young children at regular intervals. As they grow older, they can record their own thoughts and recount their own experiences of their lives at that particular moment. Each individual recorded segment provides a useful snapshot of their developing lives, and when combined in a sequence of others, it provides a more illuminating and rewarding viewing experience than you can ever imagine. Remember to record the date and time of the recording on the tape—either by relying on the DV or Digital-8 date/time stamp that's automatically embedded into the datastream, or by putting a handwritten card in front of the camcorder as you start to record. The temptation to "burn" the data and time into the picture as you record should be avoided, as you'll never be able to remove it later.

Tip

You can't shoot too much of your kids growing up—but make sure it's the right kind of footage. Set the camcorder rolling and hang in there. You'll catch the kids as they really are.

great home movies
Video portraits

Tip

It's virtually impossible to record lengthy interviews without the camcorder being mounted on a good, sturdy tripod. Position it relatively close to the subject and avoid the temptation to vary the shots more than a couple of times.

With the ever-increasing interest in family history, lots of camcorder users are choosing to gather the memories of elder relatives, friends, and other members of their local community as a means of not only compiling a detailed personal history of life in days gone by, but also as a hobby. Getting people to agree to be interviewed, and then settling them down in an environment where they can talk without feeling inhibited or self-conscious is quite an art, but once mastered, the rewards can be great. It's also the basis of documentary moviemaking as practiced by professionals, with the techniques employed being almost identical.

There are plenty of other applications, too. On pages 78–79, we touched on the idea of recording a chat with children in which they describe their life on a particular birthday. This idea can be developed to the point where children themselves might be encouraged not only to reflect on their own perceptions of the world around them but also to interview their elderly relatives, neighbors, and close family friends. It's not that difficult to do—elderly people in particular seem to relish the idea of telling their life stories—but there are some important guidelines that should be taken into account before undertaking such a project.

Are we sitting comfortably?

In setting up a recorded interview with a member of your family, it's vital that they're sitting in a setting that is comfortable for them and which provides you with all that you'll need to make a good recording. If they're to sit in their favorite chair, make sure that it is sufficiently well lit, otherwise the camcorder might have to strain for light and the resulting images will be grainy. An armchair that is next to—but not directly in front of—a large window is a good situation in which to record. If your subject is answering questions, encourage him or her to look at the interviewer rather than the camera lens. You'll notice that this is the way it's done on TV, too. Even if the person is told to look into the lens when responding to questions off-camera, they'll inevitably turn their eyes in the direction of the interviewer. Anyway, looking off camera looks more professional—but make sure their eyeline is fairly "tight" to the camera and that they're not pictured in complete profile. Around halfway is about right.

▷ Asked the right questions, older people will talk for ages about their lives. Make sure they're relaxed in a comfortable setting first, and then get them talking.

△ Shooting interviews with people who have a lifetime's experience in a particular profession or trade can provide fascinating material. For best results, you really must consider close-miking the subject, however, or their words won't be heard clearly.

Sounds good

Although you'll probably decide to position the camcorder fairly close to the interviewee (and on a tripod, of course), you might find that the camcorder's built-in microphone isn't quite good enough for optimum audio fidelity. In that case, you might consider the use of an external, plug-in, microphone such as a tie-clip microphone (*see pages 66–67*). When using a tie-clip microphone to record interviews, place the mic on a shirt or blouse approximately nine inches (20 centimeters) from the subject's mouth, and tuck the cable away where they can't fiddle with it. Fumbling of this kind will inevitably be picked up on the recording.

Shooting complementary material

Don't just record your relatives talking and leave it at that. Take additional time to record them doing their normal day-to-day things like pottering around in the garden, going shopping, preparing meals, walking and playing with their grandchildren, and so on. With this cutaway material, you'll be able to layer the spoken words over the visuals during editing. We call this the "voice-over" technique, most commonly associated where a spoken commentary is overlaid onto an edited sequence.

Questions and answers

The quality of the answers you get are directly related to the quality of the questions. If you ask your Uncle Fred to describe fighting in World War 2 it's no good simply asking, "So was it frightening being a soldier in World War 2?" Their answer, more often than not, will be, "Oh, yes." This is known as a "closed" question—you've helped to produce a simple one-word answer, and that's not really what you're looking for. If, however, you (or the person asking the questions) poses what is known as an open question, you'll get a much fuller and more descriptive answer. "Tell me how you felt when you heard that you were being called to serve," will almost certainly start the ball rolling. You want your subjects to tell their stories, not merely sit and answer your questions—it's not an interrogation. The more your interviewee opens up with heartfelt stories and memories, the better the historical resource you'll make, and in years to come, you'll be glad you did it properly.

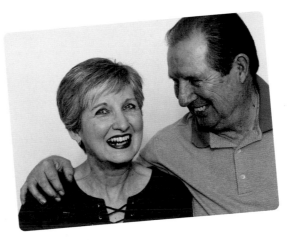

△ Young camcorder-wielding children might like to shoot question-and-answer pieces with their grandparents. Intimate two-shots like the one above can often prompt a good interaction between the interviewees.

great home movies
Weddings

First-time camcorder owners underestimate just how much work is involved in shooting a wedding. Wedding ceremonies and their associated festivities do vary hugely from one culture to another, of course, so what might be a simple job covering one can become enormously complex with another. For example, Southeast Asian cultures tend to have hugely colorful affairs that can span several days and involve hundreds of people who have traveled from all over the world. In the West—in particular the US, Canada, and northern Europe—a wedding will usually be a more controlled affair that's slightly easier to plan and shoot. That's not to say that it won't involve a lot of pre-planning to ensure that you're in the right place with the right resources at the right time, it's just that there's a certain linearity to the organization that makes it easier to capture on tape.

To shoot a good wedding video, try thinking of yourself as a documentary filmmaker. After all, you will be documenting an event involving a lot of people and at which there will be many opportunities for interesting and varied footage. Some people actually like the recording process to start at the planning stages—choosing and fitting the wedding dress, selecting the venue, deciding upon flowers, table decoration, menus, and so on. There are many cases where the last acts of freedom and pre-wedding debauchery are recorded as well. For most wedding video recordings, however, the process starts on the day itself.

Less is more

It's very tempting to shoot too much—many wedding videos last almost as long as the original event itself. Be selective with your shooting opportunities. Look carefully at what's happening and shoot with an eye for interesting content and shots that help to tell the story. Remember that, very often, the best shots and sequences are the ones in which you're in relatively close to the action and in which people are performing certain rites. Don't ask people to stand and smile at the camcorder while you knock off the odd 10 seconds here and there— that's the stills photographer's job. People greeting, joking, doing embarrassing things, and generally interacting with others are best. Take a variety of shots from different positions—and shoot to edit, listening to the sound as you're recording. In addition to the more formal aspects of the event— and the shots that you'll be expected to capture—it's important also to capture the quirky, amusing, and less-formal aspects of the event. Always keep one eye open for what's happening—and likely to happen—around you.

Difficult lighting

Many venues aren't built with video in mind— especially churches and

△ Only by checking out the wedding venue beforehand can you determine the best positions from which to shoot, so try to attend the rehearsal where possible. Using two camcorders will help you even more in that you can set a "safety" shot running while using your main camcorder to capture the details of the action.

▷ If you're shooting with a single camcorder, you'll need to be quick off the mark if going you're to catch the action. The shot of the bride and groom walking down the aisle and out of the church is one you can't afford to miss!

Tip

Make sure you have sufficient batteries and tape stock to see you through the day. If you are likely to need AC power during either the ceremony or the reception, locate a power point before the event starts—and before you need it!

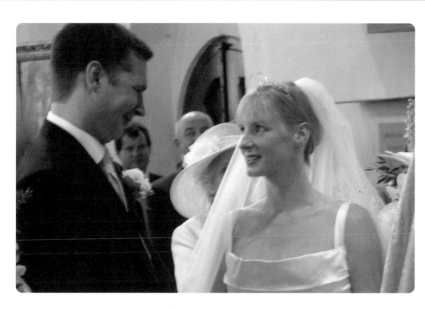

◁ You're there with a camcorder to record the wedding ceremony, so concentrate on getting the most memorable sequences of the happy couple that you possibly can. Don't forget that sound is also vitally important—good pictures are of little use if the sound is inaudible. A microphone clipped to the groom's jacket is a simple and effective option.

△ As the celebrations continue into the night, make sure you capture footage of the couple enjoying their first dance. Intimate close-up shots will work well in slow-motion montage sequences at the close of the edited wedding video production.

larger community centers. Windows cause the biggest headaches, so you'll need to consider your shooting position carefully in order to make the incoming light work in your favor rather than against you. More light is better, provided it's illuminating the subject properly, so if you have the chance to check out the venue before the event, then it's a good idea to do so.

Thinking about sound

Most weddings are followed by a reception party at which speeches are given, and it's here where many new, and even experienced, videomakers make the biggest mistakes. What seems like a good position from which to get images might not be as good for sound, so the camcorder's built-in mic might need some assistance. An external microphone on a length of cable is one solution. Alternatively, lots of specialized camera and camcorder stores sell low-cost radio microphone kits for use with modern digital camcorders, and—when used with good headphones—these will help you to overcome the problem of recording distant sound sources.

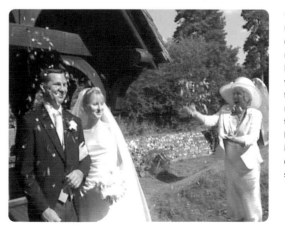

◁ Friends and family members like to throw confetti over the newly married couple as a good-luck wish, but it happens very quickly, so make sure that you're in place and ready to give the confetti-throwers a cue. Once it's happened, it's too late! This is one situation where you can assert yourself for the sake of the final product.

great home movies
Christmas and special holidays

Tip

Keep a sharp eye on what's happening all around you, and shoot for the edit. Don't reel off large amounts of tape on subjects that aren't particularly interesting to observe.

▷ Elaborate and amusing lighting displays will adorn several houses in your neighborhood during religious festivals, so take time to capture some of the better ones on video. If your own home is host to such a display, why not take some shots to feature in your video of the occasion?

Special holidays, such as the various religious and cultural celebrations that take place annually, provide the incentive for families and friends to come together. Christmas, Chinese New Year, Hanukkah, and Eid-al-Fitr are just four such events that lend themselves to home-video coverage. Filming parties, celebrations, and family reunions of all kinds is an obvious use for the camcorder in that it provides an entertaining record of the people present. It also provides an ideal record of the occasion that will prompt many happy memories in years to come.

△ When you get a chance, try to grab individual shots that help to paint a picture of the occasion. You wouldn't necessarily think of shooting images such as this, but such visual motifs can be very useful as scene-setters.

In the same way that you would approach a wedding or other special event by considering the individual elements that contribute to it, it's important to consider the manner in which a party or other special celebration comes together. There's no end of things that you can shoot in order not only to show the degree of planning and preparation that contributes to its success, but also to provide an interesting narrative for the final video.

Any event that involves even a moderate number of people requires some planning—even if it's the preparation of food or party items. It might be that there's the special outdoor provision for guests in the yard or the decoration of a large room. Maybe a hall or hotel ballroom is being hired for the special occasion. All this activity—especially the last-minute panic—lends itself perfectly to the attention of the camcorder's lens.

Don't get in people's way, but equally, don't be shy about getting shots that show the scale of activity—even if it's Aunt Dorothy burning the pie and setting off the smoke alarms. If marquees are being erected in the yard, get some documentary-style shots that show them being put up. If you can, set up a camcorder (preferably a spare, if you have one—or perhaps one that you can borrow) at a high viewpoint and shoot several hours of activity from one locked-off position (i.e. the camera is set to wide, and left to record on its own). When played back at high speed, you'll have a condensed impression of everyone going about their work just like worker-ants. Your viewers will absolutely love this! You can do this wherever a camcorder and tripod can be set up at a high viewpoint where it won't be disturbed.

The importance of mingling

It's always good to mingle at parties—and more so if you have a camcorder. With a good wide-angle lens adapter, it's easy to rub shoulders with those present in order to capture a flavor of what people are talking about and the fun they're having (or not!).

It's interesting that although people might be self-conscious about a camcorder that's focused on them from a reasonable distance, they're more likely to engage with the camera if it's pushed right into the group for the sheer fun of it. Don't be afraid to get right into the action—but, by the same token, don't alienate the genuinely shy people.

▽ Don't miss out on the action when the special celebration party gets going with a bang, and make sure you're there with the camcorder to grab the best shots of people having a good time.

▽ Parties don't just take place indoors, of course. Caribbean street parties are full of color and vitality and make wonderful subjects for video projects. Make sure you get in there to record the music, the dancing, and the general mood. Get a diverse range of shots that can later be cut along to a reggae or steel band music track, too!

Vary the pace

All parties and celebrations will have high points and low points in terms of the pace of the event. As people arrive and are being greeted, you might choose to shoot very dynamically in anticipation of cutting together a sequence to an appropriate piece of music later. In this situation, go for the quirky, unusual, and visually interesting shots—possibly with lots of movement. This is particularly applicable to dancing and large group interaction.

Alternatively, as things slow down in the evening, you might wish to shoot in a more sedate and considered manner as people chat quietly amongst themselves. If you're planning to edit it later, then such material might suit a sequence of slow dissolves over suitably slow and relaxed music.

▽ It's when the atmosphere starts to lighten up over a bottle of wine that you can get some good—and often amusing—video. especially if there's something to celebrate like a religious festival or holiday event. Use the camcorder to capture the essence of the moment without being intrusive.

▷ The pumpkin provides us with the symbolic image of Halloween in every country where it's celebrated. Use it under titles, or as an appropriate image to set a scene. It's worth grabbing some footage of the kids carving them and inserting the candles, too.

▽ A lot of activity accompanies people's celebration of Halloween— so don't be afraid to shoot as much of this as you can in order to paint a faithful and atmospheric picture.

All children love Halloween parties, and you'd be forgiven for thinking that Halloween was designed for home video! The occasion of "All Hallows Eve" is a good excuse for kids and adults to dress up in their most ghoulish and scary apparel. It's also an opportunity to frighten the wits out of friends and relatives with homemade bats, spiders' webs, and skeletal figures that only come out at night. Again, there's a lot that you can do during preparations as well as on the night—kids and adults will be making costumes, witches' broomsticks, potions, and spiders' webs. The traditional carving of the pumpkin is a key activity that shouldn't be missed, either. Don't forget that everything should be as slimy, and gruesome as possible—and all props should be wet, grimy, and gooey if they are to have the desired effect.

Make-up and scary costumes keep kids happily entertained, and by assuming the roles of witch, cat, vampire, zombie, lizard, one-eyed alien creature, or Frankenstein's monster, they'll be assured of lots of fun. You'll be assured of some good video footage, provided that you shoot with care.

Don't be afraid to go over the top with make-up; the more you exaggerate the caricature, the better it will look on video, especially if you're

shooting under variable lighting conditions at night. If you do intend to edit your footage later, then make the most of the opportunity to build some amusingly scary opening sequences—long, mysterious shadows on the ground, a skeletal hand appearing around the door, a cat's eyes piercing the darkness, and so on. Get the kids involved in organizing this and set up each little scenario for the best effect—and make sure you shoot some extra big close-ups of the character's most scary features.

Silhouettes and shadows
Use light inventively—if you have someone dressed as a character who's come back from the grave and is swathed in ragged and rotten clothes, make sure that there's a strong light nearby against which they can stand. Silhouettes and harsh shadows worked well in Michael Jackson's infamous "Thriller" video, so there's no reason why it can't work for you.

Preparation
Why not shoot the make-up preparations, too? It depends on what you wish to include in your video, but there's no doubt that you'll have an eager audience for anything that shows just how much effort the kids and adults have put into making it all work. If you know someone who is really inventive with make-up, then get them involved, and remember that care should be taken when applying make-up on children, as some of them might be allergic to certain compounds. Having established whether or not it's okay, there's no limit when it comes to creating cats, vampires, witches, or Frankenstein's monsters.

◁ No Halloween sequence would be complete without a spooky shot of the moon seen through tree branches. Shots like this are worth grabbing at any time of the year as they can be inserted into your Halloween video for a great effect!

Ordinary make-up will do (as long as there's lots of it), but stage make-up will be even better. If you have a friend or relative who has experience of theatrical make-up, then you're on your way, but even if you don't there's a lot of fun to be had in experimentation. The Grim Reaper, for instance, can be easily recreated with the help of a large black cape and a cardboard ax. A witch's nose can be made from either a cardboard cone or modeling clay held in place by string, as can fangs. Blood is easy to reproduce (mix up copious amounts of red powder paint), and a large roll of surgical bandage (or even lengths of torn-up linen sheets cut into strips) will be enough to create some very convincing back-from-the-dead mummies!

▷ If there's a Halloween party near you to which you and your family members or friends are invited, take shots of any signage that helps you to tell a story later. In this case, somebody has written a notice on a blackboard.

△ A few scary close-ups will add dramatic atmosphere. Shots like this can be very effective when combined with your title sequence.

◁ No Halloween party would be complete without several shots of kids wearing their very own Halloween masks, so don't forget to take some footage of not only the kids wearing them, but the masks being made as well.

Tip

Good lighting is the key to scary movies, whether indoors or out. If you don't have powerful portable lamps, then a strong flashlight held under people's chins might be enough for some great shots.

▷ At the risk of stating the obvious, it's a very good idea to make a simple list of everything you're likely to need before you set off on vacation. Do you have batteries, AC charger, and sufficient tapes? Don't just assume it—check it.

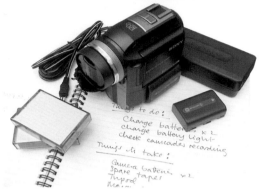

The major camcorder makers all launch their new products in time for those of us who are planning our summer vacations and want to buy the latest model. If the family's camcorder is to be used at all, it's sure to be during the summer vacation. After all, it's the time of year when we escape from our daily routines and visit all manner of exciting and interesting places, either at locations we've visited before or ones that are completely new to us. Whether you're traveling to an exotic, faraway location or somewhere closer to home, you'll want to try to capture the essence of your experience on video—and that's what the majority of camcorder owners will set out to do.

Plan your travelog

The big problem with peoples' vacation videos is that they're more often than not a random collection of badly composed shots and sequences that don't adequately reflect the true spirit of the places visited or what it meant to be there. However, it doesn't need to be like that. As with the other scenarios in this book, a little bit of forethought and preparation is sufficient to transform ordinary, directionless, and somewhat boring videos into something that resembles a captivating home video travelog that will delight family and friends! The best thing about turning holiday video into a travelog is that no special equipment is needed—all you need to do is to stop

and think about what it is that you're attempting to depict before you press the Record button.

The best vacation movies are those that tell the whole story—from initial preparations to the flight or car trip, shots of accommodation, the location or resort, and a range of shots depicting what you and your fellow travelers did when you were there. Your vacation has a natural timeline, so it's reasonable that you should aim to shoot your footage as a sort of video diary of events. That means shooting it as a documentary of the whole experience from beginning to end, taking sufficient footage at key points so that your viewers will be able to get a sense of time and place without you having to tell them as they're watching. Try to gather shots that instantly describe what's happening—a shot of the airport, or of aircraft taking off and landing is enough to tell us that you were at the airport. Not only that, but viewers will automatically assume that this is where your trip

△ To start the sequence, we have a shot of the aircraft wing taken from the passenger's point of view. The distant clouds are sufficient to convey a sense of movement.

△ Cut to a long shot of an aircraft approaching the airport. The plane descends and exits the frame bottom left.

△ Having landed, the aircraft makes its way over to the passenger terminal.

Tip

A steady establishing shot of a beautiful landscape will work well under your titles, so think ahead when setting them up. Don't rely on shots that are unsteady or full of zooms.

began. Similarly, shots on board the aircraft, at the hotel or resort, or a shot of a road-sign welcoming you to a town or city will all do your work for you. You have to go out of your way to shoot them, however—they don't appear on the video by accident. The important thing to remember is that, where possible, the camcorder should save you or another member of your family the job of having to provide a live, running commentary of what your family and friends are seeing on the screen. Again, think about what you're shooting and why. Do you need to get a shot of it? Does it add anything to the effect of the video? Will it help you to tell the story of your vacation?

The typical vacation offers so many good visual and aural possibilities that it's impossible to catalog them here, and it's really down to you to assess them as you see them. Remember the basic rule of looking for an interesting subject—kids playing ball on a beach, family members on a amusement park ride, meeting animals in a wildlife park, or taking part in water-sports—and then shoot a range of shots that tell your viewers where they are and what they're doing, in addition to a sequence of carefully composed shots that give a real feeling for the atmosphere. Most important of all—avoid the kind of unnecessary camera movement and zooming that you see in many videos of this kind.

Think of your camcorder as being a still camera that you're using to take individual shots. Focus each one on something interesting, create a pleasing composition, then start recording. After a few seconds of interesting action within the shot, stop and look for the next one. Try and select distinctly different shots that can each stand on their own, yet are related to the common theme. In this case, the theme is your family's visit to the beach. Make it as visually interesting as possible.

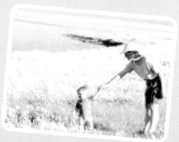

Don't forget to take your camcorder with you when visiting the ski slopes. Shots of people skiing aren't the only things you can shoot on the perfect winter vacation—many ski resorts are set in stunning scenery, and there's a lot going on besides skiing. Unsurprisingly, many of the elements of the successful summer vacation video are appropriate to the winter equivalent, too; you're telling a story, so bear that in mind whenever you consider pointing the camera and hitting the Record button.

The stunning landscapes will often be too good to miss, so take some time to grab establishing shots showing mountains, buildings, ski-lifts, and people. Since ski-resorts are located in mountainous locations such as Colorado, Banff in Canada, and the Alps in central Europe, there's plenty of potential for those shots that capture the true magnificence of the location. Those that give a real sense of perspective will often pay dividends—snow-capped mountains towering above the towns and villages below are just asking to be filmed—but in doing so, try to incorporate some foreground detail in order to convey the scale and depth of the landscape beyond.

△▷ Shooting video on ski slopes isn't easy, but it's worth trying to grab a range of shots that capture the experiences of your family and friends as they cope with ski-lifts (particularly the T-bar type), learning to stay upright when the skis are in motion, and coming to a stop in a controlled manner. Then again, there's some good footage to be had from people who can't manage any of these things.

△ Once you've taken the ski-lift up to the top of the slopes, there's often a breathtaking view to be had. There will be other people up there, too, of course, and if they're able to display great prowess, you might consider grabbing some footage of them in action as well. Many people have now turned from skis to snowboards, and if you are in the right place, these can provide some great action shots.

Vacations that involve snow will, of course, result in embarrassment for those whose skills on and off skis and snowboards aren't quite up to scratch. While it's quite inconvenient to shoot good video when intending to get in some skiing on the slopes yourself, there's a lot of good visual opportunity for you if you're intending only to be a bystander. If you're looking for some great long shots of people gliding effortlessly down the slope, you'll need to research the best viewpoints carefully. Chances are you'll need a good, sturdy tripod or at least a monopod; zooming in and following fast action is difficult enough even for professional cameramen, so you'll need to get some practice in. You won't be able to get these motion shots handheld, that's for sure.

Back closer to the ground, big close-ups perfectly convey the fun that people are having—especially when they're making mistakes or doing embarrassing things. So don't be afraid to get right in there with the action in order to capture the real flavor of the activity. Kids dressed in their protective headwear, gloves, and goggles always look like they're ready for action, and it's a good idea to shoot footage of their preparations before the real action starts. If a snowball fight hasn't yet started, maybe you should get one going!

Tip

Filming in snow always invites the shot of somebody throwing a snowball at the camera lens. Just be careful: put a piece of Perspex, glass, or even very taut kitchen wrap in front of the lens first.

△ There are people for whom the snow-covered mountain presents other kinds of challenge, such as the person who prefers to make the descent by bicycle rather than the more traditional skis. For others, a parachute is a perfectly reasonable way of getting down! Whatever their success, their endeavors provide some captivating sequences.

◁ Don't forget all the other activities that contribute to the experience—get them on film. Give your viewers a glimpse of the town or mountain village in which your hotel or guest house is located—and include the après-ski activities! If you've had a look at some of the more unusual tourist attractions—like the underground ice-sculptures here—then get some shots of them too. It all adds to the flavor of your movie.

△ If you have access to the field of play, go for some dramatic shots taken from unusual angles. This low-angle shot of the hurdler requires that you either get close to the action or you place the camcorder on a mini-tripod and use the camcorder's remote control to start and stop it. In instances like these, a wide-angle lens adapter is very useful in giving the shot a wider angle of view.

Tip

Remember that sound is just as important as pictures at sporting events large and small. Make sure that your soundtrack is not affected by people talking or shouting very close to the microphone, and use a directional mic if possible.

Shooting organized sports events is a bit more tricky than shooting informal sporting activities of the kind schools, family members, or friends would stage. For a start, the event is likely to be taking place with or without your presence, so your job is simply to try to capture as much of the activity as possible in order to fairly represent what happened on the field, on the floor, or on the track. With such a wide range of organized sporting activities to choose from, it's impossible here to offer a definitive guide to covering a specific sport, but there are still some fundamental guidelines that are worth considering.

The most important thing to bear in mind when deciding how to cover a sporting event relates not to the event at all but to the audience. Why are you recording the event and to what use will the resulting footage be put? Are you intending to record every second of the event or merely a collection of highlights? Will your audience be happy with a single camera angle or will it require several?

Covering sports with a single camcorder will always be difficult, not least because you can't point the camera in all directions all of the time. If you're following a game of football or baseball, it will be very difficult to keep the main action in focus constantly, so consider other aspects of the event that will help you to edit it smoothly—whether you intend to use digital video-editing software or simply in-camera. Use lulls or scheduled stoppages in the action to grab shots of the crowd. Find interesting people and grab close-ups of them; look for interesting activity on the touchline (such as cheerleaders or fans singing songs that denote their team loyalty). When shooting, always keep one eye on the activity in your peripheral vision while keeping the lens focused on the main action. As soon as there's an opportunity, spin the camcorder around and quickly focus on something that you can later use

as a cutaway—or even as a means of breaking up the footage in-camera. You don't necessarily have to pause the tape, either—just grab a few shots "on the fly" and then refocus on the game or sporting action.

△ Although some sporting events are full of action and drama, it isn't always possible to get a set of shots that convey the level of tension and suspense you hoped for. Pick out individual pieces of action rather than just following cars around the circuit. What is natural for our eyes isn't so easy for a camcorder—and your viewers will find it boring, too.

Using cutaways
Cutaways are very useful in the case of all organized events in which you have no control over what is happening. By cutting away to a related piece of activity—people watching, cheering, looking bored, or whatever—you have the means to cut out lengthy pauses in the main shots and paste over the joins. A cutaway need not last for long, either; once in focus, count to three in your head and then spin back to the central activity. Two or three short cutaways in succession will be sufficient for a meaningful insert sequence. Always give time for the viewer to take in what"s happening, however. In time, you'll develop a feel for what works.

◁ It's very tempting to shoot a game of tennis from a position that looks straight down the net, with one player on each side of the frame. For more dramatic shots, get some juicy player's-eye-view shots—but don't get too close! If you're planning on editing, use these to intercut with the main action shots.

Wide shots

Big stadium events can be quite awesome in their scale, and the best way to show this off is with a decent wide shot that reflects the capacity crowd. Don't be afraid of wide shots—even if you only manage to grab a couple from high up in the auditorium, you won't regret it. Even then it might be a struggle to capture the true scale of the scene, and so it's well worth getting hold of a wide-angle lens adapter. With one of these, the width of the scene will be further emphasized and the players on the field will look even further away. Wide-angle lens adaptors are usually pushed or screwed onto the front of the camcorder's own fixed lens, and will usually increase the field of view by another 50% (referred to as 0.5x lens adapters), although 0.7x adapters aren't unusual. Try to get one that can be quickly fitted or removed as required, in case you want to move quickly from a wide to get closer to the action.

Close-up shots

These are, as you'd expect, the opposite of the wide shot, and are essential not only for contrast in composition but also to give the viewer specific information about who's doing what, how the team's tactics are paying off, and so on. Some sports, like soccer or ice-hockey, lend themselves perfectly to big close-ups where you've been able to follow the very fast action smoothly. On the occasions when the action is simply too quick for you to follow adequately, it's then possible to fall back on either a very wide shot or a crowd cutaway shot as a means to cover up the break in the sequence during editing. It's another reason why having a stock of touchline shots is handy—even if it's a shot of an ice-cream seller.

Telling the story

Having a clear idea of why you're recording the event is useful because it helps you to determine how much, or how little, you need to record on the day. Obviously, if you're recording an event for analytical or for training purposes, you'll need to get as much of the action as possible regardless of any continuity considerations. If, however, you want only to compile a short sequence with a musical accompaniment, you can afford to be much more selective about what you capture on tape. Grab the highlights and don't worry about the rest.

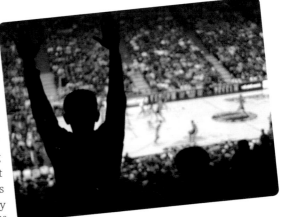

△ Recording from a position in the crowd won't be easy, so don't expect to get more than a few sample shots.

Rights issues

While it is permissible to take a camcorder or stills camera into many events for which you pay an entrance fee, it's possible that you won't be allowed to shoot video without the promoter's or facility owner's permission. Even with the required permission to record, you may find that the organizer will require "lien" over your material: that is, they will require either a veto over whether it can be used commercially—or at all. It's advisable to check this well before the event, or you might find your equipment being confiscated as soon as you arrive at the entrance gate.

great home movies
A video tour of your house and yard

As you get to know your camcorder, you'll start to look for more constructive and interesting things to do with it once the fascination of people pulling silly faces into the lens subsides. A good exercise for users of all ages is to make short documentaries on very simple themes, such as "Our House" or "My Family at Home." As a means of learning about continuity and composition, why not make a quick documentary video of your home and your yard?

It's quite a good little project to give kids who are bored during the summer vacation, but not a bad one for grown-ups either, since it helps to understand the need for planning and careful shooting. If your plan is to capture the resulting footage onto a suitably equipped computer for editing (*see Section 4: Step-by-Step Digital Video-Editing Techniques*), then you'll have a perfect excuse to try out your ideas. It's often when you edit your footage that you start to learn how not to shoot it next time!

Let's say you've been asked by a friend or distant family member to take some footage of your new home to show them where you now live. For a start,

they won't want to endure a video that's full of zooms and indeterminate panning around. As people who are used to seeing well-shot TV and film shows, they'll expect a semblance of order in your video, so treat each shot and scene as if it were a self-contained portrait. Look at each room, decide your best viewpoint, and then see how you can best represent that room in a single master shot. If you need to perform a short pan left or right, then rehearse it before recording. Similarly, if a tilt down or up is required, then work out where it should start and end before committing it to tape. Move the viewer from one room to another not by aimlessly wandering as you hold the camcorder, but by setting up these linking shots in a way that explains, in visual terms, where you were, where you are—and where you're going to take the viewer next.

It's surprising what you can achieve, even with an empty house (in fact, it's easier to experiment when there's nobody around to get in your way or show off in front of the camera). Above all, think about every shot and take your time to get it right.

Tip

You might wish to clean up the house before recording—you never know who might get to see the finished video! It's also a good idea to jot down some notes about what it is that you wish to depict in your movie before you start filming.

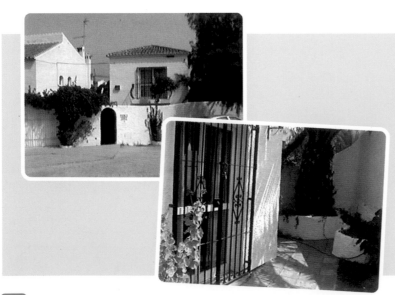

Conveying a sense of place
If necessary, start with an exterior that says, "This is where we are." You could, if you choose, narrate each shot as you record it using the camcorder's own microphone—though you'll quickly discover that it's better to leave this until the editing stage. Having grabbed an initial exterior shot, why not take a couple of additional shots closer to home as a way of reflecting its character.

▷ Cover the house on a room-by-room basis, and shoot as if you were showing a guest around for the first time. You might choose to take shots in the yard or courtyard first of all, after which you can come indoors. Avoid walking as you shoot unless you've practiced this technique and know how to do it. If you are going to attempt it, hold the camcorder sturdily—looking through the eyepiece rather than the LCD screen—and keep it zoomed to its widest setting. Even if you plan to walk between rooms, only do so between a couple of rooms at a time before stopping at a point of interest. By carefully setting up a shot of each point of interest, you have more control of the footage when you edit it, and you also enable viewers to appreciate what you're trying to get across.

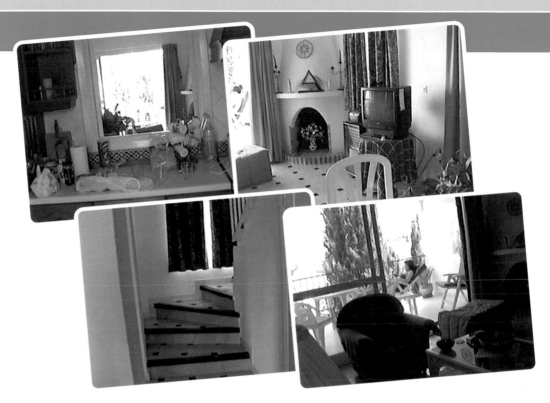

△ Don't forget the garden. If you have colorful plants, get a shot or two of them, and don't forget to grab a shot that sets your home in the context of the neighborhood, too. This is especially useful if you're shooting some video of a new home that you're planning to send to a distant relative as a means to show it off.

△ Get your mom, dad, brother, or sister to actually take you on the tour—but don't try shooting the whole thing in one take. Chop the whole video down into segments and shoot it bit by bit. Bearing in mind that this is probably the first time you've ever tackled a piece of video in this way, think about the narrative of your video tour very carefully. What will the viewers want to see? And what have you forgotten to shoot?

△ Shooting at night will have implications for the camcorder's ability to shoot in low light. Indoors, the images could well be grainy as the CCD and electronics strain to produce usable pictures, so take care. Outdoors, with a good sunset and a clear sky, you might well find that the interior house lights sit well against a backdrop of the clear evening sky.

great home movies
A video portrait of your neighborhood

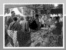

Take your camcorder out into your neighborhood and you'll quickly discover that there's lots to shoot, other than just buildings, parks, and bridges. You'll soon discover that you have an abundance of really interesting people who will be more than happy to tell you about their experiences of living and working close to where you live. Making a short video of your local community is not just a great way to hone your videomaking skills, but it gives you a perfect excuse to get to know people who live and work there, too. Although it might not appear obvious at first, every community has something to offer when it comesto making a short video profile—you just need to do a bit of research.

Start with a walk around the areas closest to where you live and take a range of shots of the streets, the parks, and some of the more interesting buildings. If somebody famous was born or lived where you currently live, try to capture evidence of their life whilst they were there. Busy street markets, unusual stores, old and unspoiled parts of the town, and people sitting on steps watching the world go by are all excellent subject matter for your video. If you're recording during a hot summer, you'll be able to feature people taking advantage of the weather in parks, convertibles, walking by the lake, feeding ducks, and so on. In winter, the same places may be transformed by a covering of snow and ice, and this will also give you some visually appealing subject matter.

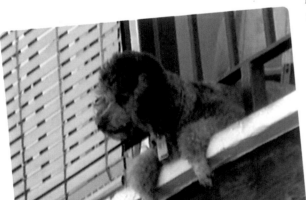

△ Always be on the look-out for unusual and funny sights, such as this poodle dog watching the world go by from an apartment window. The shot will make viewers laugh, and its quirkiness will help you to define a mood for your video which will, in turn, influence perceptions of your neighborhood.

People with stories to tell

Encouraging people to tell their stories to the camcorder produces more than just interesting video—it generates what could develop into a valuable local community resource. The popularity of the humble camcorder has given us all a great tool for sitting our family members down and encouraging them to recount their memories. If they've lived in the same street or district for many years, the chances are that they'll have a boxful of old photographs that you can refer to—and perhaps you could even scan some of them into image-editing software to produce an interesting "then-and-now" montage. At the very least, you'll be able to insert photos into the recorded interview, to which they then contribute in voiceover.

Another interesting technique is to wander around with a person who can act as your guide and record lots of interesting facts and figures in front of the camcorder. Set this up in short bites at each location—and shoot cutaways of the visual references after their own pieces have been recorded. Don't let the camera wander aimlessly during their spoken contributions.

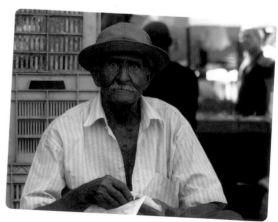

△ Don't be afraid to approach people you don't know and ask them fun questions. Most people will be happy to talk!

◁ Open-air street markets are great places to shoot video, for all sorts of reasons. When they're busy, you have an immense array of colors and textures to work with in the visual sense, and you won't be short of great sounds either. Marketplaces are good for capturing footage of all manner of people, too; don't be afraid to approach interesting people and ask them questions as the tape is rolling. Very rarely will people refuse to talk to you—but if they do, simply move onto another! You'll get some great material.

▽▷ If your neighborhood attracts a lot of tourism, it's worth getting out and about in order to capture the nighttime, as well as daytime, activities. Virtually all the world's major towns and cities have a vibrant nightlife which is there for the taking. If you live in, or near, a busy neighborhood, then you have rich pickings for some wonderful footage. Remember to listen to the sounds as you're shooting, and give them equal consideration. They'll add hugely to the overall quality—and effect—of your footage.

Tip

Ask people if you can use their personal photographs and even home movies as an accompaniment to conversations that you have recorded with them. You'll have a real documentary before you know it!

Step-by-step digital video-editing techniques

Editing is where your camcorder footage can be transformed into creative and enjoyable movies that your family, friends, and colleagues will enjoy. Thanks to modern computers, you can connect your digital camcorder and transfer the recordings from the tape to the computer's hard disk. It doesn't cost much, either; the computer software that enables you to do this comes pre-installed with many new Windows and all Apple Mac computers, so there's really no excuse not to experiment.

Editing is more than the process of merely cutting out the bits you don't want to keep, it's a process of assembling the building blocks of what will become your finished video production. Before we had access to the latest powerful and fast desktop computers complete with video-editing software, the process was achieved by copying sections of one video cassette to another—something that was not only cumbersome, but also led to a degrading of the picture and sound quality. What's worse, it made it very difficult to make any changes—even minor tweaks—afterward without having to start all over again. Digital video editing using desktop computers makes the job not only very quick and easy, but also relatively inexpensive. Buy a new Windows PC and, if you need one, an inexpensive FireWire card (*see page 106*) and you can start editing straight away. Get an Apple Macintosh computer, and you have all the tools you need right there at the touch of a button.

△ Pinnacle Liquid Edition is a professional-standard editing suite designed for the more advanced user. It has a comprehensive range of features that beginners will find hard to master.

The old-fashioned tape-based editing, which relies on segments of recording being compiled one after another on a new tape, is commonly referred to as "linear" editing. Conversely, digital video editing relies

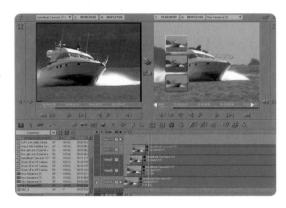

on you copying your sequences onto a computer's hard disk, giving you the capability to move shots and sequences around in the same way as you'd edit a word-processing document. That's why the process is referred to as "non-linear" editing. As you'll quickly discover, video editing using computers is not only something that's quick and easy to grasp, but it's immensely enjoyable and rewarding as well. Moreover, a nicely edited home video that contains titles, music,

Tip

When choosing editing software, go for the least complex package that will enable you to get started. Apple's iMovie and Windows Movie Maker are ideal starter packages that will do everything you need to begin with.

Low end or high end? What's the difference?

All digital video-editing applications, such as those listed here, have many common elements. However, their cost varies hugely in relation to their complexity; the low-cost starter packages like Apple's iMovie and Microsoft's Windows Movie Maker are perfect for relatively simple assembly of your home video movies, and actually offer much more than simple editing. With them, you can add titles, put in a wide range of video effects, import music, add a spoken commentary or pre-installed sound effects. You'll also be able to change the way the sequences appear on screen and even vary a clip's speed. The more expensive mid-range and high-end products offer more features—primarily allowing the editor to pile up many layers of moving video one on top of another, apply complex video and title effects, mix multitrack sound, and much more. It's always best to start with the simplest packages, however, as you may well find that they enable you to do everything you require.

△ Windows Movie Maker is an easy-to-use package aimed at beginners and comes free with all installations of Windows XP Home and Professional Operating Systems. The capture and editing interface is clear and easy to understand and overall the package is a great place for beginners to start.

and a range of sympathetically placed visual transitions will draw gasps of amazement and approval from your family and friends, too.

The process of editing begins once your videotaped footage is copied from the camcorder onto the computer, where it's stored as a series of large files on a hard disk drive. This process is called the capture process (*see pages 106–107*), and all common video-editing programs facilitate this.

You only have to look more closely at a couple of video capture and editing programs to see that most have common features. They have a main capture interface that enables you to preview the tape content prior to importing it. They also have an area— commonly called a *Clip Bin*—where the newly stored files can be accessed as editing progresses, along with an area where the selected clips are lined up one after another as the job of construction commences. This is universally referred to as the *Timeline*. Finally, all applications will give you the facility to watch a selected clip as it plays, something that's essential in making creative decisions about whether to trim it, change its visual properties, or vary its playback speed and so on.

Video capture and editing programs

The range of programs that allow you to capture your video footage from your DV, Digital-8, MICROMV, and even analog camcorder is increasing in number all the time. Although they vary in the way they look on screen, they offer the same basic functions—the big difference is that features get more powerful as you move up the price range. Popular packages include:

Free with Operating System:
Windows Movie Maker (free with Windows XP)
Apple iMovie (free with Apple Mac computer as part of iLife program package)

Low-end:
Pinnacle Studio (Windows)
Roxio VideoWave (Windows)
Magix Video Deluxe (Windows)
Muvee autoProducer (Windows)

Mid-range:
Ulead Video Studio (Windows)
Adobe Premiere Elements (Windows)
Magix Movie Edit Pro (Windows)
Sony Vegas (Windows)
Apple Final Cut Express (Mac)
Canopus Let's EDIT! (Windows)

High-end:
Adobe Premiere Pro (Windows)
Ulead Media Studio Pro (Windows)
Apple Final Cut Pro (Mac)
Pinnacle Liquid Edition (Windows)
AVID Express DV (Mac and Windows)

PRO-TIP

Watch your favorite movies and TV shows with the sound off to get an idea of how the footage is edited together. If you leave the sound on, you'll get drawn into the program, but without sound, you can see the length, rhythm, and choice of shots that make up the edit.

▽ Adobe Premiere Pro is used by professional users as well as serious video-editing enthusiasts. Premiere is well established and has a dedicated following. Total beginners might find it difficult to get to grips with, however.

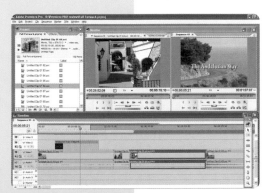

About FireWire

FireWire provides an easy method of connecting devices to your editing computer—not just camcorders, but also a range of other computer peripherals such as external hard disk units. Originally the name was registered by Apple for use on Macintosh computers, but FireWire is now a universally accepted standard for use by digital video and computer users everywhere. FireWire connectors come in two types. The small 4-pin connectors are what you'll find on your camcorder, whereas the larger 6-pin plug will be the type you'll find on your PC or Apple Mac computer. The larger type is capable of supplying power to devices like FireWire pocket disk drives and some CD writers. You'll have received a 4-pin or 6-pin FireWire cable with your Mac.

Several camcorder and computer manufacturers (particularly Sony) refer to FireWire as i.Link or simply DV-in/out for brand and copyright reasons. Technically, it's referred to as the IEEE1394 standard for transferring digital data. Don't worry, they all do the same job. With the camcorder set to Play (or VCR in the case of Sony), and connected via FireWire to the computer, you're set up for capture.

Capturing with USB connections

Most new Windows computers are now equipped with USB (Universal Serial Bus) sockets, which are commonly used in the connection of PC peripheral devices such as scanners, printers, digital cameras, and so on. It's also possible for USB to be employed in the transfer of digital video from a camcorder to the computer using software that is generally supplied with the camcorder itself. There are two variants of USB: USB 1.0 and USB 2.0, the latter of which supports much higher transfer speeds. USB 1.0 is not suitable for the efficient transfer and capture of DV-specification footage. Despite its increased data handling capability, USB 2.0 is unlikely to replace FireWire (i.Link) as the main transfer method for digital video due to FireWire's universal acceptance.

Before getting settled into the editing process on your computer, you'll need to transfer the recorded footage from the tape in the camcorder to the computer's hard disk. This process, called "video capture" involves making a simple connection between the camcorder and the computer that is universally known as FireWire. Check your camcorder's instruction manual for the location of a tiny socket marked either FireWire, DV-out, or i.Link—this needs to be linked to a similar connection on the computer in order for transfer to take place.

Capturing your video

To capture your video footage, connect the digital camcorder to your computer (Windows or Apple Mac) using a FireWire cable, which you'll normally have to buy separately from your camcorder. Having identified that the camcorder is connected, the video capture and editing software will allow you to take over the camcorder's play controls in order to transfer video recordings (either the whole tape or in sections) from the tape in the camcorder to the computer's hard disk using the FireWire connection. When all of your chosen clips have been captured onto hard disk, the video-editing software will let you build your movie in whichever way you choose by selecting clips individually or in groups, dropping them into the *Timeline* and rearranging them at will. You'll also be able to change the way the clips look, modify sound levels, add picture and sound effects, create titles, and more. You're not limited to making one movie, either; save as many versions of your movie as you choose.

Almost all modern video-capture editing programs now incorporate the ability to output the edited video production not only to the digital tape in your camcorder (using the same FireWire connection used to capture the footage at the beginning), but also as files that can be prepared and recorded to a blank DVD disk (a process called "authoring" or "burning"). In addition, it's now common for videomakers to make

What if I don't have FireWire?

Although all Apple Macs, and an increasing number of Windows machines, now come with FireWire sockets, there are still many PCs that don't. If, however, your machine has a spare PCI slot at the back (designed for fitting standard PCI expansion cards) then it's possible to buy a low-cost 2 or 3-port FireWire card that can be inserted into a spare slot. These cards must be "OHCI-compliant" in order to enable consistent, high-speed video transfer and be able to interface properly with other video-related technology within your computer. They are inexpensive, and can either be bought separately or as part of a package containing capture and editing software (for example, Pinnacle's Studio range of products).

special versions of their productions for sharing via email or in websites. This is ideal if you wish to give any distant friends and relatives who have access to the Internet the opportunity to view your latest footage.

Capturing files

With the DV or Digital-8 camcorder switched to Play (or VCR) and connected to the computer via FireWire, the first thing you'll need to do within your chosen editing application is to select the *Capture* mode. If the camcorder is properly connected and is identified as such by the hardware and software, you'll then receive confirmation of this on the

screen. In this example, Microsoft's Movie Maker software is confirming the DV camcorder connection and its readiness to capture footage. Apple's iMovie application confirms that the camera is connected in its capture screen, signifying that it awaits further instruction. Once you click the Play button with your mouse, followed by the Import button, the Mac computer will start to copy your files to the computer's internal hard disk. Although the interface will vary from one program to another, and one type of computer to another, the process is virtually identical.

Captured file formats

When you capture and edit your video footage in a computer, the DV stream that comes in via the FireWire (or i.Link) cable is turned into a form that the operating system can understand and deal with. Windows PCs will convert the incoming stream into what is known as an AVI file format so that editing programs can work with it. Apple Mac computers don't use the AVI format; instead, the Mac OS uses MOV (a Quicktime file format), with all captured files being given a .mov extension.

Tip

Before capturing DV and Digital-8 recordings to your computer, check that there's enough space on the hard disk. You'll need approximately 1GB (gigabyte) of disk storage space for every five minutes of video.

▷ Apple iMovie, Windows Movie Maker, and Pinnacle Studio are ideal capture and editing programs for beginners. They share the same method of creating small thumbnail clips, which represent each of the shots in the camcorder. The thumbnails are stored in a *Clip Bin* in readiness to start the editing process. Although they're given default clip names by the program, you can edit these to suit your own purposes.

digital video editing
The rough edit

With your video footage captured and stored on the hard disk, you'll be able to proceed to the second stage of the process. Your clips will be shown as thumbnails (small images that each represent the initial frame of the clip) which can be dragged and dropped to the main project *Timeline*. In nearly all editing programs, this is positioned across the bottom half of the computer screen, and runs from left to right. In some of the more advanced programs, such as Final Cut Pro and Ulead Media Studio Pro, it's possible to sort your captured clips in their own folders (called "bins" in editing-speak), from which they are then assigned to the *Timeline* as required.

The *Timeline* itself can take several forms. In basic programs such as iMovie (Apple Mac), Microsoft Movie Maker, and Pinnacle Studio (Windows), the *Timeline* will offer more than one display option. The most common representation is for each clip to be identified by a simple thumbnail pictorial icon. However, it's also possible to view the contents of the *Timeline* in other ways, including the option (in Pinnacle Studio) of displaying the assembly of clips as a list of text—known as an EDL (Edit Decision List). It doesn't matter how you view the *Timeline*, as the basic edit functions themselves remain unchanged. In fact, you can switch from one mode to another at your leisure. When starting out, it's best to stick with the visual thumbnails.

Tip

Save your project regularly. There's nothing worse than a computer crash destroying hours—or even crucial minutes—of work.

▽ When clips are depicted by thumbnail images in an editing program *Timeline*, they're just an eye-friendly way of representing a detailed list of shots and other instructions. Many programs will allow you to see this "edit list" mode, however. Pictured below is Pinnacle Studio 9's edit list view mode.

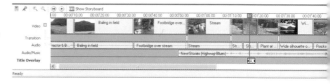

△ A *Timeline* helps you to build the movie, clip by clip, beginning at the left of the screen. Notice the similarity between that of Pinnacle Studio (top) and Movie Maker's (above).

Your first steps at editing

Editing your first digital movie is as simple as dragging a handful of clips from the *Clip Bin* and dropping them onto the *Timeline*—it's as simple as that. In Pinnacle Studio, the clips appear at the top left of the screen, and can be dragged either individually or collectively to the *Timeline* that runs across the bottom of the screen as pictured above. To make clip selection easier, simply click once on a thumbnail icon, then either click the *Play* button or hit the spacebar on the keyboard. You'll now be able to play the clip in the *Preview* window, which, in the case of nearly all editing programs, is located in the top right sector of the editing screen. Although programs differ slightly in their design and appearance, the principle is exactly the same.

In the case of some programs—Studio, iMovie, and Movie Maker included—you'll have a set of player controls directly underneath this window. Notice how the controls resemble those on your home VCR.

Once you're happy to include the clip in your movie, all you need to do is drag it down to the *Timeline* and drop it into place. You can, of course, move it around at will by clicking once and holding

	Name	Trimmed start	Movie duration	Movie start
20	Video clip: 'cawsand [8:00.00]'	0:08:00.00	0:00:26.17	0:05:21.19
	Audio clip: 'cawsand [8:00.00]'		0:00:26.17	0:05:21.19
21	Video clip: 'cawsand [8:27.10]'	0:08:27.10	0:00:10.11	0:05:48.11
	Audio clip: 'cawsand [8:27.10]'	0:08:27.10	0:00:10.11	0:05:48.11
22	Video clip: 'cawsand [8:45.06]'	0:08:45.06	0:00:08.02	0:05:58.22
	Audio clip: 'cawsand [8:45.06]'	0:08:45.06	0:00:08.02	0:05:58.22
	SmartSound© audio: 'Kickin' Back [Bass]'		0:04:20.11	0:05:58.22
	Video transition: 'Dissolve'		0:00:01.01	0:06:05.23
	Audio transition: 'Dissolve'		0:00:01.01	0:06:05.23
23	Video clip: 'cawsand [9:11.22]'	0:09:11.22	0:00:23.12	0:06:05.23
	Audio clip: 'cawsand [9:11.22]'	0:09:11.22	0:00:23.12	0:06:05.23
	Chapter 3 in Menu 1			0:06:06.24
	Video transition: 'Dissolve'		0:00:01.03	0:06:28.07
	Audio transition: 'Dissolve'		0:00:01.03	0:06:28.07
24	Video clip: 'cawsand [10:14.24]'	0:10:14.24	0:00:05.12	0:06:28.07
	Audio clip: 'cawsand [10:14.24]'	0:10:14.24	0:00:05.12	0:06:28.07

Cawsand Test1

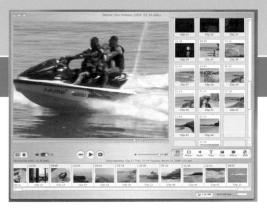

△ Notice the close similarities between Apple's iMovie software and others pictured on this page. The three main graphical features—*Clip Bin*, *Preview Window*, and *Timeline*—are easy to recognize.

◁△ All video-editing programs feature a *Preview* window that displays the active clip, as seen in iMovie (left) and Pinnacle Studio (above).

the mouse down as you move it from one part of the *Timeline* to another. If you're used to word-processing, you'll notice that many key combinations and shortcuts are as applicable to editing as they are to creating a document in Word or Excel. Shift-click more than one icon and you can move a group of clips together.

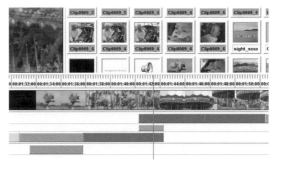

◁ Let's EDIT! from Canopus is a slightly more advanced editing application that uses a more sophisticated method of building up the clips on the *Timeline*. However, the same three basic screen elements are still there.

Deleting clips from the Timeline

In some programs, the action of deleting a clip on the *Timeline* will not affect the clip itself as it has already been captured and stored in the *Clip Bin*—you've simply removed it from the *Timeline*. This is the case with all Pinnacle programs, as well as those from Adobe and Ulead. More advanced Apple applications, such as Final Cut Express, let you delete clips from the *Timeline*, without losing access to them, but Apple's iMovie requires more care—deleting a clip from the *Timeline* means that it ceases to be readily available without involving you in a bit of work. If, therefore, you wish to remove it from the *Timeline* but not from your collection of available clips in order to use it later, simply drag the clip icon back to the *Clip Bin*. It's here, also, where you change each clip's name from the default "Clip 1" etc, to something more meaningful like "Dad Falls Over."

Automatic Scene Detection

As your video footage is entering the computer, most programs will automatically generate a new thumbnail, or picture icon, every time a new clip is detected. This process—known as Automatic Scene Detection (ASD)—makes it very easy for you to identify your clips, both in the *Clip Bin* and on the *Timeline*, and is achieved by the software comparing the changes in the date and time references that are embedded into the clip during recording. Sometimes, however, the software is unable to interpret this data properly, in which case you'll probably have the option to ask the software to create a new icon every time the picture is subject to a radical change. Usually, you can even create a new clip (and thumbnail) by simply hitting the spacebar as the footage is transferring.

Collection: My First Video
Drag a clip and drop it on the storyboard below.

22/02/2003 15:36 22/02/2003 15:36

Duration: 00:00:58
Filename: My First Video.avi
22/02/2... 03 15:39

22/02/2003 15:39 22/02/2003 15:40

Trimming clips

Having placed your selection of clips onto the *Timeline* and arranged them into roughly the right order, it's possible that some of them are too long. It might be that there's some camera shake at the beginning or end of a recording, or maybe it's simply that some of the clips last too long. Whatever the reason, it's very easy to trim their length using a variety of tools that are commonly found on all main video-editing programs.

In Apple's iMovie program, there are two methods of adjusting the length of a clip. The first can be undertaken while the clip is being viewed in the preview window. You'll note that on the left-hand side of the play bar, there are two little arrows. If you drag the right arrow along the playline, you'll see that it exposes a yellow bar. Do the same with the left arrow and the bar decreases from left to right. If you were to choose the *Crop* tool in the *Toolbar* along the top of the screen, the clip would be shortened to the length denoted by the yellow bar—in other words, the parts of the clip on either side of this would be chopped off. By clicking on the little "clock" icon (top left above the

Tip

Today's viewers are well acquainted with viewing tightly cut video and film sequences, so "if in doubt, cut it out." That's one of the golden rules of film and video editing.

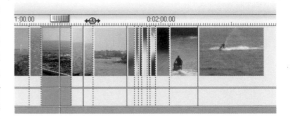

△ Very often, the default display of the *Timeline* will only let you view thumbnail icons in a rather cramped and compressed fashion. This is easily rectified in all programs. In Studio, it's simply a case of holding down the mouse button on the *Timeline* bar and dragging right to expand, or left to contract. Other programs have very similar methods designed to achieve the same effect.

Timeline), you'll see a different display for the *Timeline*. No picture thumbnails are displayed for each clip, but you'll instead be able to modify the length of a clip by clicking on either the left or the right edge of a clip and dragging it inward. This will change the duration of the selected clip in what we call a "non-destructive" manner—meaning that you can easily readjust it later if you change your mind.

The ins and outs of cutting

Every clip has a beginning and an end. We call the beginning of a shot its "in" point, with the "out" point being its end. You'll wish to trim shots for a variety of reasons, the most obvious of which is that it's simply too long. It might be that the camcorder was running for longer than it should, or you started recording long before the required action actually commenced. The trim tools will reduce the length of the clip without affecting the saved file, so you can easily change your mind. Shots can also be trimmed so that a sequence runs more fluidly and with improved continuity. You might wish to cut from a wide shot to a close-up shot, and being able to precisely determine the length of each shot will greatly improve the impact of the

sequence. The trimming tools provided in Movie Maker and Studio are very similar—simply hold the mouse down on the left or right edge of the selected clip and drag it until the length is right. In each case, the clip modification is viewable in the preview as you drag.

This technique is common to virtually all editing programs, from Pinnacle Studio to Adobe Premiere, Ulead Media Studio, Apple Final Cut Express, and even the professional-level Final Cut Pro. Windows Movie Maker (from version 2, at least), allows you to manipulate clips in much the same way.

When building a sequence of shots, it's important to get the timing and pace of the shots right. Shots that are too long will quickly bore your viewers, whereas shots that are too short will leave them confused due to lack of visual and aural information. A good rule of thumb is to construct sequences with a minimum of three shots which, when flowing one after another, possess a comfortable rhythm.

Juxtaposing shots

The real joy of editing comes when you discover how easy it is to construct, and reconstruct, sequences from the footage that you shot yourself. Suddenly, you're free from the constraint of having to watch the raw video on TV and fast-forwarding in order to get to the bits you would rather your family watched. Now, the true art of filmmaking is within your grasp, and once you get the hang of the process, you'll find that your filming techniques will improve as well. Remember that, with most of the editing applications, it's possible to save several versions of your video. Having been saved to the computer's hard disk, the thumbnails or edit decision list are there to serve as signposts to the capture files. You can therefore modify the contents of your *Timeline* in order to have a long version and a short version of your latest vacation movie just like you'd save different versions of a word-processing document or spreadsheet. In each case, programs will allow you to shuffle clips around the *Timeline* by simply dragging them and dropping. It couldn't be easier. And, if you decide that they shouldn't be there at all—simply cut them!

◁ Sometimes you need to check on the clip's properties—its timecode start and end points, the duration of the clip, and so on. Usually this will be accessible either in the *Toolbar* or—in the case of Movie Maker—by right-clicking on a clip and selecting the *Properties*. A dialog window will open, displaying everything you need to know about the clip.

△▷ Trimming a clip to make it appear longer or shorter on the *Timeline* is usually a case of clicking on the clip's left or right border and dragging it to the desired duration. In the example shown, a clip is being trimmed in Pinnacle Studio, but the technique is much the same in all mainstream editing applications.

Counting elephants

Earlier in the book we discussed the importance of pacing your shots as you record them. After running the camcorder, it's important to give the viewer time to settle into the shot before making a camera move. Not only is it important to give a reasonable hold on the shot (allow three seconds of static before stopping the recording), it's also important to carry this technique over to the construction of the sequence when editing them together. Use the "one elephant," "two elephants," "three elephants" verbal counting measure to pace the shots consistently on the *Timeline*.

digital video editing

Insert edits

Tip

If someone is doing something interesting in a shot, use an insert to provide more detail and to explain what's happening in the main shot.

Having placed a sequence of shots onto the *Timeline*, you may wish to insert a shot into an existing clip as a way of drawing the viewer's attention away from the main action to an associated point of focus. It's an age-old editing technique that involves cutting away from a main shot to something else—for instance, cutting to the central character's point-of-view (POV). On pages 50–51—*Shooting Cutaways*—we discussed the idea of grabbing not only shots of people looking at scenery or other points of interest, but also a shot of the scene through their eyes. Inserting this cutaway shot into the main "master" shot is a fundamental editing technique, and one worth experimenting with.

Many videomakers, especially those just starting out, think in very linear terms when shooting and editing their home movies, but getting to know how to use an insert shot can have a huge impact on your edited video. It might sound very simple, but it's quite surprising how few people grasp the concept and therefore don't consider its usefulness despite seeing its effects on TV and in films all of the time.

A sense of timing

Timing shots is always a challenge for the novice editor and, to begin with, it's often difficult to get a feel for how long cutaway shots should last. However, the more experience you gain of the

Inserting a clip into the Timeline

As we've previously established, all digital video editing software works in a "non-linear" way, which essentially means that you can insert shots and even whole sequences into the *Timeline* and then move them around as you change your mind. Let's look at

how an insertion is undertaken in iMovie (though the same approach works for other applications).

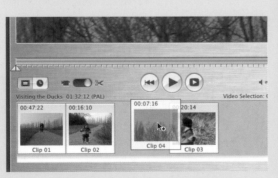

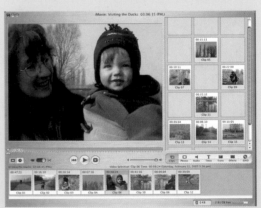

To select a clip and insert it into an existing sequence, click on the appropriate thumbnail in the *Clips* page and drag it to the *Timeline*.

Once it's there, simply drop the clip into place and play the sequence. It's worth playing a few more seconds than just the clip itself, as you'll really want to see how the insertion of this shot affects the sequence. If it's a short sequence, go to the beginning and watch the whole thing.

If it doesn't look right in this position, then simply pick it up and either move it to where you think it will work—or (in the case of iMovie), place it back into the *Clips* panel where it can be used if you want it later.

editing process, the better you'll acquire a feel for such matters. As mentioned in the previous pages, your understanding of shot duration—especially cutaway inserts—will come naturally with practice. In some sequences, a single cutaway shot can be of sufficient length that it can remain the sole insert shot. However, it's a good idea to try to construct a sequence of short shots that possesses a pleasing cutting rhythm, and three shots is a common number in this respect. If you were to apply this principle to a single cutaway sequence, it would be worth shooting either a variety of shots (WS, MCU, CU), or shots of other activities similar to that of the main cutaway.

Is an insert a cutaway?

Here's a nice sequence of shots taken at a secluded coastal location. The local people come down to the beach on warm summer evenings to soak up the sun and the atmosphere, and here we've attempted to capture this in a sequence of shots to be accompanied by a suitable piece of music. As a way of breaking up the sequence of water shots (silhouetted headland, people on the shoreline, people in the water, and so on), we have inserted a shot of an onlooker who—like the camera—is there simply to observe the scene. The insertion of this shot not only breaks the sequence up visually—but it also gives it a sense of meaning. Is it a cutaway shot, however? Not really, but if the onlooker was the main focus of activity and we chose to cut to a shot of something she was looking at, then that inserted shot would indeed be a cutaway.

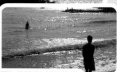

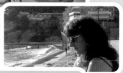

Avoiding jump cuts

Here, we have a sequence of shots taken during a flight. With the camcorder focused on the terrain 37,000 feet below us, we get a real sense not only of height, but also of movement as the aircraft flies at more than 500 miles per hour over the mountains and lakes. However, the sequence is marred by an effect called a jump-cut. The editor has put two shots (or segments of the same shot) together on the *Timeline*, so that the person or scene appears to jump slightly, because the shots are not sufficiently different. The solution to this problem is to find another shot that can be inserted into the sequence to break up the shots and add some cutaway interest.

The sequence below looks much better because it makes more sense. We start with a shot of the terrain slowly (but noticeably) moving beneath us. We then cut to a shot toward the rear of the aircraft

showing the wing, part of the engine, and window surround—and to aid continuity we can still sense the movement of the plane. Then we cut to the shot of the passenger listening to music. Finally, we cut back to another shot of the ground—this time, a view of half-empty mountain reservoirs. Not only have the shots been shuffled in order to make a more pleasing sequence, but the insertion of the passenger shot improves the relevance of the sequence by reminding the viewer of where we are and what we're doing.

digital video editing
Transitions

A transition is the traditional filmmaker's method of taking the viewer from one place to another. The simplest, and possibly still the most effective, transition is a "fade to black" and a corresponding "fade from black." Another long-established transition is the "circle" or "iris wipe" in which the visible area of the frame is reduced down into a diminishing circle to the point where it disappears altogether.

Such rudimentary transitions are easy to achieve in computer-based editing programs, of course, along with a huge range of much more complex transitions whose main purpose is to move the viewer from one point in time to another. For example, a "fade out" at the end of one sequence followed by a "fade in" at the beginning of the next tells us that time has elapsed between the two. It doesn't really matter how much—it could be minutes or it could be years, but so accustomed are audiences to seeing such a visual device employed in films and TV shows that we instinctively understand what's happening when we see them. Fade out of a shot of a plane taking off at an airport and then fade up to a shot of vacationers sipping cocktails beside a swimming pool in a sun-drenched location and you instantly assume that the aircraft was the same one that got them there. It might be true but, equally, it might not—and that demonstrates the power of movie editing.

All digital video-editing software includes a comprehensive set of transitions, a few of which are displayed on the opposite page in Pinnacle Studio 9's main Transitions Menu. Athough any of these can be applied to your clips at the click of a mouse, it's debatable whether many of the more elaborate transitions will have a place in most people's home-video productions. If there's one thing you can over-use very quickly, it's transitions, so make sure they're put to good purpose only.

A transition that's regularly used in TV and film is the dissolve, which is also known as a "mix," a "cross-fade," and a "cross-dissolve." It's the result of overlapping a fade out and a fade in so that a balance is achieved. The outgoing shot dissolves, or mixes, into the incoming shot. A very slow dissolve may indicate that a considerable time shift has occurred between the two shots. Dissolves can also be employed in gentle music sequences or a video equivalent of a slide show. It's common to use dissolves in a sequence designed to provide a relaxed musical interlude in a video production—beautiful landscape shots accompanied by mood-enhancing pastoral music, for example.

Tip

Use video transitions sparingly, as they can have a detrimental effect upon your video. If over-used, they'll give your video an amateurish look.

PRO-TIP

Apply a dissolve to the end of your last clip, and it will fade out gradually to black. Complete fade outs can be used between each major scene, but they do feel quite final, so you might want to save the fade out for the very end of your home video.

Real-time processing

Some applications, like Sony Vegas, generate the transition and effect instantly without the need for rendering. Other programs, like Adobe Premiere Pro, Ulead Media Studio Pro, Pinnacle Edition, and Canopus Edius, achieve this instant playback of transitions and effects by the use of an extra piece of hardware which is usually supplied as a PCI slot-in card. Real-Time (RT) engines—such as those from Canopus, Matrox, and Pinnacle—do the hard work of complex video processing and enable a very fast pace of working. Most modern fast computers—whether PC or Apple Mac—are capable of most common editing jobs quite satisfactorily without hardware accelerators, however.

Common types of transitions

There are several types of visual transitions. Aside from the basic fades and dissolves, there are wipes (linear, rectangular, elliptical, or circular based shapes that describe an on-screen transition that can be either simple or fairly complex) and an ever-increasing number of two- and three-dimensional transition effects that, for example, put images onto many faces of a cube, tumble them around the screen, and even make an image disappear down a virtual drain-hole. There's certain to be a much greater choice of transitions than you'll ever have justification to use!

Previewing and applying a transition

All common video-editing programs enable you to preview a selected transition before applying it to two or more clips on the *Timeline*. Additionally, most programs let you see what a transition will look like simply by clicking on its icon and viewing an instant representation.

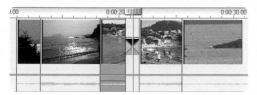

When you've made your selection, simply drag the transition icon to the relevant place between two clips on the *Timeline* or storyboard. In Studio, the icon you selected in the *Transitions* album will appear in a band between the two clips to which the transition has been applied.

As soon as you apply the transition to the *Timeline*, the preview (the temporary rendered file) will be available in the program's main *Preview* window. Click the *Play* button to inspect it or grab the slider bar immediately under the picture to inspect the new transition more closely.

If the transition is either too long or short, it's easy to change it by clicking and dragging the limits of the icon between the two clips. As you click and hold down the mouse, you'll see a

double-arrow icon. This indicates that you can now increase or decrease the duration of the transition. When released, the result of your action will remain permanent. Ensure that the clips on either side of your transition are long enough to support the transition's duration, of course!

Once there, the transition will be applied, though in some programs, you might have to wait for a short while for the computer to render the transition. Rendering is a process of creating a new clip that contains the transition or effect—and the time taken to do this is determined by the speed of the computer's processor.

Although we've looked at how transitions are applied in Studio, you can see from these two detail shots that things aren't that different in either Movie Maker (below) or iMovie (bottom). Notice that, in iMovie, you get a little red line underneath the transition icon as it renders while you continue editing.

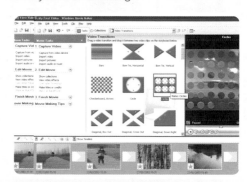

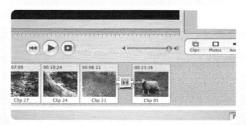

Good-quality sound can make or break a film or video production, yet it is often given a very low priority by the majority of home moviemakers in their quest to shoot better-quality images. This is a shame, since an audience is more likely to tolerate a movie where the pictures are less than perfect provided the sound is well-produced and clearly audible. On the other hand, a pin-sharp movie where the audio is muffled and badly mixed will quickly lose an audience. So the importance of audio in your home video cannot be understated. Listen to the majority of home videos and you'll appreciate that most have appalling sound, despite a camcorder's ability to deliver good stereo audio in most surroundings.

Earlier in this book, we discussed how better camera-handling techniques and the use of suitable external microphone accessories will enhance the quality of your recorded sound quite considerably. When you come to the edit, you'll immediately benefit from having been careful with your audio during shooting, and all that preparation will seem worthwhile. Although it's almost impossible to make good sound from bad, it's certainly within your grasp to hide badly recorded audio behind music, sound effects, or commentary. In the worst cases, of course,

you can simply separate the sound from the vision and delete it altogether. Good recording practice helps to avoid having to make such choices.

Most of the time, you'll maintain the simple relationship between sound and vision when editing—especially if all you're doing is reorganizing clips, trimming them, and adding titles. However, there will undoubtedly be occasions when you'll wish to separate sound from the pictures, such as when you wish to modify the intensity of the sound as it was recorded on the camcorder or when you would like to

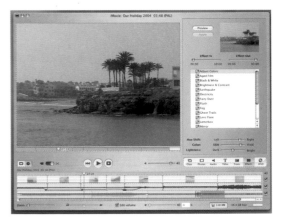

△ Apple's iMovie gives users the opportunity to vary the volume of the camcorder's audio track on a shot-by-shot basis. If you insert a transition—such as a mix, wipe, or other effect between two shots, the audio will also have the transition applied. So, if you insert a cross-dissolve on the video track, the audio track will automatically be converted to a mix.

Working with sync sound

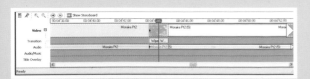

Sync, or synchronous, sound is that which was recorded by the camcorder at precisely the same time as the camera recorded the video pictures. Notice that each of the video clips represented here—Pinnacle Studio 9 (top) and Movie Maker 2 (below)—has an associated audio track alongside it on the *Timeline*, and if you inspect this further (using the menu options available to you in each case), you should see that the sound waveform is graphically represented. This makes it possible for you to pay as much attention to the sound of your video as to the pictures.

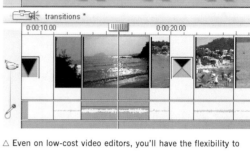

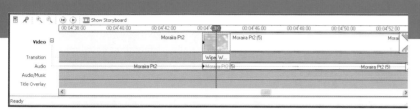

add music or commentary. At its simplest, audio mixing will involve you fading up the audio at the beginning of a shot sequence in order to avoid the crashes and bumps that will otherwise disturb the flow and the enjoyment of the finished article. At a more complex level, audio mixing can mean adding commentary, high-quality stereo music, and several layers of sound effects. These days, you can even mix your audio for playback on your 5.1 Digital Surround Sound system.

△ Microsoft Windows Movie Maker 2 has a similar mode to other programs in that it's easy to inspect the audio properties of the *Timeline* and make adjustments accordingly. You can moderate the sound level of the whole track or apply a fade in and fade out at the beginning and end respectively.

△ Even on low-cost video editors, you'll have the flexibility to balance your soundtracks in several ways. The most convenient method is the virtual sound mixer, which provides an on-screen fader for each of the tracks in question which you can then move up and down with the mouse according to whether you wish to increase or decrease the volume of sound on that track.

Tip

Use the audio rubberbands to gently fade in and out of the clips as they are assembled on the *Timeline*—even if the pictures are simply cut together. It has the effect of making the sequence less clunky.

△ There are times when sound balancing should be kept simple, of course. Movie Maker 2 has a control that couldn't make it easier to achieve a good balance between the sound that came from the camcorder and other added audio and video tracks.

Advanced audio mixing

A more advanced and costly video-editing program, Adobe Premiere Pro, provides editors with greater flexibility when mixing sound. In its audio mixing mode, you can see that the common features of *Audio Timeline*, *Waveform Editor*, and even *Virtual Mixer* are all there. Functionality is the same—it's just the screen that's much busier!

△ Most modern editing packages have an additional means of controlling sound: the so-called "rubberband" control on the *Timeline*—so called because it's possible to manually rewrite the line that represents a soundtrack's level at any one point. By clicking on the red line and pulling it up or down, you can raise or lower the level. It's also possible to put in fades and audio cross-fades this way, too.

117

Adding sound at the editing stage

△ The most convenient way of mixing the various components of your video's soundtrack is by using the virtual sound mixer. This provides an on-screen fader for each of the tracks in question, which you can then move up and down with the mouse according to whether you wish to increase or decrease the volume of sound on that track. This tool is particularly useful as it means you can ensure that music or effects are given the right sound level when playing behind a commentary or other main soundtrack. Pinnacle Studio is one of an increasing number of home-editing programs that now provide the means to mix 5.1 Digital Surround Sound channels, as represented by the 3D real-time control associated with the *Virtual Mixer* panel.

All but the most basic editing programs allow you to do more than just edit and control your synchronous video soundtracks. Even with Windows Movie Maker, Pinnacle Studio, and Apple iMovie, you can go beyond simply modifying what was imported from the camcorder, and add music, sound effects, or a commentary if desired. Surprisingly, it's all quite simple to achieve, too.

You saw on the previous pages that Apple iMovie is one application that will allow you to separate (or "extract") the audio and either delete it or move it elsewhere. You can then import your audio track and lay it along the *Timeline* underneath the visual track, or you can add sound effects, music, and even record your own spoken commentary as you view the edited sequence. A similar capability is provided in all of the mainstream applications, even at budget level. At the more advanced level, it's possible not only to delete the unwanted audio tracks, but also to add many layers of additional audio to the point where you can create an elaborate mix of sync sound, music, sound effects, commentary, and so on. You need to invest in an application like Sony Vegas, Adobe Premiere Pro, Apple Final Cut Pro and Express, Ulead Media Studio Pro, or Pinnacle Liquid Edition for such flexibility, however.

Audio in the balance

Even on low-cost video editors, you get the flexibility to balance your soundtracks in several ways. You'll be able to capture a piece of music from compact disc (known as "CD ripping") or, depending upon your computer's set-up, you might be able to import audio from another audio source such as mini disc (MD), audio cassette, or even good-old vinyl records. In most cases, it's best to actually capture the various sound sources onto the computer first (perhaps using a separate, dedicated sound-recording application), save them as either .WAV (Windows) or .AIFF (Apple Mac), and then import the resulting files into your editing application. This is relatively easy to do in most video-editing applications. Once you've achieved this, you're able to set about mixing your soundtrack—and once again, you'll soon see just how addictive this whole thing can become!

◁ It's common for a whole range of sound effects to come as part of the editing package, and this is certainly the case with those entry-level products we've already mentioned. You can have lots of fun adding thunderstorms, police sirens, birds singing, and doors creaking to your masterpiece. Not only that, but some programs—Pinnacle Studio being just one—feature an "instant music generator" program. Pinnacle's Smart Sound, for example, lets you build your own music using a large selection of digital sound loops.

Apple iMovie (versions 3 and 4) is deceptive in that it gives the appearance of offering the mixing of only three audio tracks, but this isn't so. In addition to the original camcorder stereo sound, seen above in its *Extract Audio* mode, you'll have the option of adding a commentary and also applying layers of sound effects. iMovie isn't alone in allowing several layers of sound effects (or other sounds—it doesn't have to be effects), to be stacked up one on top of the other at will; but it takes time for users to realize that this can be achieved. After all, why shouldn't you want to add some wind noise behind the shots taken at the cliff-edge, and then add not only the squawking of seagulls but also the rumbles of distant thunder behind the camera?

Sound effects can add an exciting new dimension to the most ordinary video, but as with wacky transitions, use them wisely and don't overdo them.

△ One way around the copyright laws (*see box below*) is to record your own music. All Pinnacle programs include a great piece of auto music-making software based upon loops and digital instrument samples, making it quick and easy to create a musical accompaniment that is just the right length and in the right mood or tempo for your movie. Apple Mac users have access to GarageBand, a low cost yet professional-quality program that does all that and more. Soundtrack (which comes free with Final Cut Pro) is a similar loop-based Mac program, but includes a video window, so you can match the music to your footage. Why pay for good music when you can create your own?

△ iMovie isn't alone in offering a wide range of built-in sound effects (commonly referred to as "FX") that can be added to your video. Click once on the chosen effect and then click the Play button to listen to it. If you like it and want to add it to your movie, simply click "Place at Playhead." This will place the sound effect exactly where the playhead control currently rests. You can easily move the effect by simply dragging the clip to its new location on the *Timeline*. If the sound effect you require isn't in the list, you'll probably be able to find it on a sound FX CD, some of which are free, or can be obtained for a modest single charge for unlimited use. Alternatively, record your own, save it in the appropriate file format (WAV, AIFF, etc.), and then install it into the appropriate directory.

Recording your own commentary

The low-cost programs are particularly good at making it easy for you to record a commentary as an accompaniment to your video, its soundtrack, background music, and even sound effects. Both iMovie and Studio have a quick-and-easy interface that will give you control over an external microphone (or, perhaps, a combination headset with its own microphone) so that you can operate an on-screen fader as you speak. If you're monitoring the sound playback through headphones rather than the computer's speakers, then you'll be able to balance the other tracks as well). It isn't even necessary to record the whole movie commentary (sometimes called a "narration track" or, more commonly, a "voice-over") in one pass, either; you can undertake your recording in small sections and rerecord them until they're just right. It's worth preparing a typed script beforehand, however, as it will inevitably sound more professional. Ad-libbing the commentary will sound amateurish unless you're really witty and clever!

About copyright

Remember that all commercial sound and video recordings are subject to copyright restrictions. That means that if another person or organization owns the creative and publishing rights over a piece of music or video footage then you're not allowed to copy it unless permission has been granted. If, therefore, you're planning to import a favorite music track from a CD or download it from the Internet and include it in your edited sound track, you'll need to obtain permission to do so. The exception is where music has been downloaded or copied from an accredited source, such as Apple's iTunes Music Store, where your online payment gives you limited rights to copy and share the purchased music. Just because you own a CD containing music doesn't automatically entitle you to copy it. Remember this: if you don't own it, somebody else does—and if somebody else owns it, should you be using it?

△ The choice of font (the actual style of lettering used in titles), its size, and optimum placement on the screen will vary according to the final means by which the edited movie will be shown. Regular TV screens—those with tubes rather than LCD or plasma screens—have a tendency to crop off the picture. This "over-scanning" of an image results in the outer characters of a large, centered title touching the sides of the picture. It's important, therefore, to prepare your titles and captions within a tried-and-tested safe area before committing them to tape.

The mere act of creating and adding a title to the front of your captured video footage can lead to an interesting transformation. Suddenly, your humble collection of home-video shots takes on the look of a real movie. From the moment your audience sees titles, they'll sit up and watch. Introduce some music along with your titles and they're hooked. This isn't just a home movie—this is a real movie. What's even better is that titles have never been easier to create. All the editing programs you're likely to encounter will have a title package built in, making child's play of the creation of professional-looking titles, captions, and even performers' credits.

Easy though it is to produce titles and end-credits for home videos, it's amazing just how much of a mess even experienced video producers can make of it. The choice of the right typeface, color, and positioning can be crucial, and there are many examples that are reminiscent of early attempts with desktop publishing in the late 80s and early 90s in which a local community flyer or business report would contain only the gaudiest fonts in the most inappropriate weights and sizes. The best rule, therefore, is to keep your titles clean and simple. The most effective titles are often those that consist of white lettering on black or black lettering on white.

Legibility

Although it's important to choose a font that looks good on the TV screen, it's equally important to choose the right font for all sorts of technical reasons. Generally, a serif font—such as Times New Roman—will only work well if the text is featured large on the screen. If it's very small, the fine detail of the lettering will be lost in the TV tube's scanning process. For that reason, it's a good idea to use sans-serif typefaces like Helvetica, Arial, and Arena where possible. That doesn't mean that you shouldn't be a bit more creative with the use of a wider range of fonts, but the principle is that you must consider carefully the typefaces, styles (bold, italic, underlined, etc.), and particularly colors employed. It's a good idea to study mainstream TV shows and movies in order to see how titles and subtitles are presented.

Positioning

While a main title might be placed in dead-center screen, the underlying image might suggest a different placement. With Title Deko, a package that comes with Studio, you can generate separate boxes for each text object, allowing you to arrange the titles on the screen in a manner that complements the image. With the animation tools, it's even possible to fly each word in from a different direction in addition to the more conventional dissolve and wipe tools. Look at the opening sequences of your favorite movies and you'll get lots of good ideas.

Tip

A title's on-screen duration should generally be equivalent to two full read-throughs at a modest pace. You might choose to hold a single-word title for longer, though!

△ Very often, the plain and simple white text on a black background can have a considerable effect on your viewers, although all of today's basic editing programs will enable you to create a title or caption that appears over a video clip, and this can be really effective. It's also very easy for such titles to be faded in and out, revealed as a wipe, or even manipulated three-dimensionally.

▷ If you've taken the time to shoot backgrounds that will work well with your titles, you'll find Title Deko's title template styles quite useful for creating that effective, instant title.

▷ Think carefully about not only the typeface but also its color, typesize, and positioning. Small red text without any drop-shadow or outline won't look good against a busy background.

▷ Sometimes, a more ornate and graphical typeface will help to set the mood for the movie or a forthcoming sequence. Given that the resolution will drop significantly when viewed on a TV screen, it's a good idea to position such lettering against a dark and fairly static background. This is where you'll benefit from having used a tripod when shooting.

Template Titles

Many low-cost editing packages now include a quick-and-easy titling system, such as the Title Deko application that is provided with programs like Studio and Liquid Edition. Not only do these make the creation of professional-looking titles, subtitles, and captions very easy, but you'll usually find a wide range of templates that can be used as they are or adapted for your particular use. Applying

them is simply a case of dragging them from the *Titles* folder (below left) and dropping them onto the appropriate track on the *Timeline* (below right). Many programs have a dedicated *Titles* track, enabling the titles to appear over the background sequence. Titles can be moved completely independently of the movie clips, making timing and positioning very simple to achieve.

PRO-TIP

Above all else, make sure your titles can be read easily and clearly. No matter how impressively you animate or color your titles, they are useless unless your audience can read them without effort.

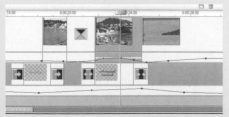

△ If you have an image capture and editing program like Adobe Photoshop (the full version or even Elements), it's possible to create some eye-catching images for titles, backgrounds, or combinations of visuals. By saving each progression separately, you can use transitions to bring them to life on the *Timeline*.

Think of a popular TV show or movie from your formative years and the chances are that you'll recall the title sequence that opened it. The massive growth in television during the 50s and 60s saw the creation of the many dynamic and often captivating title sequences that have since become iconic. Think of classic weekly shows like "Bonanza," "Dr. Kildare," "The Virginian," "The Fugitive," and—in the UK—"The Avengers," "The Saint," and "The Persuaders," and it's hard not to recall the title sequences that immediately heralded the week's transmission. With the rather limited resources (and, in some cases, budgets) available to designers, it was important to produce effective titles using simple materials.

Of course, today's digital video-editing programs are more sophisticated than those available to top professionals in those pioneering days. This means that your ability to create the most engaging and imaginative titles possible is limited only by your imagination.

Creating impressive-looking title sequences takes a lot of time and effort—not just in their execution, but in terms of the planning involved, too. It might mean, for example, that you'll need to shoot specific material for your planned sequence, and although it might only last for 30 seconds, it could be that you'll need many shots in order to build an impressive montage into which the text will be laid. The good thing about many modern titling packages is that they make it possible to generate more than one title—once inserted on the *Timeline*, it's often possible to bend, shape, and position the text into all sorts of positions and in multiple layers. The more sophisticated applications like Premiere, Media Studio Pro, Final Cut Pro, Vegas, and Liquid Edition (to name a few) let you place layer upon layer of titles and moving images so that very elaborate and eye-catching sequences can be constructed.

Using other applications

If you're familiar with image-editing and paint programs like Adobe Photoshop, Photoshop Elements, and Paint Shop Pro, you'll be able to create very unique titles and title backgrounds using all the tools available within them. Did you know, for example, that Photoshop's layers can be imported into Premiere, Final Cut Pro, and others, for animation and further manipulation? Go one step further and grab a copy of Adobe After Effects and you have a whole new world of creativity at your fingertips.

Tip

Make sure that imported images conform to the resolution of your TV system. In the USA and Canada, this will be 720 x 480 pixels (for NTSC), and in Europe and Australasia, it will be 720 x 576 (PAL).

Decorative fonts and motion

You can use decorative fonts to evoke the mood of the sequence, with many samples being supplied with editing software. Title Deko lets you change the text, modify the size and color and even add drop-shadows and other great effects. The editing software might also make it possible to determine paths that the lettering can follow to fly into, and out of, the frame over the background sequence. A word of warning, however; don't overcook the fancy typestyles, as they'll quickly become tiresome to watch. By all means create an elaborate main title, but keep other subtitles and captions simple but complementary.

As you'll see from watching TV, title sequences need not consist only of moving images that were recorded with your camcorder. If you have a scanner or some other means of grabbing photographs, drawings, and paintings into the computer, you have the potential for some very imaginative sequences. One good use of sequences that incorporate still images in this manner is in people's wedding videos; it's quite common for the video producers to assemble an affectionate montage of images that represent the lives of each of the happy couple; this can include anything from photographs to drawings and paintings. Put the kids' paintings in front of the camera or under the scanner and incorporate them, too. In fact—let them create the titles!

Importing stills

Importing images into your video production is easy if you have either a scanner (flat-bed or slide) or a digital still camera. Most Windows-based editing applications will allow you to import images in JPG, BMP, PNG, or TIF formats, with these images usually being rendered to a single format with the application itself. Apple Mac programs like iMovie, Final Cut Express, and Final Cut Pro will usually accept images in JPG, MOV, and PICT formats (among others). Windows-based applications like Pinnacle Studio and Movie Maker will readily accept BMP, PNG, and JPG images. These can be used as foreground objects, possibly in floating layers on the screen, or for use as backgrounds. You might even wish to modify them in Photoshop or Paint Shop Pro for use as textured backgrounds over which can be superimposed titles and other associated images.

Simple animation of stills as title sequences

△ Open a scanned image in an image editor and size it according to your TV system (it may not function otherwise).

△ Apply an effect—but not a high-profile effect that will dominate the whole image. Choose one that will provide a pleasing wallpaper for your title page.

△ Paste an image into the frame in a position that allows text to be flowed around it.

△ Add the first layer of text as seems appropriate to your title caption (or other images, if desired).

It's possible to create strikingly good animated title sequences from just a few vacation snaps. Having scanned them at a resolution of 150 dots per inch (dpi) or higher, you can use a paint or—better still—a digital-imaging program like Photoshop Elements to put it all together. Here's how to construct a professional-looking "build up" sequence of stills, each of which should be saved separately for reasons you'll discover later.

Users of Photoshop Elements will know how convenient it is to build up an image in layers, with individual control provided over each before finally committing the design to its export format. Having finished the design and ensuring that all the components are in the right place, you should export each layer as a separate BMP, JPG, or PICT file (according to your operating system and editing software). Give each layer a sequential file name, such as Montage01, Montage02, and so on. You'll want to handle each layer as a progression in the editing program, so they have to be kept separate.

All you have to do now is open your editing program, import the images into the project folder, and drop them into the *Timeline* in the correct sequence. Place a cross-dissolve between each of them in order to see pure magic before your very eyes! Some of the more complex programs like Adobe Premiere, Sony Vegas, Apple Final Cut Pro, and Pinnacle Liquid Edition will allow you to animate each object independently of each other and "fly" them into place just like real TV!

△ Continue to add layers with text or images to complete the design.

Video special effects

All popular video-editing packages provide you with the opportunity to change the way the pictures look. It might be that you wish to make a few changes to the quality of the image itself, or you may wish to apply some impressive graphical effects to your movies. Whatever your aim, you'll have an abundance of digital resources at your fingertips to achieve a seemingly limitless range of striking effects right there on your desktop. The big problem, of course, is that it's very tempting to go overboard with effects to the point where the production quickly becomes saturated with them, with the result that the overall quality of the edited movie suffers. Used sparingly and inventively, video effects can have a considerable impact upon your movie—but it's important to know where to draw the line.

Even the entry-level programs like iMovie and Movie Maker (that come pre-installed with Apple Mac and Windows XP-based systems respectively) have an impressive range of filters that can be used to add screen effects to your captured video footage. These range from sepia-toned effects to black-and-white, fog, scratchy old movie, and ghosting. Depending upon the package being used, it's very easy to add flashes of lightning, dark clouds, or a rainstorm to your clips while changing the intensity of colors, brightness, and contrast to match.

Video effects have a seemingly infinite number of uses, though further investigation will often reveal that the type of effects you can get away with are often dependent upon the nature of the video you're making. You can get away with almost anything if you're putting together a dynamic title sequence for a sport or even vacation video, but if the subject is more sedate, you might opt for more appropriate low-key effects instead. Let's say you've interviewed an elderly relative about his or her experiences many years ago; you could mix out to a montage of old photos or even cine film to which has been applied a combination of effects like black-and-white, soft focus, and possibly even a hint of fog. This has the effect of taking the viewer back into the dim, distant past, and it also gives the sequence a weird, dreamy quality. Your viewers will be captivated. Lay some suitably atmospheric music underneath and make clever use of appropriate titles, and you'll have a winner on your hands.

Tip

Do you want to perform a fast zoom into a small object without losing focus every time? When recording, zoom out fast while using the camcorder's remote control, and then reverse the motion in your editing package. Your zoom-in will come to a perfect, sharp, stop.

Applying video effects

The method by which video effects are applied varies between the individual packages, although the principle is the same. Usually a menu will offer the user a range of video-effects filters that can be selected and dragged to the appropriate location on the *Timeline*. Usually this will involve your dropping the effect directly onto the clip you want to modify. Depending on the application, the results of this filter application will be subject to what is known as a "rendering" process—that is, the computer will need to do some number-crunching to make it all happen—or, if your computer's processor is fast, the result of the FX application will be instantly viewable. Some programs have associated hardware accelerator cards that speed up this process considerably.

Whereas the starter packages generally feature a single video *Timeline* track onto which the clips, transitions, and effects are applied, the more sophisticated packages will offer additional tracks onto which video tracks and titles can be placed. Video FX filters can usually be applied in any quantity and to an infinite number of tracks.

Picture overlays and picture-in-picture effects

You'll often have seen examples of edited video in which a video clip is floated in a box over a background even though the action within the box continues. This kind of multi-layer approach is commonly used on the TV Travel channels where a shot of an exotic vacation destination is accompanied by textual information about the resort, the package cost, added benefits, and so on. Although not possible to achieve in the beginner packages mentioned above, this kind of effect is easily achievable in packages costing very little, with the excellent Magix Edit Pro being a good example. Placing more than one moving picture in the screen usually requires a corresponding number of video tracks in the editing program in order to maintain control over each individual picture element's size, position, and movement, and over any image filters that are used.

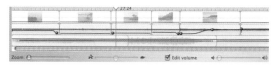

Motion control

At a much simpler level, Apple's iMovie is one program that gives you quick and easy access to a clip's speed control. After clicking once to select a clip in the *Timeline* mode, simply drag the *Motion Control* slider from the *Hare* icon to the *Tortoise* icon according to the speed required. The program will now render the clip's new speed and make it instantly available. If you don't like it and wish to change it, simply select *Undo* in the *Toolbar*. Other programs achieve this by allowing you to set the clip's speed as a percentage—with 50% therefore representing half speed and 200% representing a doubling of the speed as originally recorded.

◁ In total contrast to more sophisticated applications, iMovie provides a quick-and-easy means of modifying the speed and direction of clips. Results are instantly viewable.

△▷ The more advanced editing programs have built-in picture manipulation capabilities, such as multiple picture-in-picture (Pinnacle Liquid Edition, above). If you want really complex digital effects like Chroma Key (involving a color separation overlay technique), Adobe After Effects (right) is worth considering.

Complex mutlilayering techniques

If it's complex multilayering of moving sequences that you're after, then look no further than Adobe After Effects, which will enable you to assemble sophisticated composites from your DV footage. In this example, a homemade pop karaoke video has been made using a blue cloth and simple lighting to great effect. The area of blue in the base sequence—(the one recorded in the camcorder in which the girl singer is seen performing in front of the blue backcloth, above right)—is replaced by an animated graphic sequence, and the singer appears in front of it. After Effects and other similar applications are difficult to learn and require powerful computers to run efficiently.

Showing and sharing your movies

You might be happy to shoot and edit your video movies purely for your own satisfaction. However, you'll probably want to show your accomplishments off to members of your family, your friends, and perhaps even your work colleagues. You can do this by simply hooking up the camcorder to a TV set and playing back your sequences, or you can copy your edited movie back to the tape in the camcorder or to a VHS cassette. Even better, if you have the resources, it's now easy to copy it onto DVD, put it on the Internet, or send it as an email attachment. In this section, we look at the options available to you once you've edited your home movie.

showing and sharing
Making a videotape

Having edited your home-video production, you'll be anxious to show it to family and friends. You could gather them all in a huddle around the computer screen and let them see it—but this isn't necessarily the most appropriate viewing method. If your movie's duration is more than a couple of minutes, it won't be the most comfortable way to see it, either. What you need to do is to output the finished project in a form that makes it accessible to a wider number of people who can view it when they want, where they want.

Fortunately, you have a number of export options at your disposal. The first is to export the edited movie from the *Timeline* in the computer to a tape. This can be digital (DV or Digital-8 tape in the camcorder, assuming that your camcorder has the ability to accept a signal for recording internally) or to VHS tape.

Some programs—like Pinnacle Studio—refer to the process of exporting to a DV camcorder as the "Make Tape" mode. Others call it "Export to DV Device."

Whatever the label, the process is the same. All editing applications contain the facility to send your recording out, digitally, to a recordable DV or Digital-8 device such as a camcorder or digital recorder. Although this is a good way to store your movie in the short term, tape does deteriorate over time, so you might want to make a copy of the completed movie that won't deteriorate. You should export the completed movie as a file, and if you have room on your hard drive, you can store a perfect copy there for years. You can also store the file on a DVD indefinitely, without any loss of quality. If you plan to do this, drag the movie file itself to the disc and

▽ DV and Digital-8 pass-through copying
If your camcorder does allow you to copy back to tape via FireWire, you'll be able to make a VHS recording by making a master digital recording as described and then connecting to a VHS recorder for further copying. Alternatively, you might be able to connect the RCA Phono connectors from the camcorder (colored Red, White, and Yellow) to the VHS. The signal should flow through the camcorder direct from the computer and onto the VHS tape where it will be recorded. Check your camcorder's manual for precise settings and connections, however, as they do vary.

Problem

The camcorder won't accept the recording. What's wrong? Check that the erase prevention tab (usually colored red and located on the outer spine of the DV or Digital-8 cassette) hasn't been set to the "Save" position. This will prevent you from making a new recording on the tape. Slide it to the "Record" position.

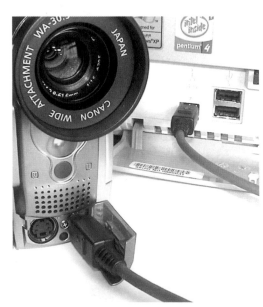

◁ **Making a DV or Digital-8 copy**
With everything connected and either a brand new cassette inserted, or a spare one having been rewound to the beginning (or set to the correct position), you're now ready to instruct the editing program to export the tape to the camcorder. Depending upon the actual program being used, this will either happen immediately (as in iMovie), or it might first need to be prepared by the computer (as in Pinnacle Studio) before sending it to the camcorder. In either case, leave the computer and camcorder to their own devices and it will be done automatically. The camcorder will stop once the recording has taken place.

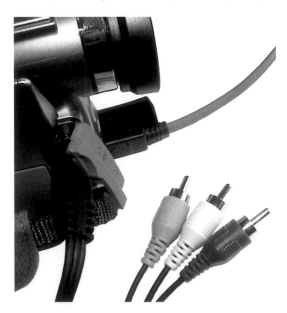

burn. When you make this kind of backup, you are making an archive copy of a computer file, as opposed to a DVD that will work in a DVD player. Years later, you could take the file from the disc and transfer it to tape, the Web, or even to DVD, as detailed on page 130.

Copying your video to a VHS tape

This is still the most common way to share edited videos with others, and it's easy to do provided that you have all the connections that came with your camcorder or the means to send the video and sound signals direct from your computer. Many digital video camcorders have the ability to accept a signal from the computer back into the camcorder using the same FireWire cable that was used to capture your footage in the first place.

With the cable connected to the computer (PC or Mac) and to the camcorder, you'll first need to switch the camcorder into either "VCR" or "Player" mode (depending on the make and model). You should now see an indent in the LCD screen or viewfinder which reads "DV-in," signifying that the camcorder can accept an external digital input via FireWire. If the camcorder cannot accept a DV-input, you'll have to explore other means (*see box: Direct output from the computer*).

| Email | HomePage | Videocamera | iDVD | QuickTime | Bluetooth |

Videocamera

Record your movie to a tape in your videocamera. This operation may take several minutes to complete.

Wait 5 ⌄ seconds for camera to get ready.

Add 1 ⌄ seconds of black before movie.

Add 1 ⌄ seconds of black to end of movie.

Make sure your camera has a recordable tape and is in VTR mode.

☐ Share selected clips only (Cancel) (Share)

△ After deciding how your edited movie is to be distributed to others—as an email attachment, back to DV tape in the camcorder, to DVD disc or as a component of a webpage— Apple's iMovie applies the appropriate settings automatically from the moment the Share button is clicked.

Tip

Back up your complete edited production to digital tape and you'll be able to recapture the contents for re-editing at a later date with no loss in quality.

Direct output from the computer

If your camcorder doesn't facilitate the re-recording of signals back to the tape inside (as is the case with many DV and Digital-8 camcorders, particularly in Europe), you might be able to connect a TV or VHS recorder to a composite video output on your computer's graphics card. This will be one of the PCI cards slotted into the rear or side of the computer. You should then connect a sound cable from the computer's sound card in order to transfer sound. If in doubt, check the manual that came with the computer or someone who knows about these things. Alternatively, you'll need a box—such as that from Canopus, Miglia, or Pinnacle, which provides an interface from the computer's FireWire socket and your analog recording (or playback) device. This will not only enable you to copy your edited movies to VHS tape, but you'll also be able to import analog recordings into the computer for editing, too.

Connecting with EuroSCART

European camcorder and VCR users will be familiar with the multi-pin connector known as SCART. When transferring from camcorder to VHS, the red, white, and yellow RCA jacks should be connected to the SCART prior to plugging into the recorder. Most SCART adapter plugs are one-way and will pass signals from the camcorder to the recorder only. To copy VHS (or TV programs) from VHS or TV to the camcorder, a two-way or switchable SCART adapter will be required. SCART connectors are not used outside Europe.

While VHS tape remains the primary means by which videomakers share their work with others, there's no doubt that DVD is fast becoming the most popular distribution medium for completed video projects. It's easy to see why. For a start, it offers much better quality than analog tape, and it also offers a true random access potential—meaning that users can flip from one segment to another instantaneously without having to wind the tape forward and backward. The DVD disc also contains a recording that has remained digital at all stages of the chain, which leads to improved technical quality, too.

Depending on what software you're using, to make a DVD from your edited project may well still involve the use of more than one application, although it's now increasingly common for the software companies to incorporate what is called "disc authoring" as an added component of the package, such as with Pinnacle Studio 9.

During the editing process, the captured video files that reside on the computer's hard disk remain as either DV-AVI or DV-MOV container formats on Windows PCs or Apple Macs respectively. However, if the contents of the *Timeline* are to be exported to a disc for playing in either a computer drive or DVD set-top player, the project will first have to converted to a format that is compatible with the destination disc format. For that to happen, we need to consider such matters as video and audio compression, resolution, and bit rates. In addition, the disc format itself will determine the duration of video that can be recorded—or burned—onto it. This is universally referred to as the authoring process.

Compression

In order to place a large amount of high-quality video footage onto a DVD disc, the material must first be converted from the native DV stream to a format that all DVD players will recognize. This is MPEG-2, a highly compressed format that manages to maintain almost all the original DV quality while dramatically reducing

Making a disc interactive

A DVD, S-VCD, or VCD disc has the advantage over tape in that the user can jump from one section to another almost instantaneously. This random accessibility is provided by a menu system which, in turn, points the user at chapter mark settings within the recording itself. Where the authoring tools are included in an editing program—such as Pinnacle Studio 9—it's quite easy to create a menu and then set up the chapter marks within the editing *Timeline*. When "authoring" the disc, the program will pull everything together automatically without your having to know the inner workings of the process.

Types of disc

To record your movie projects to disc you need a writable disc, but with such a large range of formats and discs, what's the best choice? For a start, there's CD-R, CD-RW, DVD-R, and DVD-RW. Then there's DVD-R and DVD+R, not to mention DVD+/-R, RW, and so on. If you're planning only to create your own CD or DVD disc in order to play them in your own DVD player or computer drive, then it's simply a case of testing one of the reliable brands of disc to see which suits the player. Pick a well-known brand of CD-R or DVD-R "once-recordable" disc and see how you get on with it. Use rewritable (RW) discs only for testing the functionality of your authoring process, as these discs are much less likely to work in a range of players. You're more likely to achieve broader compatibility with DVD-R than DVD+R disks. It's worth visiting www.dvdrhelp.com for a detailed compatibility check of disc makes, types, and players, as this information is constantly changing.

△▷ Easy configuration is achieved in iDVD 4 with the *Customize Settings* menu, where static and moving visual elements are added and modified simply by dropping the appropriate file onto the relevant window. Set menu background music by doing the same onto its own window as indicated. Preview the presentation at any stage by clicking the *Preview* button in order to see what everything will look like when it ends up on the final disc. If it needs changing, do it here.

△▷ Other authoring applications—such as Apple's iDVD—will accept edited files from a program like iMovie or Final Cut Express and take over the authoring process from there. The action of adding media (a built-in function of the program) will result in iDVD automatically conforming the asset files as necessary for the authoring process. Other very useful programs like TMPGenc specialize in the high-quality MPEG-2 encoding of edited AVI files and do only that.

◁ It's quite common to add some extras to your DVD disc, in the form of a slideshow featuring images from your image-editing program accompanied by a favorite piece of music imported from a resident music program. In the case of Apple, this will be iPhoto and iTunes respectively. With iDVD, everything is achieved simply by dragging and dropping files, groups of files, and individual elements as appropriate to the construction process.

Tip

It's worth producing a test-burn of a short section of your video on a rewritable disc in order to check quality prior to undertaking the final article on a DVD-R or CD-R disc.

the total file size. In addition to MPEG-2 video compression, many commercial DVD discs contain stereo or 5.1 Channel Surround sound audio that has been encoded into the Dolby AC3 format, although there are alternatives.

Depending upon the extent to which the video content can be shoe-horned into the available disc space, it's possible to save two hours of video onto a single standard 4.7GB disc, although the increase in compression will affect the picture quality. Where shorter durations are involved, it's possible to use standard 650 or 700MB CD discs instead. Using secondary disc formats like VCD (Video Compact Disc) and S-VCD (Super Video Compact Disc), you

can cram an hour of VHS-quality MPEG-1 video (VCD) or 30 minutes of DVD-quality MPEG-2 video (S-VCD) onto a cheap recordable CD.

Many video capture, editing, and share programs with built-in authoring features—such as Apple's iMovie/iDVD combination and Pinnacle Studio—will make the job of editing and compressing disc-ready files very easy. Having done so, they'll also manage the process of writing the files to CD, CD-R and RW, DVD-R, and RW discs.

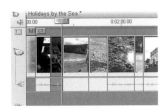

△ In Pinnacle Studio's case, a chapter mark is shown as a little flag above the *Timeline*. It marks the exact spot where the clip playback will start. In each case, a chapter mark can be set and moved as required, while you can also reassign the menu button to which it relates. If you decide that a particular chapter is not required, it's easy to delete it altogether.

A DVD disc's interactivity is provided by menus and their associated chapter marks. That means that it's possible to skip from one section of your movie to another at random without having to wait for a tape to rewind or fast forward. In order to achieve this flexibility, however, you need to do some work. For a start, it's worth giving some thought to the structure of your edited movie as you're assembling it so that you're able to divide it up into discrete and logical sections. This will make it easier for the user to see what's on offer and make a selection accordingly.

A disc menu can be created using any good graphics program like Paint Shop Pro or Photoshop Elements, or you can choose the templates that come with an increasing number of inclusive editing and authoring packages, such as Pinnacle Studio 9. Furthermore, the menu itself can be as simple or as elaborate as you like. Look at some commercial DVD titles and you'll see quite a variation in the way that they've been created. Some consist simply of a background image overlaid with text which, when clicked, launches the segment of video you have chosen. The clickable areas, or image maps, are the hot spots that are created as part of authoring, and are at the heart of the whole process. Defining these can be as simple as drawing a region within the graphic and giving the application an indication of the relevant video file or *Timeline* location, which will then be launched.

Using template menus

Studio 9, like iDVD, Ulead DVD, MovieStudio, and other programs, provides a number of template menus that can be dropped into the *Timeline* and used immediately. Chapter mark setting is achieved by first identifying the button on the menu screen to which the chapter location is to be identified, giving it a name, and then setting it. Studio has a DVD Preview option that allows you to test the project as if it were already on disc. This is a very useful and time-saving means of testing the overall functionality of your project as it is being developed, rather than leaving it until you've burned the disc and tested it, only to find you'd like to make changes.

Setting chapter marks

Every application offers its own method of setting the marks that identify the beginning of the selected video sequence; and despite the addition of software designed to make this easier to achieve, it's still something

that puts off the beginner who wishes to share his or her work on DVD. Pinnacle Studio is one of a number of applications that sets out to make this whole job much less fraught. With the program's editing and disc-authoring functions sharing the same interface, it's much easier to set chapter marks and edit menu screens than if you were reliant upon two separate applications. Apple's iMovie 4 makes chapter setting even easier.

Positioning the menu

Menus don't have to be placed at the beginning of the *Timeline*, where they will probably pop up on insertion of the disc into the DVD player or PC drive. They can be made to appear after an initial introductory sequence that autoplays when the disc is loaded, after which the user is invited to make a menu choice. Alternatively, the menu can be placed right at the end of the *Timeline* where it only pops up after the disc chapters have been viewed in their entirety. A user can always call the menu at any stage by pressing the Menu key on the DVD player's remote control.

▷ The very first frame of a sequence doesn't always lend itself to being the small, thumbnail, image that is clicked on when choosing to play that particular segment or clip. The option to select any frame within the sequence is now common to all DVD-authoring programs—such as this dialog box provided within ULead DVD MovieStudio. iDVD 4's button image styles are selectable from a drop-down menu and can be changed easily to suit your preferences.

The many template menus are easily adapted to your own use, both in terms of the text labels, the backgrounds, and the thumbnails that constitute the buttons themselves. In iDVD 4, the creation of thumbnails to represent each clip or chapter is processed automatically.

△ All applications let you switch to a *pseudo disc running* mode so that you can check the functionality of your chapter marks and menu buttons. This stops the wastage that can occur when burning faulty discs without previewing them first.

Change the template style or design of buttons and everything is automatically updated with no fuss. The Studio menu wizard—which itself is a component of the Title Deko utility—lets you change all of the elements as required, in addition to adding new options or reducing excess ones. Another common feature of many menu and authoring applications is the ability of users to select a frame of video for use as either a static thumbnail image or even a short video loop. Being able to choose a representative frame is particularly useful where, for example, the actual first frame is black (where there's a fade-up from black). Selecting a short motion-menu clip is achieved with similar ease.

△▽ Using a template doesn't mean you're stuck with it. All of the applications provide ample opportunity for you to modify and personalize your menus thanks to user-friendly wizards.

Tip

For your first effort, don't try to be too adventurous. Use the existing templates and play with them until you're confident enough to launch into your first serious project. You'll end up producing lots of expensive coffee-coasters otherwise!

Just as you'll probably find yourself having to compress a lot of clothes into a suitcase as you prepare to go on vacation, so compression is required when you plan to squeeze a lot of video into a small space. When you think that just one frame of full-screen video can consume around 1MB of storage, it's easy to see why discs need to be large and computers need to be fast in order to cope with all the data that passes through them. In order to cram a lot of high-quality video into a small space or move video sequences from one place to another, it's necessary to compress the data so that it becomes manageable while minimizing any inevitable loss of quality.

Even relatively experienced videomakers talk of DVD video as being compressed video and DV and Digital-8 as being uncompressed, but this isn't true.

Even DV is the result of a compression process that has seen each unit of video being compressed to a fifth of its original size as the data stream is prepared for recording to tape (we call this a 5:1 compression ratio). The MPEG-2 compression as used by DVD is, of course, an even heavier form of compression.

So, just as the job of packing your suitcase results, eventually, in a corresponding unpacking at your destination, so a compressed video sequence is uncompressed at the receiving end. This whole process employs a COmpression and DECompression algorithm—or codec for short. MPEG-1, and as we saw on pages 130–131, MPEG-2, are both codecs that are applied to video when it's required to play on disc in VCD and S-VCD/DVD formats, along with other applications using other media forms. Without such compression, we simply wouldn't be able to pack the required amount of data onto the respective disc formats.

Choosing the right codec

There are so many codecs to choose from that, for the beginner, it can be immensely confusing. Those programs that now incorporate export codecs into their authoring software will obviously attract those who really don't want the bother of figuring all of this out for themselves. Although users of Apple iMovie won't be able to author their discs within that program, it might be advisable to "Export to iDVD" in order to complete the job. In this case, iDVD will provide a quick and easy guide to the appropriate codecs to be used. An easy-to-use wizard system makes it easy for users of Pinnacle Studio 9 to choose the correct codec for the intended usage.

Many CD and DVD authoring wizards—including the one contained in Pinnacle applications—will give you an instant reckoner in this respect. However, do bear in mind that the more you crunch the bit rate down, the more your video quality will suffer. Almost all applications will include a feature that allows you

△ Like most mainstream editing applications, Adobe Premiere Pro provides a set of output specification templates for the preparation of discs. The effectiveness of a given codec is dependent on the rate at which data can be being pushed through the system. This is called the bit rate, and it defines the maximum rate at which a sequence can be compressed for a playback device. So, with a maximum possible data rate of 9.8Mbps (or 9800Kbps), it's necessary to ensure that the selected rate falls below that. If you wish to squeeze more than the optimum amount of video onto a standard DVD disc, you'll need to reduce the bit rate in proportion to the capacity.

to set upper and lower limits to the encoding bit rates. This variable bit rate (VBR) feature is designed to enable the codec itself to calculate the optimum compression rates for a particular sequence. If a lot of rapid movement (as in fast-moving sports shots) is included, a high bit rate is needed to cope with the dramatic changes of image data from frame to frame. Shots with little or no movement (where less data is updated) can stand a high compression, so will be happy with a low constant bit rate (CBR). You will probably find that, for an average 60-minute DVD recording, you'll need an encoding bit rate in the range of 6500Kbps to 7500Kbps, whereas the task of compressing 1.5 hours of programming onto the same disc might require a range of between 5500Kbps to 6500Kbps. The minimum bit rate for MPEG-2 is 1500Kbps.

△ As you become a more experienced user, you'll want to take more control over the many aspects of compression. Most programs will present you with a range of options to control the more complex compression parameters.

Not only is compression directly affected by the quality of the video material you're expecting to compress (lots of shaky camerawork with heavy use of the zoom will prove more difficult to compress than well-shot, tripod-mounted camerawork), but the compression algorithms themselves will vary between software brands and types. The only way to be sure of what's best for you is to experiment and discover the advantages and disadvantages of the different codecs and different settings. Start by using the template codecs supplied as part of the software. If you're not satisfied with them, you might wish to experiment with third-party alternatives like the excellent TMPGenc, available as a free-trial download from Japanese code specialist Tsunami.

△ A third-party shareware application called TMPGenc (middle image and above) is widely regarded for not only the quality of compression that it produces but the degree to which you can determine the various compression settings.

Audio compression

Digital audio (sound) is measured in terms of the audio sample rate and the bit depth of that sample. Many camcorders offer sound recording at a sample rate of 48,000 Hz (Hertz), alternatively referred to as 48 kHz, which is consistent with professional-quality digital audio tape (DAT). The bit depth will most likely be 16-bit Stereo. A CD containing music will offer samples of 44.1 kHz at 16-bit stereo. This is commonly used by DV and Digital-8 camcorders. DVD can reproduce audio sampled at the maximum rate and with 16-bit stereo sources, and this is relevant where you might wish to play back your audio on high-quality, home-audio systems—particularly 5.1 Digital Surround systems. The compression programs will provide scope for setting audio compression variables along with their video counterparts.

Tip

For best reproduction, choose the highest video and audio bit-rate settings you can in relation to the available target disc space.

showing and sharing
Movies and the Internet

 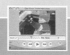

△ RealPlayer is a very popular streaming media format for which encoders are included in almost all Windows-based video-editing and compression programs. It's ideal not just for downloads, but also for streaming. To this end the BBC, CNN, and ABC News all serve radio and video programs using the system.

Thanks to the Internet, it's possible to share your edited movies not just on videotape or disc, but also by email and the Web. So popular has this method of distribution now become that virtually all of the popular video capture, editing, and compression programs you'll have read about in this book will allow you to prepare your edited movie files for Internet sharing. The limitations of the average Internet connection do mean, of course, that you won't be able to simply click on the finished AVI, MOV, or MPEG file and send it as an attachment to the email message you've just typed to Cousin Martha in New Zealand. Even if she has a faster broadband connection, she won't be able to watch the full-screen version without having to wait many hours—or even days—for it to download. So that your video clips can be viewed over the Web, you need to compress it even more than you do when saving to disc.

If you're a regular Internet user, you'll probably be aware that in order to view video sequences or listen to audio clips in a Web browser like Internet Explorer, Safari, Netscape Navigator, or Opera, you'll need something called a media player. This isn't something physical that plugs into your TV set like your VHS or DVD player, but it does do much the same job on your computer desktop by providing an interface between the browser and the file you wish to view. There are three main media players in common use—Microsoft's Windows Media Player, Apple's QuickTime, and Real Media's Real One player. There are other players, too, such as Macromedia's Flash and Shockwave players, as well as more specialized applications like DivX. However, WMP, QuickTime and Real all dominate the market and there are versions of each available for use on both Windows and Apple Mac platforms.

Sharing high-quality content

The days of blocky video in tiny windows with squawky sound are fast disappearing. Microsoft's Media Series 9 player is capable of delivering high-quality media content to a much higher standard than its predecessors. As the take-up of broadband Internet connections increases rapidly, it's possible for videomakers to show off their work to a much higher standard. Movie Maker 2 provides options to encode and export edited work for playback in Series 9 players, among others.

Sharing video via the Internet with Apple iMovie 4

The latest versions of iMovie make the sharing of video clips extremely easy. Simple wizards and menu selections are provided that will automatically compress and prepare the clip depending on your menu choice. Simply tell the program what type of connection you wish to compress for and it will do the rest. The output format will, by default, be Quicktime.

◁ Apple's Quicktime player sits at the heart of all Mac-based video capture, editing, and output, making it a natural choice for video-makers who want to share compressed files via the Internet or by email. For a modest fee, the Pro version can be obtained, which offers quite advanced editing facilities, too.

Window sizes and compression

Whether you're preparing a file for compression in WMP, Quicktime, or Real One, you'll be faced with the same set of considerations—namely the need to make the file as small as possible while retaining the maximum image and sound quality. It's not easy, and you must be prepared to make compromises. It's easy to optimize a clip for downloading or streaming by a user whose connection properties you're aware of, but if you're planning on making a clip more widely available, it's possible that you'll need to offer a range of download and streaming options. Pinnacle Studio and Apple iMovie are just two of the many starter applications that now offer simple wizard menu systems to make this easy. For the sharing of clips with end-users whose connection is a standard 56Kbps modem (whose Mac or Windows PC is connected to the Internet using an ordinary telephone line), you simply need to follow the wizard settings for 56k Modem. This will result in your having to limit the window size

of the clip (the size, in pixels, that the clip appears when viewed in its appropriate media player) to a small size, and will also require the frames-per-second rate to be modified down to something like 12 fps or even less. 10 fps or even 8 fps is not uncommon for slow connections. Given, also, that most 56K modem connections offer at best a 44K connection speed on average, you'll have to ensure that the data rate is 40Kbps or less. Audio might require a choice of 22Kbps sampling, or even less—and in mono, too. The results are less than brilliant, but that's necessary if your target viewer is to see and hear anything at all.

Network connection speeds

Even though the number of users now taking advantage of DSL (Digital Subscriber Line) connections—commonly referred to as Broadband, because of the increased bandwidth available to send and receive large chunks of data—is increasing rapidly, the majority of Internet users are still restricted to standard 56Kbps dial-up modem connections, which makes sending and receiving compressed video clips an arduous task. In fact, it's debatable whether it's worth offering people with such slow connections the opportunity of viewing your edited sequences at all due to the substantial compression required to send them across the telephone system. Those with ADSL (Asymmetric DSL, commonly employed in many countries—including North America, Europe, the Far East, and Australasia) have the advantage of higher download speeds (up to 10 or even 15 times that of an ordinary connection) and therefore higher-quality video.

The most common range of Internet connection speeds and types are: **Dial-up modem** (56Kbps or less) | **Single channel ISDN** (128Kbps) | **Dual-channel ISDN** (2 x 128Kbps) | **Corporate LAN** (100 Mbps) using an internal computer local area network of businesses and other organizations | **DSL** at various speeds (150Kbps, 256Kbps, 384Kbps, 512Kbps, and even higher).

For anything close to viewing video clips via the Internet, single-channel ISDN should be considered as the basic minimum connection speed. The increasing take-up of Broadband DSL (and, more specifically, ADSL) at speeds of in excess of 512Kbps make the downloading and streaming of Internet video at window sizes in excess of 240 x 180 pixels (in 4:3 aspect ratio) and frame rates of 25 (PAL) or 29.97 (NTSC) all the more attractive to videomakers. It's reasonable to assume that 256Kbps ADSL will soon be recognized as the basic specified connection speed for Internet video.

Tip

There's only one way to get to grips with web video: experiment with the wide range of settings, window sizes, and media formats. Test your clips thoroughly using a number of connections and then modify your codecs and settings to get the best results.

Glossary

AGC
Automatic Gain Control. Circuits designed to increase a signal in order to bring it within acceptable parameters, such as light or audio. Used in a camcorder's automatic video audio-level control circuits.

AGP
Accelerated Graphics Port connector. This connects the graphics (video) card to the computer's other central components.

AIFF
Audio Interchange File Format. The native audio format on Apple Macintosh computers.

anamorphic
Normally associated with widescreen recording and playback, anamorphic lenses optically compress the incoming 16:9 image into the 4:3 space which is then uncompressed in playback or during editing. This differs from the pseudo widescreen effect offered on many DV cams, in which a standard 4:3 picture is cropped top and bottom to give a letterbox effect (wasting valuable pixels in the process). Some recent camcorders now use a "wide" CCD chip to achieve a widescreen effect.

aspect ratio
In simple terms, a picture's aspect ratio is the ratio of the width of a picture to its height. The conventional video and TV aspect ratio is 4:3 (4 units of width measurement to every 3 units of height). Widescreen movies have a standard aspect ratio of 16:9, which is now offered by camcorders with either a wide CCD chip or an anamorphic lens. *See also resolution*

audio sampling
Sound entering the video camcorder via a mono or stereo microphone needs to be converted from analog to digital before it can be stored on tape. On entry, it is sampled at a frequency equivalent to twice its highest pitch—most commonly sampling at 48, 44.1 and 32kHz.

authoring
The process of combining all of the media assets into one file prior to the execution of a DVD or CD video project. The process results in the creation of a .VOB file containing compressed video, menu graphics, and chapter marking data.

autofocus
A circuit provided in all consumer format camcorders and many professional ones in which the optical system will focus on the predominant object within the visible image.

Autofocus works best in conditions of bright light due to the clear definition of the objects, but can "chase" for focus where the scene in front of the camera is dimly lit.

AVI
Audio Video Interleaved. A Microsoft media file format for use within Windows, and the default file format for captured video files on Windows-based systems due to its high-quality compression. Also used as an Internet streaming and non-streaming format.

back-light
Source of illumination that originates from the opposite side of the subject to the camera lens. Used to light the back of people's heads and shoulders in order to achieve depth. Also useful in landscape shots—such as shooting against the sun to emphasize depth.

bi-directional
The field of sensitivity possessed by a microphone which gives it a figure-of-eight sensitivity pattern. A bi-directional microphone is particularly useful for picking up conversation between two people.

bit
A commonly used acronym for "binary digit," the smallest piece of information a computer can use. Each alphabet character requires eight bits (called a byte) to store it. *See also byte*

Bluetooth
A system of wireless networking which enables mobile devices (cellular phones, PDAs, camcorders, computers, cameras) to communicate with each other and transfer data without the need for cables. Used in several Sony camcorders to transmit media files in and out via compatible, "paired" devices.

breakout box
A connection box designed to connect to a computer's FireWire (or other serial digital connection) in order to convert incoming analog (composite, s-video and audio) signals to IEEE1394 standard digital using the computer's FireWire port. Breakout boxes will normally facilitate digital-to-analog conversion, too.

broadband
A development of public telecommunications networks that serves to increase the amount of data that can be sent and received via a telephone line using DSL (Digital Subscriber Line) technology. Increasing use of ADSL (Asymmetric DSL) increases line speeds from

a standard 56Kbps by a factor of up to 14:1. Broadband is essential for the reception and transmission of high-quality video streaming on the Internet.

byte
A single unit of computer data made up of eight bits (0s and 1s) which is processed as one unit. It is possible to configure eight 0s and 1s in only 256 different permutations. A byte can therefore represent any value between 0 and 255. Multiples of the byte are commonly measured in thousands (Kilobyte), millions (Megabyte,) and billions (Gigabyte). A trillion bytes is called a Terabyte.

capture
The process of transferring a data stream from tape in a camcorder or recorder to the computer, using either FireWire or USB, where it can then be edited. See also capture card, FireWire, I.Link, USB

capture card
Unless pre-installed, a capture card occupies a spare PCI slot in a computer and contains the input sockets required to capture sound and vision into a computer prior to editing. Video capture cards will contain one or more IEEE1394 FireWire sockets to enable the connection of a DV or Digital-8 camcorder. *See also capture; FireWire; iLink; USB*

cardioid
A term applied to the heart-shaped field of sensitivity of many popular microhones, with the larger area being in front of the microphone's pickup head.

CCD
Charge Coupled Device. A critical component of a digital video camcorder, the CCD has a photo-sensitive surface containing an array of semi-conductors, each collects a piece of data known as a pixel (picture cell). The CCD then converts the information into an electrical charge which is proportional to each pixel's color (chrominance) and saturation (luminance). As a general rule, the larger the CCD the more pixels it is capable of generating, which in turn leads to higher quality images. Consumer digital video camcorders employ CCDs whose size typically ranges from 1/6 inch to 1/3 inch, generating perhaps 300,000 pixels for each color (for single CCD units).

CD burner
A device designed to write and read compact discs (CDs) in a variety of formats, including data, audio and video (as VCD or S-VCD).

chromakey
The electronic substitution of an alternative image or sequence into an area of continuous color within a video picture. This is commonly identified with TV weather broadcasts where a presenter appears in front of a computer-generated weather map while actually standing in front of a blue or green screen. The overlaid image is keyed to a specified color—or chroma reference. Also known as Color Separation Overlay (CSO).

chrominance
The color component of a video signal.

codec
An acronym for Compression/Decompression. A codec is essentially a set of mathematical algorithms which, when applied to an image or sound file, dispense with redundant data in a way that still enables the original image or sound (or at least a very close approximation) to be reconstructed.

color temperature
See Kelvin scale.

composite video
An analog video signal in which the luminance and chrominance signals are combined into a composite signal that uses a single connection for transfer of data between devices.

compression
The process of shrinking and recoding digital data so that it occupies less storage space or transfers faster between systems. The CCD and capture circuitry in a camcorder generate too much data for the tape or disc storage system to handle, so the onboard processor needs to compress that data, dumping what isn't necessary and maintaining what it needs to recreate the image and audio later.

cutaway
The practice of cutting away from the main action or subject to a complementary action or subject during filming or editing.

data transfer rate
The speed of data transmitted across a network, measured in bits per second (bps) or multiples of (Kbps/Mbps).

depth of focus
The sharpness of the image from foreground to background, determined by the amount of light hitting the subject and which, in turn, determines the lens aperture (f-stop). The greater the aperture (iris, exposure setting) the less depth of focus. The smaller the iris the greater the depth of focus.

depth of field
The term applied to the area of sharpness immediately before and behind the object in focus. A tightly framed flower blowing in the breeze will be in focus through a limited range from the lens, beyond which it will be out of focus in the foreground and background.

Digital-8
Digital video recording system developed by Sony which enables recording of a DV video datastream to Hi-8 and Digital-8 tape cassettes. Codec is identical to MiniDV. *See also codec; MiniDV; Hi-8*

digital zoom
A feature of some camcorders that achieve increased magnification by electronically magnifying the pixels that make up the digital image. Digital zoom can produce heavy blockiness at higher magnification.

digitizer
A device used to convert analog recordings from VHS, S-VHS, Video-8, Hi-8, etc., to a digital video stream via FireWire or USB for capture and editing in a computer.

DiVX
An alternative to the standard MPEG-2 DVD format, DIVX achieves a similar level of playback quality despite a higher level of compression. DiVX lost out to MPEG-2 as a DVD standard, but the standard remains popular for Internet downloads.

download
The process of transferring data from a remote computer (such as an Internet server) to a personal or network computer. The opposite of upload.

DVD
Digital Versatile Disc. High-capacity development of the Compact Disc, allowing storage of up to 4.7GB of data, including MPEG-2 files for playback on domestic DVD players.

DVD burner
A device capable of writing and reading files appropriate to DVD movie playback, in addition to other popular CD formats. A DVD drive is required to author and burn DVD-recordable and re-writable disks for playback in domestic DVD players and computer-based media players.

DVE
Digital Video Effects. The manipulation of images relative to others that exist digitally on the *Timeline* during editing and compositing. Commonly used to describe Picture-in-Picture and multi-layered effects.

edit (editing) software
Computer-based applications designed to facilitate the capture and combining of video and audio clips, together with associated images, titles, audio effects, on a *Timeline* in preparation for output to a range of destination media such as videotape, disc, Web, and email.

Edit Decision List (EDL)
The list of decisions that have been made during the use of an editing program. The EDL contains specific references to timecode in/out points and all the events connected with the assembly of the final master program in order that the project might be later re-assembled using the list as a blueprint. An EDL is used to convert an offline edit to an online master edit.

fields
Pictures from a conventional television comprise sequences of frames, each made up of two interlaced fields. PAL video uses 25 frames per second which are displayed at 50 Hz. NTSC is displayed using 525 lines at 30 fps (actually 29.97 fps) at 60Hz. Each field represents one pass—odd scanning lines followed by even lines. This reduces the effect of flicker.

FireWire
Also known on some makes of camcorder and computer as "i.Link." The standard for high-speed digital data transfer employing a single cable connection which was developed and patented by Apple Computer Inc. Now the standard means of connecting digital camcorders to suitably equipped computers and other devices, and properly referred to as the IEEE1394 standard.

font
Style of lettering, or typeface, as applied to titles and captions.

f-stop
A measurement of the aperture, or opening, of a lens and measured in f-numbers. Each f-stop represents a doubling of the amount of light entering the lens over the preceding higher number. E.g., f2 passes twice as much light as f2.8.

FX (effects)
A general film and TV production term for effects, which can be applied to either sound (SFX) or video (VFX). In desktop video, FX are normally associated with the digital transitions that are applied to two or more video tracks—the FX track being the one containing the transition between the primary

and secondary video tracks. In audio, an FX track is one containing spot effects of dogs barking, gunshots, and so on.

GPU
Graphics Processor Unit. Processes graphics information and is responsible for converting digital bits (1s and 0s) into images.

hard disk drive
The hard disk drive (or HDD) is the vital component of a computer that stores documents and other files as generated or modified by the user. Large capacity hard disks are required for desktop video editors, where 1GB is required to store almost 5 minutes of captured video footage.

Hi-8
Variant of the old Video-8 analog video recording system, fast becoming obsolete. Higher quality than VHS, but poor in comparison to DV standards. *See also Y/C Component; Video-8; Digital-8; S-Video*

Hz
Hertz, or cycles per second. Sound sampling frequences are measured in kHz (kiloHertz). DV camcorders typically sample and digitize audio at 48 kHz 16-bit stereo. 12-bit audio (as available on camcorder with an audio dub facility) is sampled at 32 mHz, 12-bit rates.

i.Link
The Sony registered brand name for the digital connection which conforms to the IEEE1394 standard for high-speed data transmission. Commonly known as FireWire. *See also FireWire*

IEEE1394
The technical specification for the standard of data transfer commonly known as FireWire, which was originally developed and patented by Apple Computer Inc. *See also FireWire; i.Link*

image stablization
Optical Image Stabilization (OIS) and Electronic Image Stabilization (EIS). The former uses optical elements to compensate for camera shake, the latter processes incoming data digitally to similar effect. The advantages are minimal in low-cost digital camcorders.

JPEG
Abbreviation for the Joint Picture Experts Group. An industry group which defines the compression standards for photographic images. The abbreviated form gives its name to a lossy compressed file format commonly used in the transfer of images, such as those

that make up webpages, where smaller file sizes are required in order to make the download process faster.

Kelvin scale
A scale for measuring the color (or 'temperature') of light, and universally used by film and video-makers as well as stills photographers. Average daylight is measured as 6,500 Kelvin in Europe and 5,000 Kelvin in North America.Blue colors radiate high temperatures, whereas red colors radiate lower temperatures.

LCD
Liquid Crystal Display. The type of color display commonly used in the flip-out screens on camcorders. Also used in some viewfinders.

Li-ion
Lithium Ion. A compact rechargeable battery system for use with camcorders and other portable devices. The battery's charge will be seen to drop quickly during initial use, but will then stabilize.

luminance
The technical name for the saturation, or brightness, of a video signal.

Mac, Apple Mac
Apple MacIntosh computer. A competing standard to Microsoft's Windows and very popular with the creative community in the fields of design, print, audio production, and video post production. Required to run Final Cut Pro, Pro Tools, DVD Studio Pro, iMovie, and Final Cut Express.

macro
A lens, or lens attachment, designed to provide pin-sharp images of objects situated in very close proximity to the front lens element.

matte
A matte is so-called due to its roots in early cinema production, where a "traveling matte" (as flown by the mythical Ali Baba) was inserted into a sequence of film using hand-painted luminance reference and optical printing. Today, electronic blue and green screen techniques have replaced hand-painted mattes. *See also chromakey*

Memory Stick
Flash memory storage card developed by Sony. Memory Stick PRO allows 1GB storage with a theoretical capability of 32GB. Other branded variants include the MC (Memory Card) and SD Card (Panasonic, JVC, Canon, etc).

MICROMV
Sony digital video format that encodes a variant of MPEG-2 to videocassettes that are 30% smaller than MiniDV.

mini-jack
The standard means input and output for microphones and headphones on consumer format digital camcorders, mobile audio players, etc.

MOV
The file extension applied to QuickTime media files. The default video capture file format as used by Apple Mac-based video capture and editing applications.

MP3
Type 3 codec used to compress audio files into a form small enough to be downloaded from websites and stored in portable devices, such as the Apple iPod.

MPEG
Motion Picture Expert Group. The body responsible for the MPEG-1, MPEG-2, MP3 and MPEG-4 compression formats as used in digital audio-visual media

Network Handycam
Sony's range of MiniDV and MICROMV format camcorders that employ Bluetooth wireless networking capabilities, and are therefore able to pair with cellphones, PDAs and suitably equipped computers to send and receive compressed media files without physical connections. *See also Bluetooth*

Ni-Cad
Nickel Cadmium. A type of rechargeable battery cell commonly found on professional camcorder systems and some consumer formats. It discharges at a steady, even rate.

NLE
Non-Linear Editing. The use of computer systems to digitally capture and arrange video, audio, and associated media clips using appropriate editing software. Evolved from the use of linear, tape-based editing in which sequences had to be assembled in a linear manner, making re-arrangement difficult.

NTSC
National Television Standards Committee. This is the TV standard employed in the USA, Canada, Japan, and other countries in South America and many nations in the Pacific. NTSC uses 525 lines made up of two interlaced fields scanning at 29.97 frames per second or 59.94 fields per second. SECAM recordings will often play in monochrome on PAL TV receivers.

OHCI
Open Host Controller Interface. An agreement between manufacturers that enables a sharing of standards for computer peripherals for improved compatibility.

PAL
Phase Alternation Line. The standard TV display format for the UK, most other European countries (with the exception of France), Australia, New Zealand, and several African nations including South Africa. PAL is made up of 625 lines, using 25 frames made up of two interlaced fields, this producing 50 fields per second.

Panther
Common name for the Apple Macintosh computer operating system version 10.3, known also as OSX 10.3.

PCI
Peripheral Component Interconnect. The standard 32-bit bus that transfers data around the computer. A PCI bus can transfer 132MB per second at a 33MHz clock frequency.

pixelation
An unwanted visual artifact where the image breaks down into recognizable blocks of color. This most frequently occurs as a result of compression, particularly in color boundaries or areas where there are high-contrast edges.

post-production
This is the process that takes place once production footage has been acquired, and encompasses everything from the first offline cut to computer graphics, edit mastering, compositing, and audio track-laying and dubbing. In professional video it's common to talk of a production going into "post."

POV
Point-of-View shot. The POV is a commonly employed cinematic device designed to represent the viewpoint of a character in a sequence. A cyclist, for instance, might be proceeding along a street when a car crosses his or her path. The camera assumes the position of the cyclist as contact with the car is made, enabling the viewer to see the cyclist's "point of view."

progressive download
A method of receiving a media resource from a remote Web server without having to wait for a complete download prior to viewing or listening to the file. In the case of audio and video, the early portion of the file will be viewable while the remainder downloads in the background.

progressive scan
A process of combining interlaced fields into a sequence of single "progressive" frames at rates of 1/50th sec (PAL) and 1/60th sec (NTSC). This reduces the effect of flicker, and benefits the recording and playback of sequences where sharp individual frames are required. Several DV camcorders now support Progressive scan shooting. *See also PAL; NTSC*

QuickTime
Media compression and streaming playback format developed initially for use on Apple Mac computers, and now also available for use with Windows PCs. QuickTime Pro offers additional paid-for functions, including simple editing and file conversion.

RAM
Random Access Memory. The memory "space" made available by the computer into which some or all of an application's code is loaded and remembered while you work with it. In general, the more RAM a computer has the better its general program management will be—especially for those programs that handle large video, audio, and image files.

RCA phono
A standard audio connection device as used in consumer and some professional audio and video systems. Commonly colored yellow (video), red (audio, right channel), and white (audio, left channel), and provided as part of the cabling issued with most camcorders.

REAL
Media player developed by Real Networks for playback of Real Video and Real Audio files on Windows and Apple Mac platforms.

real time
The ability to set up and view often complex video effects and composites immediately at full resolution. Real Time (RT) video cards boost the computer's ability to perform these tasks without the editor having to wait for rendering to take place. *See also render*

render
The process of producing a composite file from a number of source files—such as video clips, audio clips, titles, graphics, etc., on a desktop video program *Timeline*. A render will also take place in order that the result of applying a transition between two video clips may be viewed. On fast computers, renders will take place in real time. On other systems, rendering might be undertaken as a background activity. A "final render" is the effect of preparing the completed project in a format appropriate to a particular use, such as compressing as MPEG-2 for DVD playback.

resolution
A digital video frame's resolution is measured in pixels in both the horizontal and vertical planes. An NTSC picture will have a digital resolution of 720 x 480 pixels, whereas a PAL image will consist of 720 x 576 pixels. SECAM images have the same resolution as PAL. *See also NTSC; SECAM*

RGB
Red, Green, Blue—the three primary colors employed and processed by all analog and digital video systems.

SECAM
Sequential Couleur avec Memoire. A TV system developed in Russia and adopted by France. Similar to PAL 625, it employs a modified system of color encoding. SECAM sequences played on PAL devices look black and white.

Signal-to-Noise Ratio
Also referred to as S/N Ratio. The relationship between the signal you want to hear and the noise (tape hiss, etc) that you don't. Measured in decibels (dB).

storyboard
The graphical representation of the shots that make up a sequence, in the form of drawings that depict a shot's contents. Also alternative form of visually displaying shot thumbnails in an editing program's *Timeline*.

streaming
A method of making a media file (audio, video) available to a user's Web browser without requiring a download in order to hear or see it. Commonly used for live Web-casting or where lengthy duration files are to be relayed over the Internet.

S-VCD
Super Video Compact Disc. Uses MPEG-2 encoding to store and replay media files at a resolution of 480 x 576 (PAL) and 480 x 480 (NTSC) on a standard CD for playback on DVD players or computer-based media players.

S-VHS
Super Video Home System. Variant of VHS which uses higher bandwidth and Y/C component signal processing to reduce noise inherent with standard VHS systems. *See also VHS, Y/C component.*

S-Video
A process of transferring and recording standard composite video in which the chrominance (color) and luminance (saturation) are handled separately in order to reduce picture noise. Used by Hi-8 and S-VHS format devices.

telephoto
Term applied to a lens with a high level of magnification. A zoom lens's telephoto setting is considered to be its maximum magnification factor.

timecode
A system of uniquely identifying a frame within a video recording, whether analog or digital. The timecode is made up of four sets of two digits, representing hours, minutes, seconds, and frames, which are generated internally within the camcorder (or, in the case of other recording systems, by a standalone time code generator) and electronically embedded into the recording. Timecodes can be used to identify the location of a shot within a recording on tape providing that the codes are unique—DV camcorders have a habit of re-setting the code to zero if a blank section of tape is detected.

timeline
The visualization of a video or film project in time. Desktop video applications employ a *Timeline* as means of constructing the clips that make up a project, starting with the first clip at the zero point and proceeding to the end in a left to right direction. Some desktop video editing tools offer an alternative method of viewing clips on a *Timeline* which is commonly referred to as the storyboard viewing mode.

transition
A visual transition is the means by which the viewer is transported from one part of the story to another using a wide range of visual tools. The most common transition is a dissolve (also known as a mix or crossfade). Other transitions includes wipes (linear, rectangular, and circular) and DVEs (complex digital effects in which shots or sequences are treated as objects and assigned paths to control their motion—zooming in, zooming out, rotating, and so on).

turnkey
A system that has been designed and built to be switched on and operated without the user having to make additional modifications or settings. Many professional desktop video editing and compositing workstations are designed as turnkey systems.

upload
The process of transferring data from a personal or network computer to a remote computer, such as an Internet server.

USB
Universal Serial Bus. A connecting port (socket) on most modern computers for the connection of peripheral devices to the Apple Mac or Windows PC which can be daisy-chained together or used via an external connecting "hub." MiniUSB is a variant of the standard connector which enables users of digital video camcorders to export digital images, sounds and MPEG-1, MPEG-4 compressed via clips to an from a user's computer using supplied software. USB has two versions: USB 1 offers transfer speeds of 12Mbps. USB 2 transfers data at 480Mbps.

VCD
Video Compact Disc. Uses MPEG-1 encoding to store and replay media files at a resolution of 352 x 288 (PAL) and 352 x 240 (NTSC) on a standard CD for playback on DVD or computer-based players, such as Windows Media Player, Real or QuickTime.

VCR
Abbreviation for video cassette recorder.

VHS
Video Home System. Consumer video format which uses half-inch wide tape to record an analog signal. Dates from mid-1970s and fast becoming obsolete. *See also S-VHS*

Video-8
Analog format developed by Sony and fast becoming obsolete. Uses 8mm wide videotape cassettes. See also *Hi-8; Digital-8*

video capture card
A PCI adapter used to connect video equipment to a computer for editing purposes. Typically, the capture card will contain one or more (often three) FireWire ports enabling the transfer of data from the camcorder to the computer and back, and may contain analog connections as well. As many computers now contain FireWire ports as standard, capture cards are less vital than they once were.

video card
Also known as a graphics card. These take instructions from your computer's CPU and convert them to a form that can be displayed on the computer's analog or digital screen.

VOG
Voice of God. Name given to the commentary or narration of a video. The narrator is not seen but is omnipresent, hence the term. Commonly referred to as a voiceover, the commentary, narration or VOG track will be added to the edited production by a Voice Artist using a V/O booth at an audio dubbing facility.

WAV
Derived from "wave" or "waveform." The native audio file format as used by Windows-based computer systems.

white balance
Often referred to as WB, the process of referencing a camera or camcorder to either daylight or artificial (indoor) light in order that white objects (e.g. paper) appear their correct color on camera. See also *Kelvin scale; Color temperature*

widescreen
A wide TV image, also referred to as 16:9 due to the relative horizontal and vertical proportions.

wide chip
A CCD imaging chip employed by manufacturers like Sony to enable the resolving a true widescreen images at the ratio of 16:9 without the need to crop a standard 4:3 image by the use of black bands at the top and bottom of the screen.

wide-angle converter
An optical lens attachment designed to reduce the minimum focal length of the lens and therefore increase the field of view. Will also have the effect of increasing the depth of focus of a shot. Typically, a wide-angle lens converter halves the lens's widest focal length to increase the angle of vision.

Windows
The most commonly used computer operating system from Microsoft. Applications that have been designed only for Windows will not run on Apple Mac computers, unless re-written for the purpose. *See also XP*

XLR
A standard 3-pin connection most commonly used with microphones and high-quality audio sources feeding a camcorder, recorder, or mixer with a balanced audio signal. MiniDV camcorders normally have unbalanced "mini-jack" type connectors, for which a converter needs to be used when connecting XLR mic cables.

XP
Computer operating system from Microsoft which provides the platform upon which all other software applications run. Comes in XP Home and XP Professional variants.

Y/C component
A video signal in which the two main components—the Luminance (Y) and the Chrominance (C)—remain separate throughout the signal chain. If the Y and C components remain separate, the resulting image display will not suffer from the same cross-luminance and cross-chrominance artifacts as composite video. *See also Composite video*

zoom
A zoom lens is used to vary the focal length of a lens by altering the relationship of the optical elements within the lens. Zooming in and out can also be achieved by digital signal processing within the camcorder—called digital zoom—though high zoom ratios are to be avoided due to the resulting heavy pixelation.

Index

AC mains 37
accessory shoe 16, 26, 67
 see also "hot shoes"
action shots 46-7
Adobe After Effects 123, 125
Adobe Premiere Pro 29, 105, 111, 114,
 117, 123, 134
ADSL 137
.AIFF 118
AKG microphone 69
"anamorphic" widescreen 32, 33
Apple Mac 17, 70, 104, 106, 107, 108
Apple QuickTime player 136, 137
 GarageBand 119
artificial light 26
artificial lighting 65
aspect ratio 32
audio
 compression 130, 135
 "dub" facility 68, 69
 mixing 117
 recording settings 68
 track 118, 119
auto-exposure 22, 23, 27, 49, 65
auto-exposure circuit 63, 64
auto-focus 9, 15, 20, 21, 49
automatic exposure mode 62
automatic exposure system 24
Automatic Gain Control (AGC) 24
Automatic Scene Detection (ASD) 109
Auto White Balance mode 27
authoring process 130, 132
AV sockets 14
AVI file 107, 131, 136

babies, filming 82-3
background light 64
backgrounds 42-3
 textured 123
"Back Light" feature 23, 64
Back Light filter 64
battery 15
battery light 16, 25, 26
big close-up shot (BCU) 60
binary code 10
bit rate 130, 134, 135
body language 76
Broadband 136, 137
built-in flash 15
built-in microphone 67, 80, 85

camcorder effects 30-1
camcorder support 24
camera shake 39, 43, 56, 110
camera position 80
Canopus Edius 109, 114
capture interface 105
Capture mode 107
capturing 106, 107
Charge Coupled Device (CCD) 18, 24, 25,
 60, 64
"CD ripping" 118
center-weighted meter 23
chapter marks 132
children, filming 76-7,
 birthday parties 78-9
Christmas 88
Chroma Key 125
"church window syndrome" 23
"clip bin" 105, 107, 109
clips, deleting 109
clips, trimming 110-11
close-up 18, 38, 39, 44, 45, 48-9, 53,
 59, 83, 91, 97
codec 134
color 60-1
color temperature 26, 27, 60
commentary 68, 69, 119
 recording 119
composite video
composition 33, 58-9
compression 131, 134-5
 and window size 137
concerts 80-1
constant bit rate (CBR) 135
continuity 52
contrast 18, 23, 65
"contrast ratio" 62, 63
copyright 81, 119
Crop tool 110
cross-dissolves 114, 116, 123
cross-fades 114, 117
cutaway shots 50-1, 96,112, 113

daylight 26
depth of field 20, 24, 33
depth of focus 43, 54, 63
Digital-8 14, 15, 28, 70, 83, 107, 128,
 129, 134
"digital domain" 10
digital sound loops 118
Digital Subscriber Line (DSL) 137
digital video 10

digital video effects (DVE) 30, 31
digital zoom 45
digital zooming 19
directional microphone 16, 66, 67, 80, 81
disc, types of 130
dissolves see cross dissolves
DiVX
Dolby AC3 131
dramatic shots 23, 46, 97
dummy jack 28
DV 28, 32, 70, 83, 107, 128, 129, 134
DV-AVI 130
DV-MOV 130
DV stream 107, 130
DVD 15, 32
 authoring 106
 burning 106
 formats 134
 making a 130-1
 menus 132-3
 storing on 128

Edit Decision List (EDL) 108, 111
edit list mode 108
edit software 104-5
editing 38-9
 with timecode 29
 sound 116-17
Electret Condenser microphone 66, 67, 69
establishing shots 40-1, 57, 59
EuroSCART see SCART
"Export to DV Device" 128
exposure 14, 18, 22-3, 61, 63, 64
"Extract Audio" mode 119
 measuring 23

fade 114, 117
field of view 20
fields 29
Final Cut Express 109, 111, 123, 131
Final Cut Pro 108, 119, 123
FireWire 15, 17, 106, 128, 129
FireWire card 107
"fixed focus" lens 19
flash light 15, 91
focal length 14, 18, 19, 45
focus 9, 14, 15, 18, 49
focus lock 20
focus, manual 20
focusing 20-1
font see typefaces

footage organizing 70-1
f-stop 22
FX (effects) 119

grain 25, 65

Halloween 90-1
halogen lamp 25, 26
hard disk drive
headphones 16, 66, 67, 69, 81
Hertz (Hz) 135
Hi-8 10
high angle shots 78, 82
"hot shoes" 14
house and garden video 98-9

iDVD 4 131, 133, 134
IEEE1394 17, 106
i.Link 15, 17, 106
image importing 123
iMovie 104, 107, 108, 110, 115, 116,
 118, 119, 123, 124, 129, 131
iMovie 4 136
Info Lithium battery 15
Infrared Sensor 15
insert shot 112
"intelligent accessories" 14
interfaces 132-3
Internet 136
 connection speeds 137
interview 84
iPhoto 131
iris wipe 114
ISDN 137
iTunes 119, 131

JPG format 123
jump-cuts 113
juxtaposing shots 111, 113

Kelvin scale 26, 27, 60

LCD screen 15, 20, 25, 27, 28, 42, 48,
 69, 74, 75, 77, 129
legibility, title 120
lens
 "fixed focus" lens 19
 wide 18
 wide-angle 27, 42, 88
 zoom 19, 43, 44, 63
light 22, 23, 46, 62, 63, 87

Line of Continuity rule 53
Lithium Ion battery 15
low light 24-5, 62, 65

macro facility 49
Macromedia Flash player 136
Magix Edit Pro 125
"Make Tape" mode 128
manual focus 20, 49
master shot 50
media player 136
medium close-up (MCU) 52
memory card 14, 15, 17
Memory Stick 15
menu positioning 133
MICROMV 14, 15, 28
microphone 14
Microsoft 108
MiniDisc Walkman 81
Mini-DV 14, 15
mini-tripod 16, 17, 40
MKE300 microphone 67
monopod 16, 17, 20, 43, 47, 80, 95
motion control 125
MOV format 107, 123, 136
Movie Maker 104, 105, 107, 108, 110, 111, 115, 116, 118, 123, 124
MPEG 1 134, 136
MPEG –2 15, 130, 131, 134
musicmaking software 119

narration 69
narration microphone 68
narration track see voice over
natural light 18
neighborhood video 100-1
night shots 25
"noddy" shot 52
"noise" 67
"non linear" editing 104, 112
NTSC TV 29, 33, 37, 122

"OHCI-compliant" 107
overexposure 23
over-the-shoulder shot (O/S) 54-5, 74

Paint Shop Pro 123, 132
PAL TV 29, 33, 37, 122
pan head 17
panning shots 17, 38, 47
PCI cards 114, 129,
Photoshop Elements 123, 132

PICT format 123
picture noise 65
picture overlays 125
Pinnacle Edition 104, 114, 123
Pinnacle Studio 107, 108, 110, 111, 114, 115, 116, 118, 123, 131, 132
pixelation 45
pixels 19, 33, 45
planning 36-7
Playback mode 14
point-of-view shot (POV) 56-7,
positioning, title 120
power switch 14
"pre-stripping" 28
Program AE settings 27
programs, editing 105
"pulling focus" 21
Pulse Code Modulation (PCM) 68

QuickTime player 136, 137

RCA phono connectors 128
reaction shots 79
Real Media One player 136
Real Time (RT) engines 114, 137
Record mode 14
reflected light 25
Remote Control 15
rendering 115, 124
reverse shots 52-3
rewritable (RW) discs 130
Rights 97
Rule of Thirds, The 58

SCART 129
school plays 80-1
SD Card 15
shade 62
Shockwave player 136
shot continuity 52
shots
 action 46-7, 94
 big close-up 60
 cutaway 50-1, 96,112, 113
 dramatic 23, 46
 high angle 78, 82
 insert shot 112
 juxtaposing 111, 113
 master 50
 night 25
 "noddy" 52
 over-the-shoulder (O/S) 54-5, 74

panning 17, 38, 47
point-of-view (POV) 56-7,
 reaction 79
 reverse 52-3
 tilting 17
 walking 17, 56
Signal-to-Noise ratio 67
slow motion 46
social groupings 74
"spot focus" 21
Sony DCR-PC330 DV 22
Sony Vegas 123
sound editing 116-17
sound effects 117, 118, 119
sound recording 66
sports events 46, 96-7
stage make-up 91
summer vacation 92-3
surroundings 42-3
S-VCD 130, 131, 134
sync sound 116, 118

tape compartment 14
tape logging 70, 71
telephoto 14 18, 19
template menus 132
template titles 121
thumbnail clips 107, 108, 111, 133
tie-clip microphone 66, 67, 85
tilt head 17
tilting shots 17
Title Deko 120, 121, 122, 133
title sequences 122,123
titling 120-1
timecode 28-9, 69
timing 112-13
timeline 105, 108, 109, 110, 111, 115, 117, 125, 128,130, 133
TMPGenc program 131, 135
toddlers, filming 82-3
touchscreen menu 30
transition 114-15, 116
trim tools 110
tripod 10, 16, 17, 20, 21, 33, 49, 53, 80, 81, 82, 95
typefaces 120, 121
typesize 121

Ulead Media Studio Pro 108, 111, 114
underexposure 25
USB 17, 106

vacations, special 88-9
vacation videos 92
vanishing point 58, 59
variable bit rate (VBR) 135
VCD 130, 131, 134
VCR 129
vertical smearing 25, 65
VHS tape 61, 128, 129
Video-8 10
video
 capture 106
 compression 134-5
 diary 83
 effects 124
 portraits 84-5
videotape, making a 128-9
viewfinder 15, 25, 27, 42, 74, 77, 129
virtual sound mixer 117, 118
visual variety 50
"voice over" 85, 119

walking shots 17
.WAV 118
waveform editor 117
web video 137
weddings 86-7
white balance 26, 27, 60, 61
wide lens 18
widescreen 32, 33
wide shot 38, 39, 44, 45
wide-angle lens adapter 47, 76, 96
wide-angle converter 97
wide-angle lens 20, 47, 88
wide shots 97
widescreen 32-3
wildlife 49
wind noise 14, 66
Windows 17, 70, 106, 107, 118, 124
Windows Media Player 136
winter vacation 94-5
wizards 133, 136

zoom 14, 18, 21, 44-5, 48
zoom lens 19, 43, 44, 63
zoom microphone 14
zoom ratios 45, 66
zooming 11, 23, 45, 46, 48, 64

Bibliography, online resources, and acknowledgments

Bibliography

It's impossible to list all the useful books on the subject of digital video, so here's a small sample:

Microsoft Windows Movie Maker 2: Do Amazing Things!
by John Beuchler (January 2004) Microsoft Press
ISBN: 0735620148

iMovie: The Missing Manual
by David Pogue (June 2000) O'Reilly UK
ISBN: 1565928598

Digital Video for Dummies
by Keith Underdahl (July 2003) John Wiley & Sons Inc
ISBN: 0764541145

The Little Digital Video Book
by Michael Rubin (October 2001) Peachpit Press
ISBN: 0201758482

The Complete Guide to Digital Video
by Ed Gaskell (November 2003) Ilex Press
ISBN: 190470509X

Macintosh iLife '04
by Jim Heid (May 2004) Peachpit Press
ISBN: 0321246713

Pinnacle Studio 9 Ignite!
by Aneesha Bakharia (May 2004) Muska & Lipman
ISBN: 159200475X

Adobe Premiere Pro for Dummies by Keith Underdahl
(October 2003) John Wiley & Sons Inc
ISBN: 076454344X

Premiere Pro Windows—The Visual QuickPro Guide
by Antony Bolante (November 2003) Peachpit Press
ISBN: 0321213467

QuickTime for the Web: For Windows and Macintosh
by Steven Gulie (July 2003) Morgan Kaufmann
ISBN: 1558609040

Online Resources

Just a few of the many websites designed to help digital video enthusiasts:

http://www.dvdrhelp.com

Everything you need to know about the whole range of disc formats used for sharing digital video movies in VCD, S-VCD and DVD disc formats. Essential for hardware, software, and disc-format compatibility checks.

http://www.papajohn.net

John "Papajohn" Beuchler offers arguably the most authoritative source of information and guidance on the use of Microsoft Windows Movie Maker 2 anywhere on the planet. Don't forget his book, either.

http://www.creativecow.com

Short for Creative Communities of the World, this oddly named site is a mine of useful information for all digital video users at every level.

http://www.adamwilt.com

Adam Wilt calls himself a video geek, but is actually a highly respected California-based video systems engineer. One of the best sources of technical background info on all things digital video. Worth a visit for the DV FAQ alone.

http://www.videoguys.com

New York outfit offering advice on everything you'll ever need to know about video and more, including *The Desktop Video Cookbook Online*.

http://www.mikeshaw.co.uk

UK-based website offering excellent tips on Pinnacle Studio and Pinnacle Edition from the very expert Mike Shaw.

Not forgetting...

http://www.simplydv.com and http://forums.simplydv.co.uk

The no-nonsense guide to choosing and using digital video. Popular UK-based website set up and maintained by the author of this very book. You should be an expert by now, but check out our busy web forums anyway.

Acknowledgments

I must thank Alastair Campbell and Steve Luck at Ilex Press for inviting me to write this book, and Stuart Andrews for giving me the space to get on with it despite the pressure of deadlines. I'm especially grateful to Alan Buckingham for his expert guidance and for introducing me to the folks at Ilex. Acknowledgment is due to the many people who have helped to make the SimplyDV.com web forums such a success, too; these include Graham "Skier" Hughes and Bram Corstjens who provided images at very short notice for use on pages 94-95 and 124-125 respectively. Thanks also to Greg, Natalie, and Paul for putting up with the domestic mayhem, and to little Ewan for his star quality in front of the lens. Finally, a massive thank you to my wonderful wife of many years, Sylvia. Without her patience and unrelenting support I might be forced to live in the real world, wherever that is.

KELLEY LIBRARY